Ready to Roll

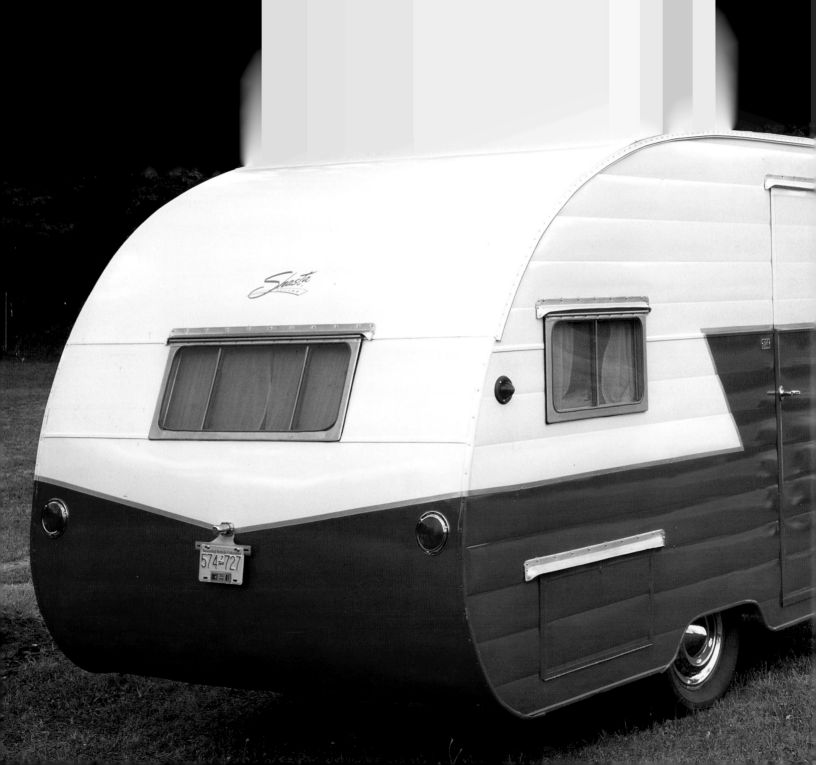

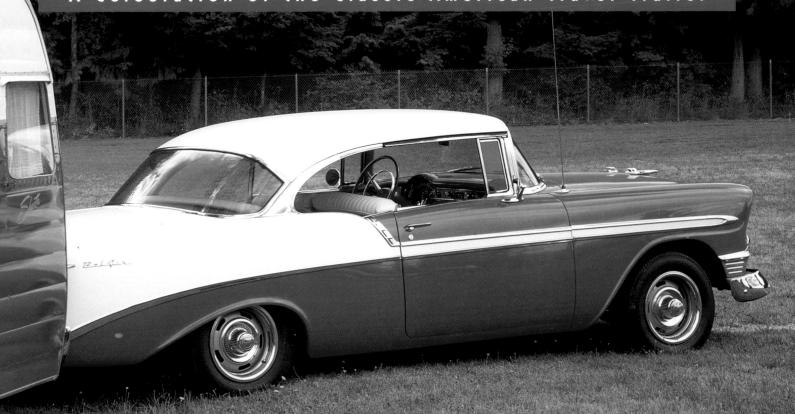

Ready to Roll

A Celebration of the Classic American Travel Trailer

ARROL GELLNER AND DOUGLAS KEISTER

Viking Studio

VIKING STUDIO

Published by the Penguin Group
Penguin Group (USA) Inc., 375 Hudson Street,
New York, New York 10014, U.S.A.
Penguin Books Ltd, 80 Strand,
London WC2R 0RL, England
Penguin Books Australia Ltd, 250 Camberwell Road, Cam-
berwell, Victoria 3124, Australia
Penguin Books Canada Ltd, 10 Alcorn Avenue,
Toronto, Ontario, Canada M4V 3B2
Penguin Books India (P) Ltd, 11 Community Centre,
Panchsheel Park, New Delhi – 110 017, India
Penguin Books (N.Z.) Ltd, Cnr Rosedale and Airborne
Roads, Albany, Auckland, New Zealand
Penguin Books (South Africa) (Pty) Ltd, 24 Sturdee Avenue,
Rosebank, Johannesburg 2196, South Africa

Penguin Books Ltd, Registered Offices:
80 Strand, London WC2R 0RL, England

First published in 2003 by Viking Studio,
a member of Penguin Group (USA) Inc.

1 2 3 4 5 6 7 8 9 10

Copyright © Arrol Gellner, 2003
Copyright © Douglas Keister, 2003
All rights reserved

LIBRARY OF CONGRESS CATALOGING-IN-PUBLICATION DATA

Keister, Douglas
 Ready to roll / Douglas Keister, Arrol Gellner.
 p. cm.
 ISBN 0-670-03055-4
 1. Travel trailers—United States—History. 2. Travel trail-
ers—United States—Pictorial works. I. Gellner, Arrol. II. Title.
TL297.K38 2003
629.226'0973—dc21 2003041150
This book is printed on acid-free paper. ∞

Printed in China
Set in Itc Kabel Book

DESIGNED BY JAYE ZIMET

Doug dedicates this book to the memory of his father, Carl H. Keister, who said that "the best thing this country ever did for the common man was build roads . . . lots of 'em."

Arrol dedicates this book to Ruthmarie . . . Aufwieder sehen liebe TANTE.

Contents

1. Hitting the Road
7

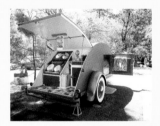

2. Tents and Teardrops
29

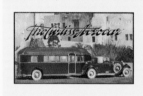

3. Aerocars
43

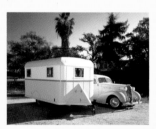

4. Bread Loaves
55

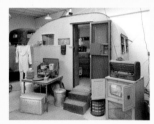

5. Canned Hams
67

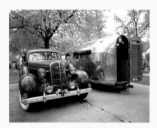

6. Hawley and Wally
85

**7. Great Nomadic
Neighborhoods** 105

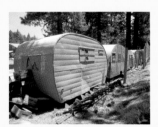

8. Endings and Encores
129

Resources
139

Acknowledgments
141

Ready to Roll

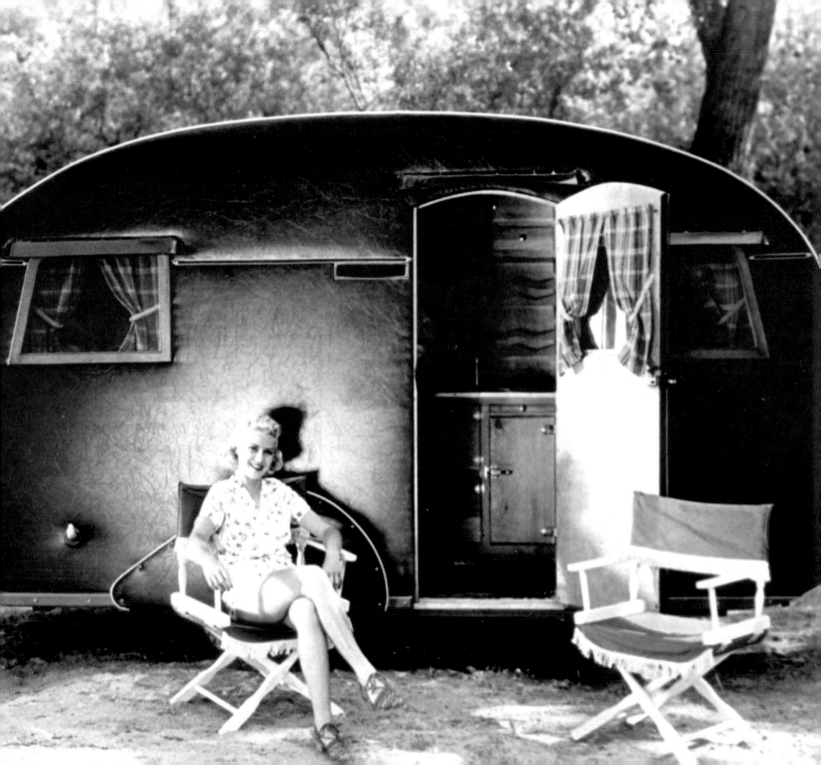

The American travel trailer was born at the dawn of the twentieth century, out of changing national attitudes to nature, travel, and aesthetics that were part of a larger reaction against the stuffiness and pretense of the Victorian era. In architecture, the Craftsman movement scorned ornamentation and artifice, and reveled in the use of natural materials—stone, clinker brick, and wood—used frankly and without apology. In art, the Cubists revolted against representationalism, the Futurists glorified the technological dynamism of twentieth-

ral resources such as minerals and timber became a matter of national policy, and many millions of acres of wildland were brought under public ownership.

The country's awakening appreciation of nature and wilderness was spurred on by a burgeoning system of national parks. The first of these, Yellowstone, was established in 1872, followed by Yosemite and Sequoia in 1890 and Mount Rainier in 1899. Following the turn of the century, the nation's mushrooming population and rapid industrialization gave

thanks largely to the industrial revolution. Prior to the turn of the century, agriculture remained the nation's primary occupation, but by 1920 less than half the national population remained on farms. Automobile ownership boomed during the same period: In 1900, there were eight thousand or so automobiles registered in the nation; by 1920, this number had soared to eight million, giving ordinary Americans mobility for the first time in history.

The time available to enjoy this new freedom was also increasing. Labor organizations

1. Hitting the Road

century life, and the Dadaists attacked conventional behavior and "spat in the eye of the world."

From 1901 through 1909, the nation was led by Theodore Roosevelt, former Rough Rider and Dakota Territory cattle rancher, whose penchant for the outdoors was legendary. Under Roosevelt's aegis, the conservation of natu-

even greater urgency to the preservation of America's natural treasures. By 1916, when they were placed under the administrative umbrella of the newly founded National Park Service, there were a total of twelve national parks encompassing well over six million acres.

The early twentieth century also saw a profound change in America's demographics,

had begun agitating for an eight-hour workday in the 1860s, but the pursuit was marked by strikes, violence, and heavy resistance, particularly in heavy industry. Only in 1916, when federal law decreed an eight-hour day for railroad workers, did resistance begin to crumble. The following year, the Supreme Court upheld the right of states to regulate working hours, which

OPPOSITE: **Movie actress Claire Trevor relaxes in front of a classic canned ham trailer in this photo dating from the 1940s. The canned ham's hallmark was an ovoid profile played against completely flat sides, a shape that had considerably more flair than the blocky "bread loaf" shape yet avoided the need for costly compound curves. However, the fore-to-aft curve of the roof made for costly and inefficient cabinetry and also complicated the installation of front and rear windows. Inevitably, the canned ham's profile moved steadily toward the seductive economics of the right angle. By the late 1950s, canned hams had become more oblong than egg shaped.** Courtesy Milton Newman Collection.

had previously been in dispute. By the time of Franklin Roosevelt's New Deal in the early 1930s, the eight-hour day had been firmly established.

Finally, a Way to Get There

At the center of the changes sweeping the nation in the new century stood the American automobile. The revolution began modestly enough: During the winter of 1892, a pair of Springfield, Massachusetts, bicycle manufacturers, Charles and Frank Duryea, cobbled together their first self-propelled vehicle, seven years after Karl Benz drove his pioneering *motorwagen* through the streets of Mannheim, Germany. In 1895, the Duryeas entered an improved model in America's first endurance race, a 54-mile course that skirted Lake Michigan between Chicago and Evanston, Illinois. They won, beating the only other car able to finish—a Benz, naturally.

By 1896, the Duryeas were building motorcars commercially; the first year's production totaled thirteen automobiles. That same year, a shrewd Detroit machinist named Henry Ford built his first car, the Quadricycle. In 1899, Ransom E. Olds began producing motorcars at a specially designed factory in Lansing, Michigan. Two years later, Olds began volume production of his Curved Dash Runabout, affordably priced at $650, and sold a record-shattering 425 cars.

Only one early automaker could boast of a heritage reaching back to the trailer's storied ancestors, however. The Studebaker Brothers Manufacturing Company was founded in 1852, when two of the five Studebaker brothers began manufacturing Conestoga wagons in South Bend, Indiana. Their product was soon part of one of the great migrations in the nation's history, as many a pioneer family crossed the Great Plains in a Studebaker-built Conestoga. By the late 1870s, the firm billed itself as "the Largest Vehicle Builders in the World—Facilities Sufficient to Make a Wagon Every Seven Minutes." Ironically, Studebaker's introduction of an electric runabout in 1902, followed by a gasoline model in 1904, soon overshadowed its long wagon-building history.

Mobility for the Masses

While early century runabouts of the sort built by Oldsmobile and Studebaker were increasingly affordable, their meager power, primitive drive trains, and scant weather protection made them unsuited to anything more than short runs about town. Long-distance touring demanded a more sophisticated automobile with shaft-driven rear wheels, a steering wheel rather than a tiller, doors, and a folding top that could provide at least minimal protection against foul weather. Vehicles so equipped were already designated "touring cars" by the early years of the century, bespeaking the public's almost immediate interest in comfortable, long-distance sightseeing via automobile.

Unfortunately, touring cars remained costly during the early years of the new century, a fact that helped limit recreational motoring to the wealthy. This situation changed abruptly in October 1908, when Henry Ford introduced his Model T, an automobile boasting all the essential features of a touring car, yet costing only $850. At a stroke, Ford had fulfilled his aim to transform the automobile from a rich man's toy into everyman's transportation.

The Model T's instant success obliged the Ford Motor Company to devise new manufacturing techniques at its Highland Park, Michigan, plant, culminating in the development of one of the earliest automobile assembly lines. Even these steps proved insufficient to meet the public's insatiable appetite for the "Tin Lizzie," however, and early in the 1920s Ford opened his gigantic River Rouge plant near Dearborn, Michigan. "The Rouge" was a nearly self-sufficient industrial colossus where, in addition to manufacturing and assembling Model Ts, the automaker produced his own steel, glass, and rubber from raw materials shipped in from Ford-owned mines and plantations around the world.

The production efficiencies instated at River Rouge allowed Ford to reduce prices even further, and by 1919, Model Ts accounted for 42 percent of all automobile sales in the

United States. When production finally ended in 1927, more than fifteen million Tin Lizzies had been built.

The changes wrought by the automobile, and especially by the Model T, would have a profound impact on the American psyche: For the first time, Americans of ordinary means could travel when and where they pleased, not just as local train schedules dictated. By the same token, the automobile gave the public access to the vast areas not served by rail, encouraging travel and exploration in the least-traveled corners of the nation.

Out of the Quagmire

There was a catch to this new promise of freedom, however. The automobile's potential was entirely dependent on the quality of the nation's roads, which remained execrable in the early years of the twentieth century. Many cities, not to mention rural areas, still had unpaved dirt roads that generated choking dust clouds in summertime and dissolved into rutted quagmires during the winter.

The issue of road improvement galvanized the motoring public. A Better Roads movement had already formed early in the century, indirectly spurring progress in other areas of recreational motoring as well. In 1902, when nationwide automobile ownership stood at about 23,000, nine regional automobile clubs in the Chicago area were consolidated into the fifteen-hundred-member American Automobile Association, with the agenda of championing road improvement on a national scale. The new group was instrumental in securing passage of the Good Roads Bill of 1903, which created the Bureau of Public Roads, the forerunner of today's Department of Transportation.

While the fight for better roads dragged on, the AAA had a more immediate effect on promoting tourism nationwide. In 1905, the organization issued its first road map, an ink-on-linen depiction of Staten Island, New York. Strip maps depicting routes between cities followed in 1911; the first of these extended from New York to Jacksonville, Florida, one of many popular southern wintering spots for wealthy East Coast vacationers.

In 1915, the AAA introduced emergency road service, whereby mechanics on motorcycles were dispatched to the aid of stranded motorists. Given the notorious unreliability of early automobiles, the program soon proved popular nationwide. A year later, the AAA published its first hotel directory, and its first camping book followed in 1920. By 1937, the organization had begun inspecting and rating restaurants and lodgings.

While the AAA did much to encourage recreational motoring, the larger struggle to improve the condition of the nation's roads continued to be fraught with political maneuvering, false starts, and uncertainty as to whether federal involvement was even constitutional. As Woodrow Wilson took office in 1913, debate on the roads issue dragged on. Finally, on July 11, 1916, after years of congressional wrangling, Wilson—himself an avid motorist—signed the Federal Roads Act, which allocated $75 million for the improvement of post roads to states that agreed to organize highway departments. At the time, the legislation's carefully invoked references to maintaining postal delivery routes were deemed necessary to justify the federal government's involvement in state road building.

Pressure for further road improvement followed apace with the automobile's soaring popularity. A second Federal Roads Act was passed in 1921, this one aiming to improve and connect some 200,000 miles of state highway into a national network. The resulting jumble of interstate road names was once again the subject of federal intervention in the mid-1920s, this time to institute a rational system of road numbering.

A Grassroots Revolution

Recreational vehicles designed to take advantage of the nation's improved roads were already available by the late teens, though their high cost meant that only the wealthy could afford them. They included house cars—self-propelled domiciles usually mounted on heavy truck chassis—as well as fully enclosed travel trailers. Among the most advanced was

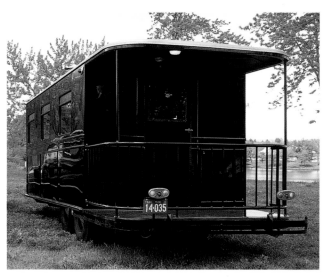

the Curtiss Motor Bungalow, a trailer introduced by aircraft pioneer Glenn Curtiss in 1919. Based on a prototype built two years earlier, the Motor Bungalow featured a lightweight, aircraft-inspired trusswork structure as well as a novel fifth-wheel towing arrangement patented by Curtiss. "Roughing it" in a Motor Bungalow was hardly an option: Each custom-built unit was laid out, trimmed, and upholstered much like a private railcar, and was priced accordingly. When sales proved disappointing, however, Curtiss turned his attention to more promising interests, and the Motor Bungalow disappeared from the market by 1922.

Meanwhile, the real motivation for the coming trailer revolution was quietly growing from America's grass roots. Better roads and cheaper automobiles were opening recreational travel to more and more people of ordinary means, while the widespread adoption of the forty-hour work week offered them the leisure time to indulge in it. By the late teens,

ABOVE: Prior to the arrival of affordable, mass-produced travel trailers such as the Covered Wagon, trailering remained largely a pastime for the wealthy. This unusually large trailer, first registered in 1932 but probably predating that time, was custom-built for the wealthy owners of the Martin Dairy Company of Welland, Ontario. It was used for recreation as well as for parades and special occasions; its unusual "back porch" was probably inspired by the open end platforms of private railcars, and no doubt provided an excellent venue for long-winded speeches.

RIGHT: Although it lacks cooking and lavatory facilities, the trailer's interior is finished much as a fine home of the twenties might have been, and includes features such as parquet flooring, mahogany and gumwood paneling, and recessed panel doors. The windows roll down using automotive-style crank handle regulators; above each is a stained-glass panel. Early trailer interiors were generally outfitted by cabinetmakers who, lacking any other aesthetic precedent, simply followed popular domestic styles. Only later did trailer interiors develop their own characteristic interior features, most of which grew out of the need to conserve space.

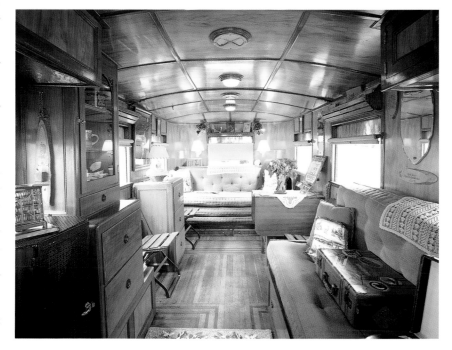

The middle class naturally made do with considerably fewer creature comforts than the wealthy in their custom-built trailers. In the early days of auto camping, most campers either stretched out on their car seats or carried along tents. In this advertisement dating from the late twenties, Outers Equipment Company of Chicago offered a compromise: a folding bed designed to fit inside most popular cars of the era, which collapsed to the size of a golf bag when not in use. Despite the ingenuity of such devices, auto campers soon came to prefer tent trailers, which provided generous accommodations for sleeping and storage, but did not take up space aboard the vehicle.

adventurous motorists were flocking onto the highways to see the sights their nation offered them.

The largest auto camping migrations occurred during winter, when Northerners abandoned their snowbound states for warmer southern climates and, above all, for the tropical beaches of Florida. It was there that the folksy and fraternal auto-camping craze began, quite apart from the excursions of the wealthy in their custom-built fifth-wheel trailers.

At first, overnight travelers simply slept in their cars, or set up a tent they carried in the trunk. Some ingenious souls attached homemade awnings directly to the vehicle to provide shelter. Auto accessory manufacturers quickly saw the potential in this market and began catering to campers with devices known as "auto tents" which could turn the family jalopy into a rudimentary camping shelter. Gadgets from collapsible tables to portable kitchenettes were also offered, although restricted trunk space meant that these items often had to be carried inside the vehicle.

Belying the posh implications of the term "touring car," however, few automobiles of the teens and early twenties were well suited to making long journeys, with inexpensive cars such as the Model T even less so. Hence, campers and long-distance travelers were wise to carry radiator water and several spare tires. Nor were the nation's businesses yet geared to highway travel: Roadside gasoline

stations, restaurants, and lodgings remained few and far between on all but the most developed routes, obliging motorists to carry canned food, blankets, and extra gasoline as well.

Despite such minor hardships, the popularity of auto camping continued to soar during the early twenties, fanned by well-publicized "camping trips" such as the one President Warren Harding hosted for Thomas Edison, Harvey Firestone, and Henry Ford in 1921.

The course of the auto-camping craze was soon changed by automotive evolution, however. In 1922, Hudson introduced the first affordable all-weather body on its midpriced Essex model, and within a few years, closed bodies were increasingly demanded by the public. The idea of loading dusty camping equipment into the more refined interiors of these cars began to lose its appeal. Moreover, by the early twenties, tent trailers with generous onboard storage were already being offered by manufacturers such as Warner, Chenango, and Auto-Kamp. By using a variety of ingenious fold-out extensions to increase interior space, these compact units also provided a more comfortable shelter than accessories appended directly to automobiles. By the end of the twenties, tent trailers were the new standard in overnight camping gear, while auto tents came to be seen as distinctly passé.

Around this time, Glenn Curtiss returned to

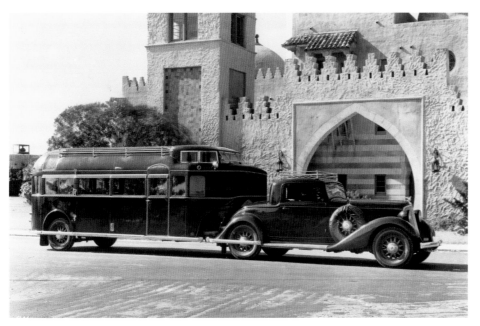

Glenn Curtiss's Aerocar Land Yacht fifth-wheel trailer was the ultimate plaything for the wealthy. Costing between $3,000 and $15,000 dollars—the lower figure being about five times the price of a standard Ford or Chevrolet of the era—it could naturally be customized to suit the buyer. The Aerocar was designed to be occupied while in motion; hence this example features a raised cockpit at the fore end, from which its captain could survey the road ahead and, if he wished, direct the chauffeur by telephone. Wooden artillery wheels identify this trailer as an early model; later units featured stamped-steel wheels. With characteristic business prowess, Curtiss staged this publicity shot in front of the fantastical North African structures of Opa-Locka, Florida, a town he helped develop during the 1920s. Courtesy Vince Martinico Collection.

the trailering scene with an even more luxurious trailer that he called, without apparent irony, the Aerocar Land Yacht. Like the Motor Bungalow, this huge, custom-built fifth-wheel trailer was essentially a Pullman car for the highway. The Land Yacht's master could issue instructions to the tow car via telephone; higher-priced models (they ranged from about $3,000 to $15,000) boasted a "flying bridge" with lounge chairs and panoramic windows that let occupants observe the passing scenery in utmost comfort. Meanwhile, chefs in the adjoining galley might prepare a gourmet meal to be taken en route, perhaps to a fashionable camping destination such as Ollie Trout's Florida trailer park.

Whence the Home on Wheels?

It seems natural enough that the Land Yacht's amenities would recall those of private railroad cars. Yet what inspired Curtiss and later builders to place these self-contained apartments on single-axle trailers? Such vehicles have, of course, existed for millennia: the ox-cart, the horse-drawn sulky, and even the human-powered *jinrikisha* are all single-axle trailers in the broadest sense, though none served as

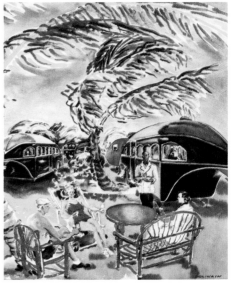

Curtiss Aerocars dominate this stylized depiction of Ollie Trout's Florida trailer park, which appeared in a 1937 issue of *Fortune* magazine. Located on Biscayne Boulevard in Miami, Ollie Trout's was long considered the premier destination for wealthy trailerites, and its top-dollar fees helped ensure a rarefied clientele. Courtesy Wayne Fergusson Collection.

domiciles. Rather, the earliest examples of trailers for domestic use had two axles placed at the extreme ends. The most familiar examples come down to us from the Gypsies, a nomadic people thought to have migrated to the West from northwestern India by way of Persia during the first millennium A.D. By the fifteenth century, the Gypsies and their colorful rolling abodes were found throughout Western Europe, where they were alternately mythologized and maligned.

For Americans, a more recent and more relevant icon was the Conestoga, a two-axle horse-drawn wagon with a canvas roof carried on hoops, which served as temporary housing for countless pioneers on their grueling migrations westward. For Victorian-era Americans, the Conestoga embodied many of the same ideals later reprised during the trailer boom: personal freedom, an intimacy with nature, and the uniquely American ability to reinvent oneself regardless of class or status.

At the same time, however, there were a slew of trailer dwellers who were rather less admired by the Victorians, including horse traders, carnival workers, patent-medicine peddlers, and other itinerants. Alas, it was the image of these unsavory characters, and not that of Great Plains adventurers, that would ultimately attach itself to trailerites in the new century.

The dawning twentieth century continued to see many uses for wagons and trailers. Among the most unusual was the sheepherder's ark, a horse-drawn wagon with a can-

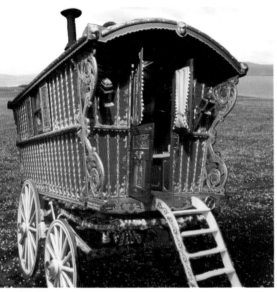

ABOVE: **Great Britain's Romany folk, better known as Gypsies, long subsisted on itinerant work such as pot mending, harness repairing, seasonal harvesting, and fortune-telling. Their wagons, ranking among the earliest travel trailers, were generally simple horse-drawn affairs with canvas bow tops. Wealthy Romany folk, however, commissioned elaborately decorated wagons such as this example built by Dunton and Sons of Reading, Berkshire, and hence known as a Reading. Dunton was among the premier builders of Gypsy wagons for Romany folk, as well as for the occasional non-Romany British eccentric. The Dunton firm operated from the 1870s until 1922; this restored example dates from 1918.** Gypsy wagon photographed at the Glasgow Museum of Transport with permission of Glasgow Museums, Glasgow, Scotland.

BELOW: **Few objects bespeak the pioneering spirit of the American West as vividly as the canvas-roofed Conestoga wagon, in which families migrating westward somehow managed to survive month upon month of bone-jarring travel. The ability to prevail over such incredibly harsh conditions has since become one of the defining traits of the American character.** Photograph © Jess Smith.

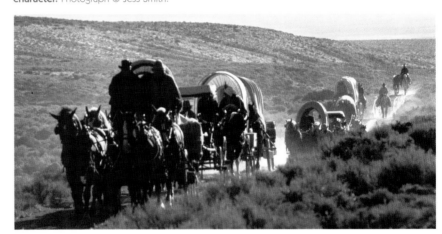

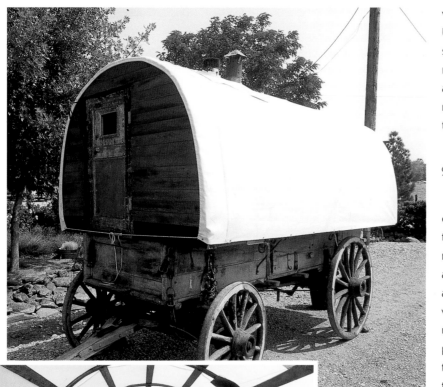

vas roof that was used in the United States by both Basque and Irish sheepherders. The sheepherder's ark eventually evolved into the modern sheep wagon, a two-axle trailer with automotive tires, a galvanized steel body, and a relatively short tongue that made it suitable for towing by motor vehicles rather than horses.

The Caravanners

While trailers have long been employed for domestic and commercial uses, the roots of the modern recreational trailer are much more recent. They can be traced back to England around 1880, when Dr. W. Gordon Stables, an author of boys' books, ordered an 18-foot wagon from the Bristol Carriage Company for use as a mobile study for writing. Lacking any precedent for this use, Bristol simply patterned the design of Stables's pioneering "caravan" on the firm's commercial Bible Wagons.

ABOVE: The sheepherder's ark, used in the United States by both Basque and Irish immigrants, bears a striking resemblance to the earlier Conestoga wagon. Its roof profile is simpler, however, replacing the Conestoga's swaybacked profile with vertical end walls and a uniform series of bows. A long tongue identifies this ark as a horse-drawn vehicle; shorter tongues were eventually used for wagons drawn by motor vehicles. This example, dating from the early years of the twentieth century, was photographed in Cedarville, California.

LEFT: The basic amenities found inside the sheepherder's ark include a comfortable bed, a cookstove, and a few storage lockers. While the translucent canvas roof carried on bows creates an unusually bright and inviting interior, its negligible insulating properties would make this a chilly spot on cold nights.

Others followed Stables's lead, and the popularity of caravanning grew steadily through the turn of the century; in 1907, the Caravan Club was formed, with Stables as president. At this time, caravans remained little more than crude, wagon-based camping shacks, with interiors containing a cookstove and perhaps a bunk or two. Moreover, they continued to be horse drawn well into the twentieth century: While a few auto-drawn examples existed as early as 1915, it was not until 1919 that motor vehicles had widely supplanted horsepower.

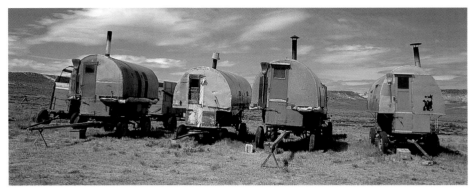

The sheep wagon, descendant of the sheepherder's ark, differs in having automotive-type wheels and a shorter tongue designed for towing by a motor vehicle rather than a horse. These wagons, dating from around 1910, but modified with tin roofs and automotive tires were photographed on the Magagna Brothers' sheep ranch north of Rock Springs, Wyoming. Photograph © C. J. Hadley.

The English caravanning craze began around 1880, when Dr. W. Gordon Stables, an author of books for boys, had a two-axle wagon custom built as a mobile writing study. Other wealthy adventurers took note, and the Caravan Club was formed in 1907. By 1919, automobiles had supplanted animal power; taking advantage of the stability of the automotive chassis, trailers in the now-familiar single-axle style replaced the earlier two-axle format. This late English example is a mid-1950s Thomson Almond photographed in Salen, Isle of Mull, Scotland.

Once automotive power was adopted, however, it induced a fundamental change in the caravan's design: Being hitched to a relatively stable automotive chassis rather than to a draft animal, it could now make do with a single axle set just behind its center of gravity, rather than an axle fore and aft. The single-axle arrangement proved simple, cheap, and space efficient, and also made backing easier for drivers with ordinary skills. In the United States, it was quickly adopted for tent trailers and later for travel trailers, although the latter occasion-ally employed tandem or even triple axles for greater capacity.

While the caravan inarguably contained the basic elements of the modern travel trailer, its potential on the famously gloomy British Isles was less than explosive. Hence, as trailering approached its first golden age in the United States, its popularity was already waning in Great Britain.

Tin Can Tourists

In the United States, auto camping had developed into a full-blown craze by the mid-twenties. An informal survey in the August 1924 issue of the *Christian Science Monitor* reported that one out of five vehicles passing through Laconia, New Hampshire, carried some form of camping gear. Campgrounds

catering to auto campers sprang up throughout the nation. Florida, a longtime winter destination that well knew the value of tourist dollars, led the way: As early as 1920, the city of Arcadia opened a trailer park on Highway 17 (still extant today), while an editorial in the *DeSoto County News* urged that a local tourist camp immediately be put in proper condition to better attract auto campers.

The first organized group of "snowbirds" was the Tin Can Tourists, a group of auto campers harking from the frigid Upper Midwest, who had informally begun wintering in various Florida cities as early as 1916. The group's genesis in Florida has been variously ascribed to Arcadia, Dade City, and Tampa, but it was in East Tampa's DeSoto Park that the Tin Can Tourists were officially organized in the winter of 1919. The idea for the club came from James M. Morrison, who proposed it to the twenty-two or so families camped there that season. The Golden Rule was declared to be the Tin Can Tourists' motto, while their charter, a veritable time capsule of the twenties zeitgeist, sought to "unite fraternally all auto campers . . . provide clean and wholesome entertainment in camps and at meetings . . . to spread the gospel of cleanliness in all camps . . . [and] to help a fellow member in distress on the road."

The group's name derived from the stockpile of canned foods they carried on their winter sojourns, and perhaps no less from the jury-rigged camping jalopies they drove. Nor did the Tin Canners take themselves too seriously: Their nominal leader held the title of "Royal Can Opener"; their secret password, "nit nac," requires no explanation; and for the first decade, the official membership badge consisted of an empty soup can affixed to the radiator cap.

By 1921, DeSoto Park was playing host to more than eighteen hundred Tin Canners lodged in 723 camps. Ironically, this success soon brought internal strife, and in 1924 a group defected to form the Camping Tourists of America. The CTA purchased 34 acres surrounding the ruins of the former Braden plantation in Manatee County to form Braden Castle Park, today one of the nation's oldest remaining trailer parks.

While the Tin Can Tourists generally confined their travels to states east of the Mississippi, the popularity of auto camping spanned the nation. It received a serendipitous boost in the Plains states, where towns had customarily set aside large plots of land called "wagon yards" in which visiting horse-and-wagon rigs could unhitch, feed, and water their teams.

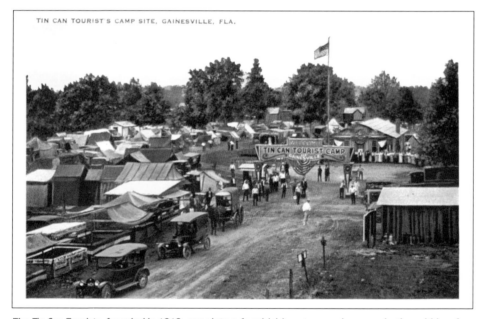

The Tin Can Tourists, founded in 1919, grew into a formidable auto-camping organization within a few short years. This postcard view dating from the late 1920s depicts the frenetic activity of a TCT camp in Gainesville, Florida. Courtesy Milton Newman Collection.

Just as motor vehicles were making wagon yards obsolete, the auto campers began arriving, and many such areas were revamped to accommodate them. Picnic tables, rest rooms, and even landscaping appeared, and by 1930 municipal auto camps had become familiar fixtures in towns throughout the West.

The Other Covered Wagon

Auto camping was now both popular and affordable, with numerous manufacturers offering ingenious folding tents that could be easily towed behind the family flivver. Traveling in an enclosed trailer such as the Curtiss Aerocar, on the other hand, remained a luxury reserved for the wealthy. It might well have remained so were it not for the amateur efforts of one Arthur Sherman, a bacteriologist who built himself a clumsy, boxlike camping trailer only to find that thousands of Americans wanted one just like it.

Among trailerites, the story has practically passed into myth: In July 1928, Sherman and his family set out for a fishing trip in northern Michigan with the era's most sophisticated piece of camping gear in tow—a compact tent trailer whose various sections folded out to form, it was claimed, a roomy, comfortable, and waterproof canvas cabin.

Sherman arrived at the campground in the midst of a downpour, and to his dismay the simple, ten-minute assembly procedure described in the trailer brochure quickly ballooned into a one-hour-plus exercise in frustration, during which he, his family, and the trailer's contents received a thorough drenching. In classic American fashion, however, Sherman didn't just get mad—he also got even. On returning from this backwoods debacle, he sketched a plan for a solid-walled trailer with no canvas, no folding panels, and no need for setting up, and hired a carpenter to build it during the winter of 1928.

When Sherman went camping with his crude box-on-wheels, jokingly christened the "Covered Wagon" by his children, he found himself besieged by admiring campers who

FOR THAT SOUTHERN TRIP

An "Auto-Kamp" Trailer is the ideal way to motor south for the winter, because it offers comforts, conveniences and safety long wanted but not usually obtained by motor tourists who love the open.

The Auto-Kamp Trailer

Will trail any car. Easy for any car to pull. Camp up or down in a few minutes. Insect-proof and rain-proof. Double spring beds, ice box, provision container, electric lights, folding table and handy shelves are all "Auto-Kamp" equipment. Send for details of various models, prices, etc.

ACTUAL USERS SAY: "Have driven it over 12,000 miles." "Surely have enjoyed the comforts." "Completed trip across the continent." "700 miles through mountains nine passengers." "The ideal way to travel." Hundreds of others testify to "Auto-Kamp" joys.

AUTO - CAMP TRAILER CO.
3620 Sheridan Ave.
Saginaw, Mich.

LEFT: During the 1920s, folding tent trailers steadily gained popularity over awnings and other camping accessories that attached directly to parked automobiles. By removing camping gear to a separate trailer, the vehicle was once again freed up for passengers, and could also be moved while camp was set up. This advertisement for the popular Auto-Kamp trailer dates from 1924; it was directed at snowbirds such as the Tin Can Tourists, hence the reference to "that Southern trip." The Saginaw, Michigan-based Auto-Kamp Trailer Co. produced units essentially similar to this one from the midteens through 1930, when the Depression forced its closure.

NOW YOU CAN TRAVEL IN SOLID COMFORT!

More Fun than Camping

The Covered Wagon is ready in 10 seconds! Good beds with spring mattresses, for 4 adults; electric lights; stove with hood; ice box. No tent or canvas extensions. Good ventilation—4 large windows and door, with screens, roll shades and weather strip. Well built of Prestwood insulating board. Cool in summer, warm in winter. *New,* exclusive, patented features. Visit the places you've read about. Ideal for long tours, hunting or fishing trips or for use as summer cottage. New folder mailed FREE. Write today.

The Covered Wagon Co.
14624 E. Jefferson Ave.
Detroit, Mich.

FREE FOLDER!

ABOVE: In January 1930, Arthur Sherman first exhibited his Covered Wagon at the Detroit Auto Show in the hope of selling a few units; he returned with orders for 118. Just a year later, Sherman's Covered Wagon Company was marketing the trailer nationally. This ad appeared in the January 1931 issue of *National Geographic.*

seemed to share his aversion for fumbling with canvas. Inevitably, Sherman began selling his Covered Wagon trailers, first in ones and twos, and eventually by the hundreds. By 1935, the erstwhile pharmacist had become the nation's largest trailer manufacturer.

Sherman's Covered Wagon Company was a rare success story in the bleakest years of the Depression, and naturally, it attracted notice—both from competitors and from the American press, who were desperate for stories containing some glimmer of economic hope. For their part, Sherman's competitors—including those who had specialized in all manner of sophisticated, fold-out gadgetry—were eventually obliged to adopt the Covered Wagon's hard-walled construction.

The Backyarders

Naturally, not everyone could afford a factory-built trailer such as Sherman's. "Backyarders" had begun the trailering phenomenon, and homemade units continued to account for a large percentage of trailers on the road. Since the late 1920s, this trend had been aided by a variety of firms advertising trailer components, plans, and accessories in the back pages of hobbyist magazines such as *Popular Mechanics*. Among these was

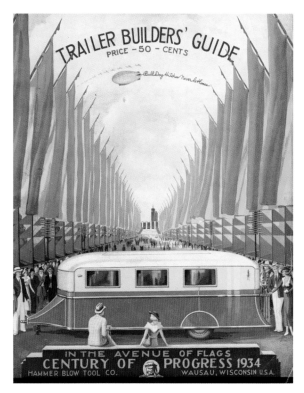

In 1934, the Hammer Blow Tool Company made capital use of its display on the Avenue of Flags at Chicago's Century of Progress Exposition. By offering this Trailer Builders' Guide for fifty cents, the Wausau, Wisconsin, manufacturer of hitches and other trailer gear encouraged numerous would-be trailerites to buy its products. The script issuing from the dirigible reads "Bulldog Hitches Never Let Loose." Courtesy Vince Martinico Collection.

the Hammer Blow Tool Company, a supplier of axles, hitches, and other trailer hardware, which stimulated the sale of its products by offering complete trailer plans by mail order. With their well-tested design and detailed instructions, "Hammer Blows" were a popular

and relatively inexpensive alternative to manufactured trailers.

Other trailer enthusiasts simply concocted their own designs from scratch, or copied others they admired. Occasionally, these homemade trailers were elegantly crafted affairs; more often, though, they were overweight, unsanitary, and barely roadworthy, as there were no trailer safety regulations in place until the mid-1930s. Nevertheless, as the Depression wore on and struggling Americans found they could no longer afford a conventional home, more and more homemade trailers appeared on the nation's roadsides. Even after 1930, when commercial manufacturers began to proliferate, a good portion of the trailer revolution remained in the hands of do-it-yourselfers. Toward the close of 1930, *Automotive Daily News* reported that, of the estimated 160,000 trailers on the road, more than three-quarters were homebuilt.

An Economic Lifeboat

The Depression-era trailer boom begun by Sherman's Covered Wagon also lured a number of stalwart American firms into the trailer business in hopes of shoring up their plunging profits. Most notable was the prestigious automaker Pierce-Arrow, which was in dire straits

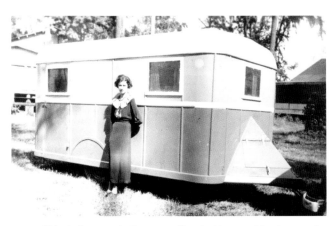

ABOVE: This trailer was built—according to Hammer Blow's popular plans—for the honeymoon of the young lady posed here, circa 1936. Remarkably, it has survived intact with all its honeymoon memorabilia, and is now among the prized possessions of trailer collector extraordinaire, Vince Martinico.

RIGHT: Pierce-Arrow, once ranked among America's most respected luxury car builders, was in dire straits by the mid-1930s. In an effort to occupy its languishing plant facilities, the company designed and built a superb trailer called the Travelodge, which measured up to Pierce-Arrow standards in every respect. The trailer was introduced in late 1936, but alas, a market for such vehicles no longer existed in Depression-racked America. Only about 450 units were sold, and having failed at this final gambit, Pierce-Arrow was liquidated in 1938. Proudly posed here are a 1936 Model A Travelodge hitched to a 1937 Pierce-Arrow Model 1702 limousine. In the background is one of the milder examples of streamlining found on passenger locomotives of the era—a 1937 Royal Hudson class 4-6-4 built for the Canadian Pacific Railway by the Montreal Locomotive Works.

by 1934. Founded as a maker of household goods in 1878, the Buffalo, New York, firm cannily entered the bicycle business during the late-century bicycle craze and then expanded into automobiles after the turn of the century. In 1904, Pierce introduced the Great Arrow, a large four-passenger touring car that established the firm's reputation for quality and

Throughout the 1930s, Hammer Blow and other accessory manufacturers also advertised a vast range of components for home-built trailers, usually in the back pages of magazines such as *Popular Mechanics* and *Popular Science*. In an era when runaway trailers still remained a problem, this ad for Hammer Blow's Bulldog brand hitches kept the message brief and to the point. Courtesy Vince Martinico Collection.

placed it among the early lights of American luxury cars, including Cadillac, Packard, and later Lincoln and Duesenberg.

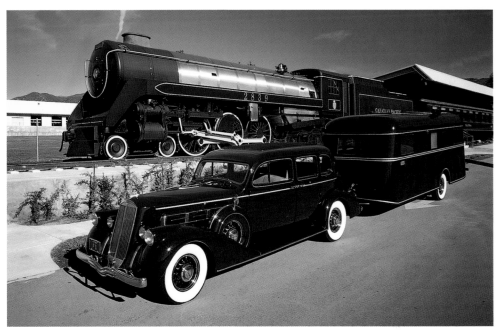

In 1928, the Studebaker Corporation assumed control of Pierce-Arrow, instantly elevating the former builder of Conestoga wagons into America's fourth largest automaker. Yet by 1933 Studebaker itself was in bankruptcy, and sold Pierce-Arrow to a group of Buffalo investors for $1 million. Despite another reorganization in 1934, Pierce-Arrow sold just 1,740 cars that year, and continued to lose money as the Depression wore on.

In 1936, the firm made a last-ditch effort to occupy its languishing plant facilities by introducing a high-end travel trailer called the Travelodge. It was a Pierce-Arrow in every respect: Three models were offered, all featuring a steel frame sheathed in aluminum skin, as well a specially developed independent suspension. Interiors were finished in birch and gumwood, and held an array of deluxe appointments, including an icebox, gas stove, wood-fired heater, onboard water tank, and sleeping berths. Despite its debut at the very height of the trailer boom, however, the luxurious Travelodge sold a mere 450 or so units—hardly enough to save the firm. Pierce-Arrow was accordingly liquidated in 1938; the surplus parts and tooling that remained in its Buffalo factory were later scrapped for the war effort.

Bread Loaves, Canned Hams, and Teardrops

Meanwhile, the design of manufactured trailers had settled into two basic groups. The first, including the Covered Wagon and its imitators, were slab-sided blocks whose main visual distinction came from their softly rounded corners and roof edges. The resulting fresh-from-the-breadpan shape soon earned these

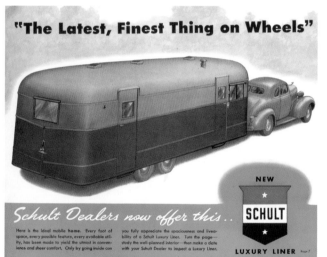

"The Latest, Finest Thing on Wheels"

Schult Dealers now offer this...

NEW
SCHULT
LUXURY LINER Page 7

Here is the ideal mobile home. Every foot of space, every possible feature, every available utility, has been made to yield the utmost in convenience and sheer comfort. Only by going inside can you fully appreciate the spaciousness and liveability of a Schult Luxury Liner. Turn the page—study the well-planned interior—then make a date with your Schult Dealer to inspect a Luxury Liner.

This ad for Schult Luxury Liner trailers, dating from the late 1930s, makes the origins of the term "bread loaf" quite clear. The rounded corners and slanting aft end were merely small concessions to the public's prewar appetite for streamlined forms. A rectangle was of course the least costly and most space-efficient form for a trailer, one reason a very similar shape was eventually chosen for the parsimonious "committee trailer" design of the war years. By the late 1950s, the bread loaf had lost the last of its rounded edges and, in the guise of the mobile home, settled into today's familiar hard-edged, boxy shape. Courtesy Milton Newman Collection.

trailers the nickname "bread loaves." Space efficient and simple to construct, bread loaf designs were popular with established trailer builders, backstreet shops, and do-it-yourselfers alike.

The other trailer form hewed closer to the English-caravan prototype, which had grown more curvaceous by the early 1930s. Roughly egg-shaped in silhouette, with flat panels on the sides and a roof arching from front to rear, the caravan's curious design invited another food analogy: that of a canned ham turned on its edge. While the ham can shape yielded a less space-efficient interior than did the bread loaf's simple rectangular volume, its style was a more pleasing match for contemporary automobiles, which had begun to lose their blocky shape by the early thirties.

The canned ham also developed a miniature cousin, the teardrop trailer, whose low-roofed interior was just large enough to sleep two persons. In a teardrop, the kitchen was ingeniously removed to the outside of the trailer: A broad hatch at the rear could be raised to reveal cooking and storage areas. Teardrops were, in a sense, the spiritual successors to the tent trailer, providing basic accommodations in the least possible space.

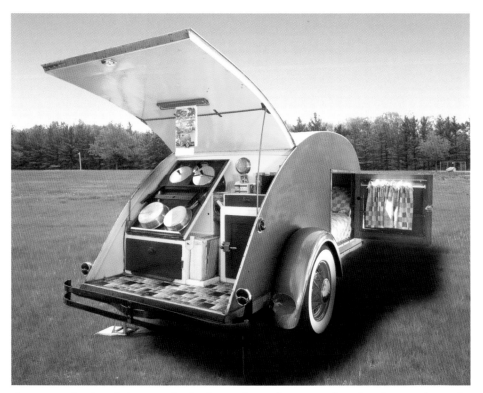

Compact and stripped down to the fundamentals—a place to cook and a place to sleep—the teardrop filled the vacuum left by the demise of tent trailers. At the same time, its streamlined shape made it far more exciting to behold than the dowdy tent trailer with its buckboardlike bed and artillery wheels. From the midthirties on, teardrops would remain a diminutive but durable trailer type, especially among do-it-yourselfers building from kits or magazine plans.

Whether bread loaves, canned hams, or teardrops, trailers had already begun to emulate the softer forms of automotive styling by the mid-1930s. Soon, the curve would assert itself even more forcefully, yielding some of the most memorable designs of the prewar era.

Streamlining Sweeps the Industry

While early American trailer designs were based on the rather pokey and rectangular English caravans of the 1920s, by the early thirties inspiration in both nations was arriving, not on wheels, but on wings. Aircraft design had been moving toward more slippery aerodynamic shapes since the late twenties; in 1933, the Italian Macchi-72 seaplane broke the aircraft speed record with a run over Lake Garda at 423 miles per hour, aided by its astonishingly sleek fuselage. In the United States, the government built a massive wind tunnel at its airfield in Langley, Virginia, in order to study aircraft streamlining scientifically. The adoption of all-metal fuselages, made possible by lighter and stronger alloys such as duralumin, resulted in breathtakingly streamlined aircraft forms such as the twin-engined Lockheed Electra. The fact that such designs were generated by technical efficiency rather than by some arbitrary aesthetic convinced many industrial designers that streamlining held the key to truly modern forms.

By the early thirties, aircraft design was already influencing the auto industry. Among the earliest examples was the 1934 Chrysler Airflow, whose unconventional profile stemmed partly from the discovery that most cars offered less wind resistance when moving backward. The Airflow's design eschewed the bolt-upright radiator and timidly raked windshield typical of the period, instead emulating the sloping trunk lid and softly rounded contours found at the rear of most cars. To fan publicity for the Airflow's debut, Chrysler engineers reversed the body on a standard sedan of the period and drove it around Detroit rear-end first. Although the Airflow was probably

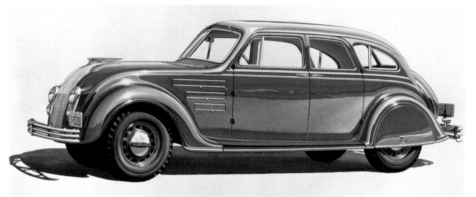

ABOVE: In 1934, the Chrysler Corporation threw itself headlong into the streamlining craze with the introduction of its Chrysler and DeSoto Airflow models, virtual twins whose unusual profiles were dictated by aerodynamic efficiency rather than styling whims. Alas, the public appeared to prefer the latter. Although the new models did not sell especially well, they nevertheless foretold the course of prewar automotive styling. Courtesy DaimlerChrysler Corporate Historical Collection.

RIGHT: Seemingly more airplane than trailer, Bowlus-Teller's Road Chief set a new standard in trailer technology. William Hawley Bowlus, a brilliant sailplane designer whose Albatross glider set numerous records for nonpowered flight, put his experience to good use in the Road Chief's design. The trailer's duralumin skin was applied over a lightweight, aircraft-style skeleton, yielding a total weight of a mere 1,100 pounds. As has often been the case with pioneering products, however, the Road Chief's advanced design did not translate into strong sales. Bowlus-Teller was out of business by 1936, though its trailer was soon reborn under new auspices.

too radical for the mainstream market—its sales were disappointing—there was no turning back. Within a few years, all American automakers had adopted some form of streamlined styling.

Meanwhile, American railroads strove to outdo one another with streamlined locomotives styled by high-profile industrial designers. Among these were Raymond Loewy's "cat-whiskered" GG-1 electric locomotives for the Pennsylvania Railroad, introduced in 1934, and Henry Dreyfus's bullet-nosed J-3 steam locomotives for the New York Central Railroad, circa 1937. Inasmuch as there was little technical gain in locomotive streamlining, such designs proved more beneficial to public relations than to efficiency. Nevertheless, by the late 1930s, streamlining was being applied to even less likely candidates such as typewriters, toasters, and mimeograph machines.

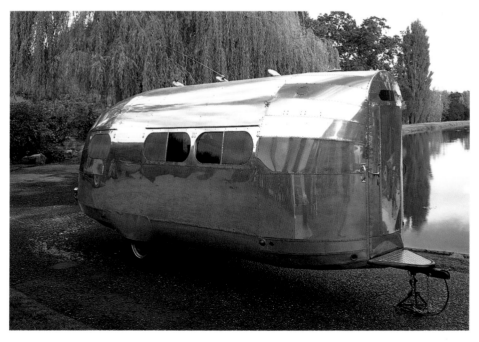

The Silver Palaces

Glenn Curtiss's Aerocar fifth-wheels of 1928 had already boasted a modest form of streamlining, and perhaps unsurprisingly, the era's sleekest trailer design would come from an aircraft engineer as well. William Hawley Bowlus was already renowned for his record-setting sailplanes when he designed a prototype trailer to serve as a portable shelter during his test flights in the southern California desert. Designed essentially like an aircraft fuselage, the trailer's structure consisted of a series of wooden ribs affixed to a longitudinal spar; this skeletal structure was in turn sheathed in a tight-fitting canvas skin.

When Bowlus and his partner Jacob Teller began producing the trailer commercially in the midthirties, its design was revised to use a skin and ribs of duralumin, an aircraft alloy one-third the weight of steel. Weighing in at about 1,100 pounds, the Bowlus-Teller was far lighter than its contemporaries—an attribute even more valuable than its aerodynamic shape.

The high cost of Bowlus's trailer hindered sales, however, and the venture soon went bankrupt. In late 1936, the basic Bowlus-Teller design was adapted and marketed by Wally Byam as the Airstream and remains in production today—vastly refined, but philosophically unchanged from its beginnings in the streamline era.

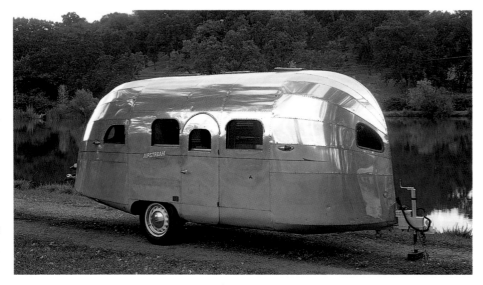

Following Bowlus-Teller's closing, trailer maven and erstwhile Bowlus dealer Wally Byam purchased some of the bankrupt firm's machinery, rehired ex-Bowlus employees, and began manufacturing a nearly identical trailer under his own newly invented moniker, "Airstream." Byam soon initiated Airstream's longstanding policy of evolutionary refinement: He relocated the door, which in Bowlus's design had been awkwardly placed over the hitch, to the right side of the trailer. It has remained there ever since.

The Red Hot Trailer

By mid-1935, the media had latched on to the trailering phenomenon with a vengeance. Publications ranging from the *New York Times* to *Fortune* to *Popular Science* all rhapsodized the travel trailer. Americans, who had always fancied themselves rough-and-ready outdoor types, were carried away by this blizzard of articles on trailering. In a 1936 survey conducted by *Fortune* magazine that asked, "Would you like to own a trailer and spend part of the year traveling in it?," 49.3 percent of Americans answered yes.

Stoked by such glowing reports, demand for trailers continued to skyrocket. Although records are sketchy, as many as two thousand trailer manufacturers were operating between 1930 and 1940, with perhaps fifty or sixty accounting for the lion's share of sales. The balance of sales came from hobbyists, backstreet mechanics, or moonlighting cabinetmakers who dreamed of becoming the next Arthur Sherman—a notion that was not terribly far-

fetched, considering that some trailer manufacturers carried order backlogs of up to six months.

Trailer mania hit a feverish peak during the summer and fall of 1936, with media reports pushing the phenomenon to the very limits of credulity. Even the normally moderate American Automobile Association boldly predicted that there would be one million trailerites by the end of 1936, and five million by 1940. In 1935, Wall Street pundit Roger Babson, who had made his reputation by forecasting the stock market crash of 1929, declared: "Within two decades, one out of every two Americans will be living in a trailer." In the spring of 1936, Babson's prediction was loudly repeated in the premier issue of *Trailer Travel* magazine. In December 1936, *Architectural Record* announced that by New Year's Eve, no fewer than one million people would be living in trailers. Meanwhile, trailering images began to seep into popular culture in a variety of forms, from cartoons to board games to puzzles. In a high-water mark for the sort of superheated trailer boom rhetoric then rampant in the media, the May 1937 issue of *Literary Digest*, ventured a possible trailer production of four hundred thousand units for the year.

From Boom to Blowout

Ultimately, only around ninety thousand units were produced in 1937—less than a quarter of what was predicted. Moreover, by the autumn of that year, in a kind of miniature replay of the Crash of 1929, the trailer bubble burst. The reasons were manifold, but trailer manufacturers were partly to blame for their own woes: By encouraging, and even amplifying, the overblown growth predictions circulated by the media, they initiated a spiraling trend of overcapacity and overproduction. In reality, the market for trailers had already been largely saturated by 1937, with sales slumping rapidly thereafter.

Arthur Sherman's Covered Wagon Company, then the leading manufacturer, had stockpiled a huge inventory of components to meet

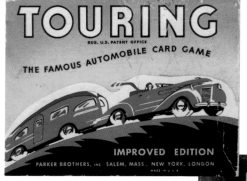

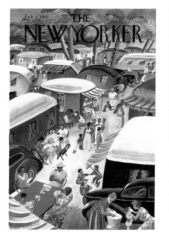

LEFT: By the late 1930s, trailering had become a national fascination, and trailer imagery permeated every aspect of popular culture. In 1937, Parker Brothers introduced "Touring," a trailer-themed board game. Touring game courtesy Wayne Fergusson Collection.

BELOW: A licensed Mickey Mouse puzzle adapted from the 1938 cartoon "Mickey's Trailer," in which Mickey Mouse, Donald Duck, and Goofy go trailering cross-country with predictably disastrous results. Disney characters© Disney Enterprises Inc. Used by permission from Disney Enterprises Inc.

FAR LEFT: With its gentle parody of trailering, the February 8, 1941, cover of *The New Yorker* remained blissfully distant from the conflict that would soon embroil the nation. America's entry into World War II also permanently altered the course of the trailer industry, as trailers began to be perceived as mundane temporary housing rather than as a means of recreation. ©2002 The New Yorker Collection from www.cartoonbank.com. All rights reserved.

skyrocketing demand, only to find actual orders running at perhaps 10 percent of these forecasts. While Covered Wagon struggled with this financial albatross, its smaller and more agile competitors nibbled away at its market share, a loss from which the company never fully recovered.

Yet there was another reason for the abrupt collapse of the trailer market: The public was simply beginning to tire of the relentless hyperbole surrounding the so-called trailer revolution, and a backlash inevitably set in. The media's giddy, rose-colored accounts were gradually supplanted by more hostile examinations of the trailering phenomenon. Trailer parks were pilloried as a new kind of American slum-on-wheels and were even accused of being a breeding ground for epidemics, while trailerites were increasingly portrayed as freeloaders helping themselves to public roads and facilities without paying taxes for their support.

The lingering effects of the Depression had also stained trailering's wholesome image, as the middle-class recreational trailerites who had filled municipal camps were slowly replaced by the indigent and unemployed. In the final years of the 1930s, city governments, fearing the formation of trailerite slums on their outskirts, enacted sweeping restrictions on municipal camp facilities, or simply closed them altogether. Recalling old associations with horse traders, traveling peddlers, and other disreputable types, trailer dwellers once again began to be seen as shiftless and untrustworthy—a misjudgment that dogs them even today.

Bad News and Good

In a final bit of bad news for trailering, a series of strikes in the auto industry sent the battered American economy into another downturn. For a year and a half, trailer builders limped along in the face of declining demand for their products. Then came the Emergency, the period bracketed by Hitler's invasion of Poland in 1939 and Japan's attack on Pearl Harbor in December 1941. The War Production Board, which controlled the allocation of resources and industrial production for the war effort, initially declared travel trailers a nonessential product, effectively sidelining their manufacture. Wisely, and no doubt somewhat desperately, the trailer industry appealed this ruling, arguing the trailer's usefulness for temporary housing. The government ultimately relented, and in fact began ordering large numbers of units through the National Housing Agency to provide shelter for military families and defense workers alike.

Some five thousand of these trailers were

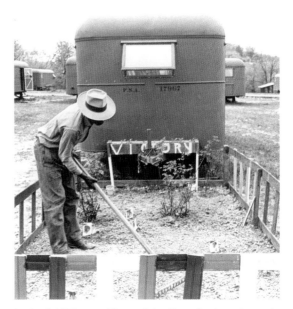

In April 1942, a resident of the Farm Services Agency's camp project for Negroes tends his victory garden in Arlington, Virginia; government-requisitioned "war trailers" populate the background. The FSA oversaw a number of sizable government trailer camps during the war years. By the time this photograph was taken, however, President Franklin D. Roosevelt had already authorized the creation of the National Housing Authority to consolidate the civilian agencies previously involved in supplying government housing. By war's end, some 35,000 trailers had been purchased by the U.S. government and administered by the NHA for wartime use. Photograph by Marjory Collins. Courtesy Milton Newman Collection.

unique 18- and 22-foot units conceived by industrial designer William Stout, and featured walls that folded out to increase the interior area about two and a half times. A more conventional standard design was developed early in 1942 by three members of a committee

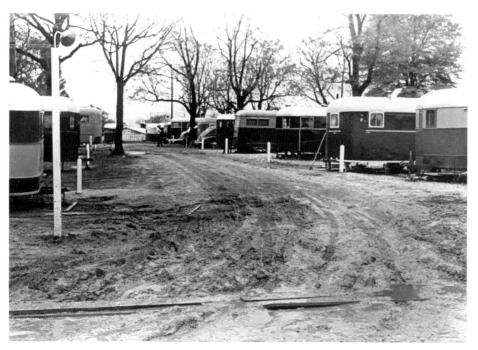

A dismal winter scene at Camp Livingstone, a trailer camp for enlisted men and construction workers near Alexandria, Louisiana. Occupants of such camps typically paid from two to two and a half dollars per week for trailer space, but amenities such as communal baths and laundries were rudimentary, and the unpaved roads and walkways generally turned to quagmires in winter. America's wartime preparations had quietly begun during the Emergency, the period following Hitler's march into Poland in 1939, and camps such as this one were already established when the Japanese attacked Pearl Harbor in December 1941. This photo by frequent FSA photographer Marion Post Wolcott was taken in December 1940. Courtesy Milton Newman Collection.

The Fork in the Road

While the travel trailer began its life as a vehicle meant for short-term recreational use, by the late 1930s it was already apparent that many trailers were instead serving as permanent, year-round residences. Their widespread use as temporary housing during World War II, and the attendant relaxation of antitrailer zoning restrictions, helped further legitimize trailers as a form of domicile. Inevitably, the opposing demands of recreational versus permanent use soon led to a profound divergence in the trailer's intended usage.

After World War II, a variety of modestly sized trailer designs returned to serve the recreational market in both the bread loaf and canned-ham formats, and sales once again boomed. Sixty thousand units were produced in 1947, and the following year's output topped one hundred thousand. Meanwhile, the industry began to tacitly acknowledge the widespread use of trailers as permanent residences by offering ever larger and roomier designs.

While still officially marketed for recreation, more and more such trailers could be found permanently moored in trailer parks. The divergent trailer designs of the late 1940s and early 1950s mark an important turning point in the industry. At first, the larger units retained the 8-foot-wide chassis of their predecessors, and were simply lengthened to capture additional

appointed by the Trailer Coach Manufacturers Association at the government's behest. These so-called committee trailers were a far cry from their glamorous civilian predecessors: Due to the government's allocation of a scant 275 pounds of steel and 3 pounds of copper to each unit, they were framed of low-grade pine lumber, with Homasote exterior sheathing,

flimsy Upson board interior paneling, and a painted canvas roof. During the years 1942–43, about thirty-five thousand such trailers were built for various departments of the federal government, giving the trailer industry a much-needed infusion of capital. Despite these huge numbers, their ethereal construction has ensured that few survive today.

interior space; by the early fifties, some of these behemoths exceeded 25 feet in length. The problems of maneuvering such cumbersome rigs were obvious enough to be spoofed in director Vincente Minnelli's *The Long, Long Trailer*, a 1954 film featuring Lucille Ball and Desi Arnaz and costarring a huge, two-toned New Moon trailer that provided the comedians with a rich supply of hijinks.

In 1953, the industry group known as the Trailer Coach Manufacturers Association changed its name to the Mobile Home Manufacturers Association, presaging the eventual metamorphosis of the larger recreational trailers into mobile homes meant to be towed under special permit and seldom if ever moved again. Still, the familiar 8-foot-wide bread loaf and canned-ham formats of the postwar years remained largely unchanged until 1954, when Elmer Frey, president of Wisconsin's Marshfield Homes, introduced the Tenwide, a new trailer whose chassis was a whopping 2 feet wider than standard units.

The Tenwide's debut drew a storm of protest from Marshfield's competitors, who were not anxious to be saddled with scores of obsolete 8-foot-wide units, and who correctly foresaw being dragged into a regulatory minefield should they follow Marshfield's lead. Indeed, Frey and others in the industry were eventually obliged to lobby individual states to allow the transportation of 10-foot-wide trailers. Neverthe-

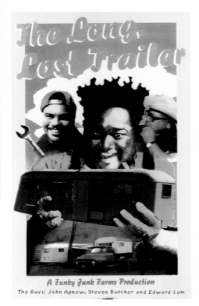

A Funky Junk Farms Production
The Guys: John Agnew, Steven Butcher and Edward Lum

ABOVE: Trailers were once again a hot topic in the 1950s. In 1954, director Vincente Minnelli released the comedy feature film *The Long, Long Trailer*, starring Lucille Ball, Desi Arnaz, and a recalcitrant New Moon travel trailer. This Spanish-language version of the movie poster, *Después de la Boda* (*After the Wedding*), was probably directed at the appreciable Cuban film audience of the pre-Castro era. Courtesy Funky Junk Farms.

ABOVE RIGHT: Trailer enthusiasts John Agnew, Edward Lum, and Steven Butcher produced a spoof of Minnelli's film entitled *The Long, Lost Trailer* to advertise their business of renting vintage trailers and other unusual vehicles.

LEFT: The "Tenwide" was big news in 1955, when a host of manufacturers saw no alternative but to join the upstart Marshfield Homes in offering 10-foot-wide trailers. Following a vigorous lobbying campaign by the trailer industry, all fifty states eventually relaxed transportation restrictions on oversized trailers. Within a decade, 12-foot-wide, 14-foot-wide, and double-12-foot-wide trailers followed, though they were now pointedly rechristened mobile homes. Courtesy Grant Dixon Collection.

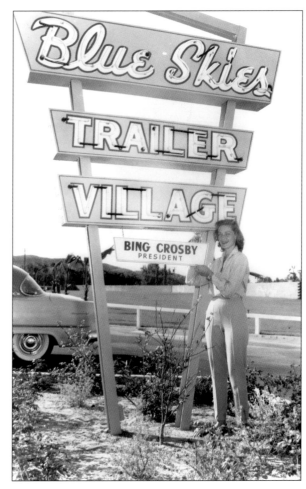

Film actress Lauren Bacall poses at the entrance of Blue Skies Trailer Village, a trailer park conceived by Bing Crosby in 1953, and today one of the most exclusive in America. Crosby and his cofounders recruited forty-eight members of the entertainment industry as investors, including comedian Jack Benny and film stars Danny Kaye and Claudette Colbert. Architect William Cody laid out the original portion of the park, whose eighty-six lots were arranged to ensure unobstructed views of the surrounding mountains. Courtesy Grant Dixon Collection.

less, Frey's audacious introduction of the Tenwide irreversibly upped the ante for his competitors. Within a year, four other manufacturers introduced their own 10-foot-wide models, and within three years, another eight joined the group. The better part of the trailer industry was now focused on the needs of year-round trailer dwellers, and not on those of recreational travelers.

Meanwhile, trailer parks had also become larger and better planned. Syd Adler and Franklyn McDonald's 160-acre Trailer Estates, which opened in Bradenton, Florida, in 1955, featured recreation facilities aimed at retirees, and even provided a full schedule of social activities such as potlucks, dancing, and shuffleboard. A few parks even retained an air of exclusivity rare in connection with trailering; Blue Skies Trailer Village in Palm Springs, cofounded by Bing Crosby in 1953, boasted forty-eight stockholders from the entertainment industry, including Danny Kaye, Claudette Colbert, and Jack Benny.

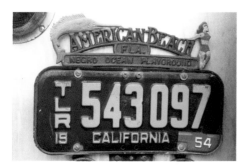

Segregation remained a de facto policy in many recreation areas of the South, as this souvenir license plate frame will attest. A number of academic studies have since observed that trailer parks remain largely the domain of retired white working-class residents—a perception that still hinders the acceptance of manufactured homes as an affordable housing solution for every demographic group.

In the main, however, trailer parks developed into havens for largely white, working-class Americans, many of them retired and elderly. Segregation remained a de facto policy in many Southern recreation areas, as evidenced by "Negro" resorts such as American Beach, Florida. At the same time, numerous sociological studies found that trailer parks, contrary to their often negative portrayal, possessed a greater sense of stability and community than either apartments or subdivisions.

Trailer Redux

Despite the eventual diffusion of much of the industry's efforts into mobile home manufacturing, the postwar era represented a rebirth

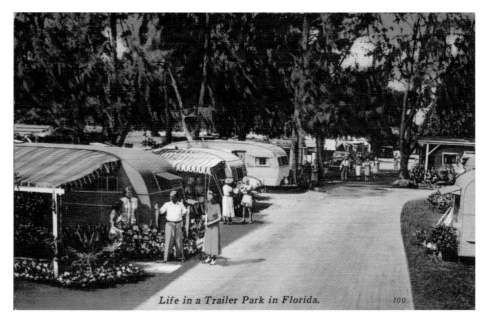

Life in a Trailer Park in Florida. 100

Awnings abound in this tinted postcard depiction of "Life in a Trailer Park in Florida." While the oft-quoted statistic that claims one in three Floridians lives in a trailer may be apocryphal, the state nevertheless remains the undisputed trailer capital of the United States.

Federal Aid Highway Act of 1952. Another expansion of the act in 1956 created the official designation of "National System of Interstate and Defense Highways," and established design standards that included 12-foot lane widths, a minimum of two lanes in each direction, and a designated speed of 50 to 70 miles per hour. These specifications—devised largely in the interests of national defense—also happened to make recreational traveling faster and smoother than ever before.

Nor were automobiles or motoring ever as celebrated as during the postwar era. Detroit's cars boasted formidable new V8 engines that could drag an 18-foot trailer uphill like a sack of feathers, while their front ends developed the

of sorts for the travel trailer. Military spending had helped rocket the economy out of its Depression-era doldrums, leaving Americans with disposable income for the first time in two decades, and reinvigorating recreation- and tourism-related industries.

The war's aftermath also gave new impetus to the establishment of a national system of interstate highways to facilitate both commerce and defense—an idea Congress had examined as early as 1938, but which had been bogged down in financing issues. In 1944, however, in light of wartime concerns, Congress passed the Federal Aid Highway Act, which chartered a national system of interstate highways extending some 40,000 miles. National routes were planned by both state highway agencies and by the Department of Defense, yet the huge undertaking remained stalled until President Dwight Eisenhower, an early proponent of a national interstate defense system, authorized funding via the

Numerous scholars have analyzed—and occasionally overanalyzed—both the sociology and iconography of mobile home living. While the appeal of the mobile home lifestyle continues to escape many, it is difficult to criticize a phenomenon that furnishes security, pride of place, and social interaction in a truly affordable package.

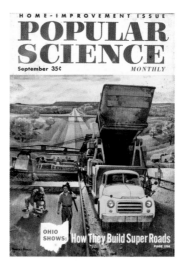

America's growing network of superhighways was born through the government's postwar desire to facilitate national defense and evacuation. With their vast scale and breathtaking engineering, however, superhighways quickly became popular icons, as heroically depicted on this *Popular Science* magazine cover from September 1955.

broad, chrome-plated grilles that envious Britons dubbed "the American Dollar Grin." The era's outlandish automotive styling had its own influence on trailer design: With the notable exception of Airstream, manufacturers clamored to incorporate—or more often, simply append—fashionable styling devices such as two-toning,

raked front ends, wraparound windows, and even tail fins.

Between new money, big cars, and smooth highways, trailering could hardly have found a better time for a comeback.

Changing Times

Yet this postwar exuberance was soon to be tempered. In 1959, labor unrest in the steel industry and a general recession combined to slow auto sales to a crawl. At the same time,

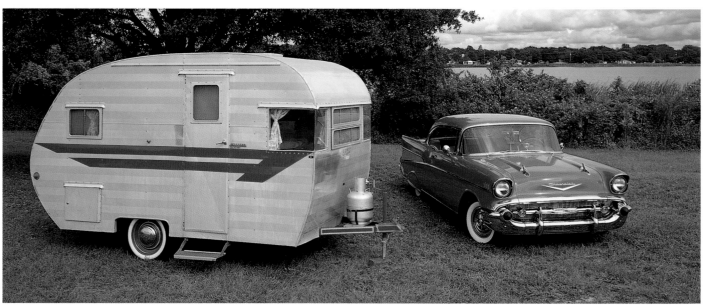

Displaying the quintessential "American Dollar Grin," a 1957 Chevrolet poses beside a well-matched Comet travel trailer of the same vintage. Trailer travel reached a new level of popularity during the 1950s, when the nation prospered as never before. Wartime production had propelled the economy out of its Depression-era doldrums, and pent-up postwar demand for automobiles and other civilian goods sustained this growth. With prosperity came discretionary income for recreation. Trailering, above all other forms of recreation, indulged both the nation's mania for automobiles and its eagerness to travel the new "Eisenhower interstates."

mounting criticism of Detroit's chrome-laden, gas-guzzling behemoths also began to register on America's auto-infatuated society. For the first time, compact models from the nation's two remaining independent automakers, Rambler and Studebaker, joined foreign imports such as the Renault Dauphine and the soon-to-be ubiquitous Volkswagen Beetle to make serious inroads against Detroit's usual offerings. The Big Three scrambled to introduce compacts of their own, paring down their mammoth standard models in the process. For the 1961 model year, even America's flagship Lincoln and Cadillac marques had been significantly trimmed.

Paradoxically, amid all this downsizing, trailers grew larger than ever. By 1960, the 10-foot-wide chassis was already the industry standard, and at least one 12-foot-wide model had been introduced. Within another decade, both 14-foot-wide and 12-foot-double-wide trailers were available. The evolving distinction between travel trailers and manufactured homes was now complete.

Meanwhile, what remained of the recreational trailer industry did its best to stay in the public eye. Wally Byam's Airstream caravans, which began with a forty-one trailer excursion to Africa in 1959, continued on through Europe, Central America, and Asia during the early sixties. Meanwhile, the rather low-budget Miss Travel Trailer/Miss Mobile Home contest embodied the schism in trailer forms.

Still, it was all a far cry from trailering's halcyon days of the mid-1930s. Already buffeted by the industry's diffusion into mobile home manufacturing, the travel trailer also faced growing competition from rejuvenated versions of two old recreational vehicle concepts. At the heart of both was the advantage of self-propulsion, a feature the trailer could by definition never lay claim to.

The first of these challenges came from the truck camper, a structure designed to nest inside the bed of a pickup truck. After decades in the domain of backyard builders, the commercial manufacture of these campers began to boom in the early sixties. For the occasional traveler, a truck camper was less expensive and easier to maneuver than a trailer, and could be legally occupied while in motion. It could also be separated from the vehicle—albeit less conveniently than a trailer could—leaving the pickup truck free for other uses. Sizes ranged from units no larger than the pickup bed itself to wallowing contraptions cantilevered

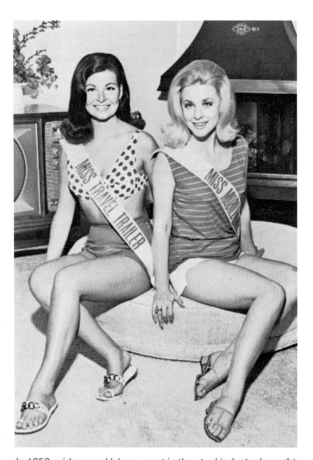

In 1959, widespread labor unrest in the steel industry brought the soaring postwar economy back down to earth. Automobile sales slowed markedly, dragging trailer sales down with them. Meanwhile, the trailer was completing its evolution into two distinct forms. Although a number of firms continued to manufacture small travel trailers for recreational use, a large portion of the industry changed its focus to enormous "mobile homes" meant to be towed under a special permit and then permanently parked. Emblematic of this division are Miss Travel Trailer and Miss Mobile Home, separate winners of a trailer industry contest circa the early 1960s. *Courtesy Wayne Fergusson Collection.*

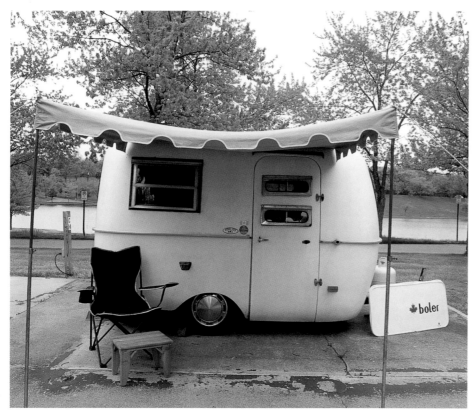

well beyond the body sides, cab, and rear bumper.

Predictably enough, demand for ever roomier campers spurred a return to the old concept of the house car, which had last flourished commercially during the teens and twenties. Rechristened "motor homes," such vehicles did away with the physical limitations of the pickup bed by mounting an essentially trailerlike body directly on a bare heavy-duty truck chassis. Being self-contained, motor homes were easier to maneuver than travel trailers, although their single-purpose design also made them a dubious investment for those who traveled only occasionally. Nevertheless, by the late 1970s, motor homes had reached a level of size and sophistication that easily rivaled contemporary trailers.

Still Ready to Roll

Yet despite the incursion of truck campers and motor homes into the the trailer's traditional domain, there remained a core market of recreational travelers who were unswayed by the lure of self-propulsion. Today, around two dozen major firms continue to manufacture travel trailers, although only one—Airstream Trailers, Inc.—survives from trailering's golden age of the mid-1930s.

In the seventy-odd years since Americans first fell for the humble little Covered Wagon, the travel trailer has varied wildly in form, from

The trailer industry was first buffeted by the rise of truck campers during the 1960s and later by the burgeoning popularity of motor homes in the 1970s. Both products were self-propelled, an advantage which trailers could by definition never lay claim to. Many trailer manufacturers accordingly expanded into truck camper or motor home production, though some continued building large travel trailers for die-hard buyers. The wallowing, oversized recreational vehicles of this era, whether truck campers, motor homes, or trailers, were little short of rolling motel rooms, complete with televisions and air-conditioning.

However, a few trailer builders did return to the original spirit of the Covered Wagon by providing a comfortable night's sleep in the simplest possible format. One of these was the modest, Canadian-built Boler. Designed by Ray Olecko, who had previously received a patent for fiberglass septic tanks, the Boler's pioneering body design employed an ultralightweight fiberglass shell. Olecko named the trailer for its similarity to a bowler hat. Boler production began in 1968 and continued under various franchises until at least 1978; between seven and ten thousand units were produced during that time.

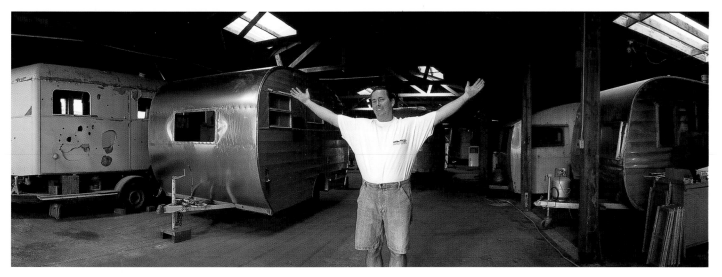

With a renewed appreciation of American travel trailers has come a rehabilitation of the trailer's checkered past, as well as new interest in its future. Pictured here is trailer restorer Craig Dorsey, whose Anaheim, California, warehouse is stocked with at least a dozen vintage trailers at any one time. After years of decline and neglect, the trailer is once again ready to roll.

aristocratic fifth-wheels to streamlined silver palaces; from bread loaves to canned hams; from drab wartime housing to the long, long trailers of the postwar era. In that span of time, it has also made a poignant journey from national phenomenon to national scourge and back again. Only now are trailers beginning to be appreciated by collectors, both as functional objects and as classic pieces of Americana.

As these pages will testify, the travel trailer is still very much with us. Across the nation, venerable examples from all eras are being rescued, restored, and cherished not as museum pieces, but as living, road-ready Americana. In this harried age when both work and play seem to occur at breakneck speed, trailers remind us of slower, simpler, and folksier days, when the prospect of living in a swell little home on the road was thrill enough.

OVERLEAF: The Kit Kamper was among the most popular teardrop trailers of the postwar era. Its producer, the Kit Manufacturing Company, was founded in an abandoned fruit stand in Norwalk, California, in 1945. Initially, Kit offered teardrops in knocked-down form. However, it soon became apparent that buyers preferred their trailers ready for use, and the firm duly began selling the units fully assembled. By 1947, demand for the now ironically named Kit Kamper was so brisk that the factory operated two shifts producing forty teardrops daily. This 1947 model boasts unique Kit features, such as fiberglass fenders and an additional door on the left side. Production of teardrop models was halted the same year in favor of a larger and more conventional trailer design. Today, the Kit Manufacturing Company remains a major producer of recreational vehicles and mobile home equipment. The tow vehicle in the background is a 1974 Volkswagen Thing, distant cousin of the utilitarian Kübelwagen used by the German military during World War II. The vehicles were photographed at the Tropical Palms Resort in Kissimmee, Florida.

At the dawn of the twentieth century, Americans found themselves equally fascinated by the works of nature and the works of industry. The coexistence of these seemingly strange bedfellows is evident in the well-publicized camping trip President Warren Harding hosted for Henry Ford, Harvey Firestone, and Thomas Edison in 1921. To contemporary minds, there was no paradox in men exalting nature while simultaneously transforming large portions of it into gritty industrial landscapes.

flies that attached directly to the vehicle consumed even more space when not in use, and also precluded the automobile's movement when set up.

The arrival of the earliest tent trailers in the midteens instantly did away with these annoyances. By removing camping gear to a separate self-contained unit, the auto was once again freed for passengers. Moreover, by detaching the trailer, the car could still be used while camp was set up.

The simplest tent trailers consisted of little

for provisions and camping gear behind the tailgate.

Tent trailers generally rode on single axles with wooden-spoked artillery wheels until the late twenties, when manufacturers followed the auto industry's widespread adoption of steel-spoked wheels, and later of stamped-steel disc wheels. Wood remained the primary material for trailer bodies, however, with only incidental braces and reinforcements being made of wrought iron or steel.

Tent trailers grew more complex as the

2. Tents and Teardrops

The period's characteristic ease in reconciling natural and industrial ideals helps explain the rapid rise of auto camping, which combined an awakening love of nature with the longstanding Yankee love for mechanical gadgets. The tent trailer, one of the forebears of the travel trailer, perfectly embodied this combination.

In the early days of auto camping, camping gear, baggage, and provisions had to be stowed aboard the automobile between destinations, often leaving scant room for passengers. Later camping accessories such as canvas

more than a wooden buckboard with a canvas superstructure. More elaborate models, made by such companies as Auto-Kamp and Warner, featured various configurations of hinged panels that swung into place to form elevated beds. When fully stowed, the mattresses, canvas, and necessary supports were neatly contained in a rectangular wooden box perhaps 4 feet wide. In camp, the panels folded out of the unit to rest on attached props, after which a number of wooden stakes or bows were placed into sockets to support the canvas roof. Many units also featured storage compartments

twenties wore on, and erecting one with any degree of efficiency—and especially unfurling and rigging the canvas—was a chore that demanded two fairly strong people and considerable practice. Even in favorable weather, the task could seldom be completed in the time claimed by the manufacturer; in wind or rain, it took longer yet.

It was just such an experience that sent Arthur Sherman in search of a better solution. The result was his fully enclosed Covered Wagon, which began the trend toward solid-walled trailers during the early 1930s, and

soon made collapsible canvas units obsolete.

Yet even after solid-walled travel trailers had taken over the industry, the tent trailer retained a spiritual successor in the miniature canned-ham trailer known as the teardrop. Like the tent trailer before it, the teardrop's interior was almost entirely devoted to a comfortable bed, while at the rear, where the tent trailer's tailgate had been, a hatch could be raised to reveal a compact area for cooking. Refuting the trend toward ever larger and more elaborate travel trailers, the modest little teardrop held its own by simply sticking to the basics, and survives in this form today.

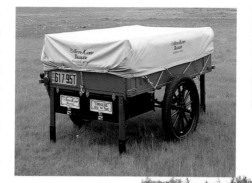

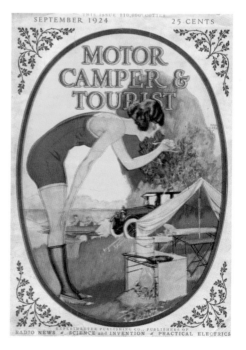

BOTTOM LEFT: **During the midtwenties, auto camping was popular enough to claim its own monthly magazine,** *Motor Camper & Tourist.* **The September 1924 issue seen here, which cost 25 cents and boasted a circulation of 110,000, featured articles on "How to Drive on Mountain Roads" and how to "Go Light Camping"** using the least equipment. There were also pieces on camping in Wisconsin, Quebec, and Cincinnati, along with discussions of camp cookery, camp management, and new accessories and equipment. There was a question-and-answer section, jokes, and even a primer on the use of radios (the publisher also produced a radio magazine). Courtesy Vince Martinico Collection.

RIGHT: **Two sheet metal drawers just ahead of the tailboard form the Auto-Kamp's galley; ice placed in the rear**

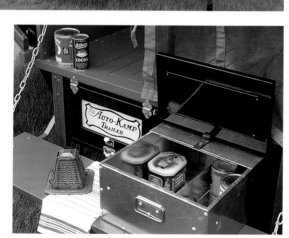

portion of one drawer provides a rudimentary icebox while cooking utensils or nonperishable food can be stored in the other.

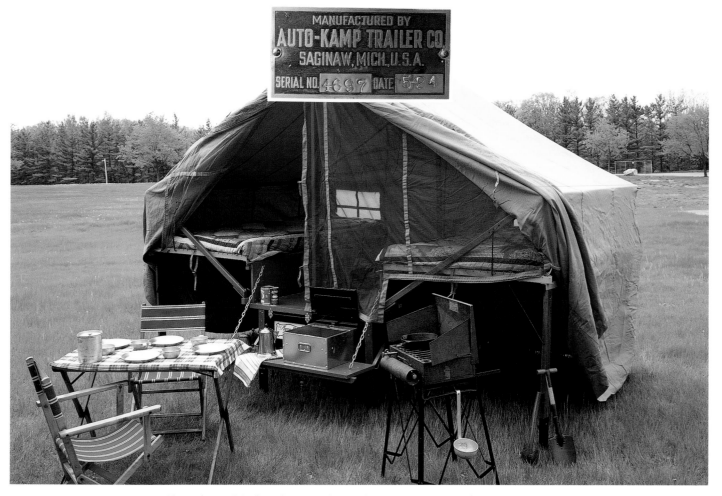

OPPOSITE TOP AND MIDDLE RIGHT; ABOVE: Three views of the ingeniously designed 1924 Auto-Kamp tent trailer, showing the sequence in which such units were typically set up for camp. First, four retractable legs are deployed to stabilize the trailer bed; at the base of each, a sliding metal sleeve locked by a thumbscrew compensates for irregular terrain.

Next, the tailgate is lowered to form a tailboard. The mattress frames are folded out of the trailer bed and supported on a similar set of legs. The diagonal struts and ridgepole frame, which are normally bundled in the trailer bed, are now assembled and placed into sockets in the trailer body.

Finally, the canvas tent and flies stored in the trailer bed are stretched onto the wooden struts, and the trailer is ready for occupancy. Accessories, such as the 1927 Prentiss Wabers folding cookstove seen here, can now be set up to complete the camp. Although manufacturers often claimed that such trailers could be erected in twenty minutes, about forty minutes was more realistic, and inclement weather could slow things down even further.

The Auto-Kamp Trailer Company was based in Saginaw, Michigan, and began manufacturing tent trailers around 1914; later models featured disc wheels in place of the wooden-spoked artillery wheels seen here. The firm closed in 1930, a victim of the Depression. This trailer was photographed at Camp Dearborn, Michigan, not too far from its birthplace.

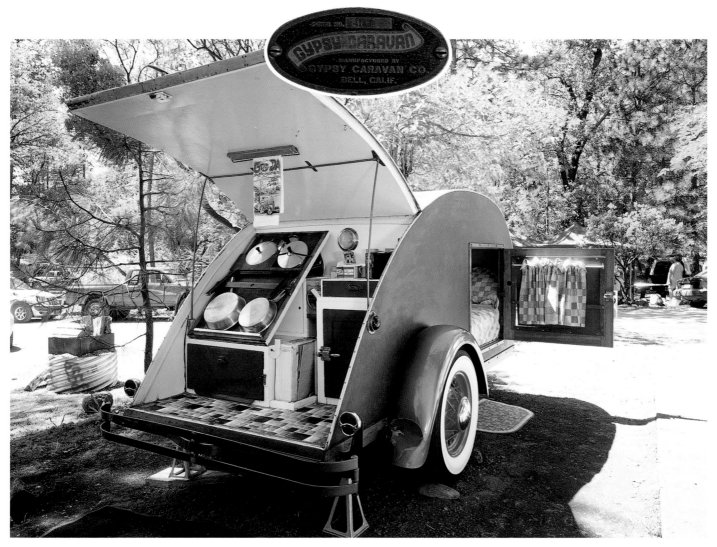

Spiritual successor to the tent trailer, the so-called teardrop was essentially an updated, solid-walled version of the tent trailer. Its design retained such traits as compact size, an aft-mounted external galley, and an interior devoted mainly to sleeping, while eliminating the tent trailer's troublesome folding panels and canvas. This 1937 Gypsy Caravan is among the most stylish examples of the era. Manufactured by Gypsy Caravan Company in Bell, California, it features the classic ovoid silhouette that earned these trailers their name. It also illustrates the evolution of the tent trailer's tailgate into an enormous hatch giving access to a spacious galley complete with icebox. The trailer's exterior is finished in a padded artificial leather much like the DuPont Fabrikoid found on Glenn Curtiss's contemporary Aerocar Land Yacht. Standard automotive spoked wheels and wide whitewall tires complete a dapper little package. Fastidious care by a mere three owners during its lifetime has left this trailer in mint unrestored condition.

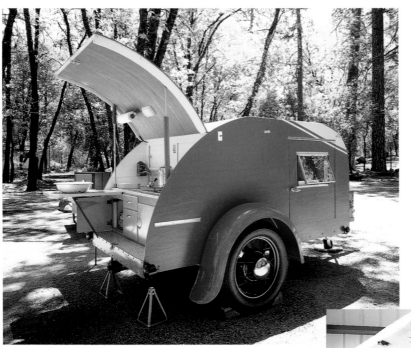

LEFT: The diminutive size and modest cost of teardrops made them among the most popular trailer types offered as do-it-yourself kits. This example, probably built from plans found in the March/April 1939 issue of *Popular Homecraft* magazine, was completed in 1941. From the thirties through the fifties, "build-your-own-trailer" articles were also a staple of magazines such as *Popular Mechanics* and *Popular Science*. Moreover, the back pages of issues almost invariably featured advertisements for kit trailers and an array of stock trailer components.

RIGHT: Familiar automotive cues once again appear in this 1947 kit trailer, with its curved bumper, stamped-steel wheels, and "baby moon" hubcaps borrowed from passenger cars of the period. Kit trailer chassis used widely available stock automotive components such as axles, wheels, bumpers, and taillights, leaving their streamlined bodies as the main challenge for builders. Here, the exterior finish is aluminum, a durable and attractive metal that could also be easily worked by hobbyists.

RIGHT: The partially deployed Kamp Master, showing the canvas flies—replaceable with mosquito netting in warm weather—and the full-height door. The sleeping compartment, just visible through the open front hatch, could be used with the trailer in either the stowed or deployed position. Thanks to a weight of only 840 pounds, the unit required no trailer brakes and imposed a relatively light 94-pound tongue load on the tow vehicle, avoiding the need for overload springs. Moreover, its streamlined shape was said to reduce drag by some 200 pounds at 60 miles per hour, as compared to conventional rectangular trailers. The Kamp Master's manufacturer, King's Trailer Company, billed its aluminum skin as a "Life-time" finish—a claim this example dating from 1950 seems to bear out.

BELOW: This characteristically text-heavy brochure dating from the late forties advertised the Kamp Master, an unusual teardrop-derived design

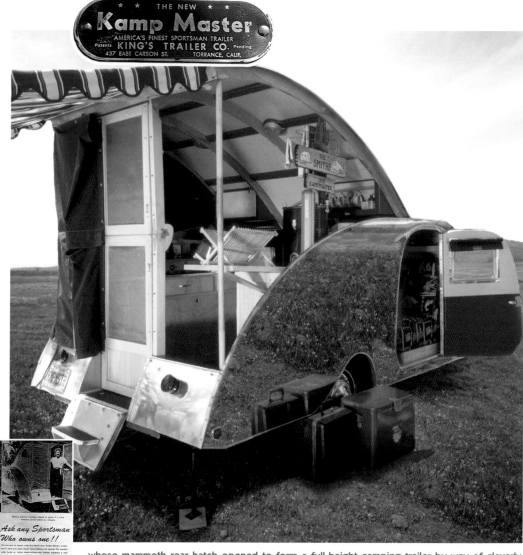

whose mammoth rear hatch opened to form a full-height camping trailer by way of cleverly designed canvas flies. In addition to its full-height door, the Kamp Master featured a teardrop-style hatch that opened into the sleeping compartment. Aimed at outdoorsmen, the trailer boasted a leather-lined interior with plenty of cupboard and closet space, as well as a rod-and-gun shelf. The advertising copy repeatedly stressed the trailer's streamlined styling, including a rather dubious claim made in capital letters: NO WIND RESISTANCE.

Modernistic Camper

MODERNISTIC MANUFACTURING
1230 E. 109th ST. LOS ANGELES, CALIFORNIA

BELOW: The vogue for streamlined styling that began in the midthirties was still going strong after World War II, as this advertisement from the November 1947 issue of *Popular Science* will attest. In addition to its streamlined shape, the Modernistic Sports Trailer, manufactured in Los Angeles, was unique in having a demountable upper body that allowed the lower portion to be used as a utility trailer. Sold in kit form, the Modernistic Sports Trailer was advertised as costing only half as much as the assembled version—or as the manufacturer put it, "Two days of your time . . . saves you over $200." The unit featured Timken high-speed bearings, Ford 16-inch stamped wheels, and off-the-shelf clearance lights and taillights, all common automotive items.

ABOVE: At Lake Shasta, California, Smokey Bear presides over a 1947 Modernistic teardrop, whose gleaming skin of Kaiser aluminum looks about as old as tomorrow. Unlike Masonite-bodied trailers, which quickly fall to pieces if not properly maintained, aluminum-skinned units can take years of neglect and still be returned to near new condition—albeit through generous applications of elbow grease.

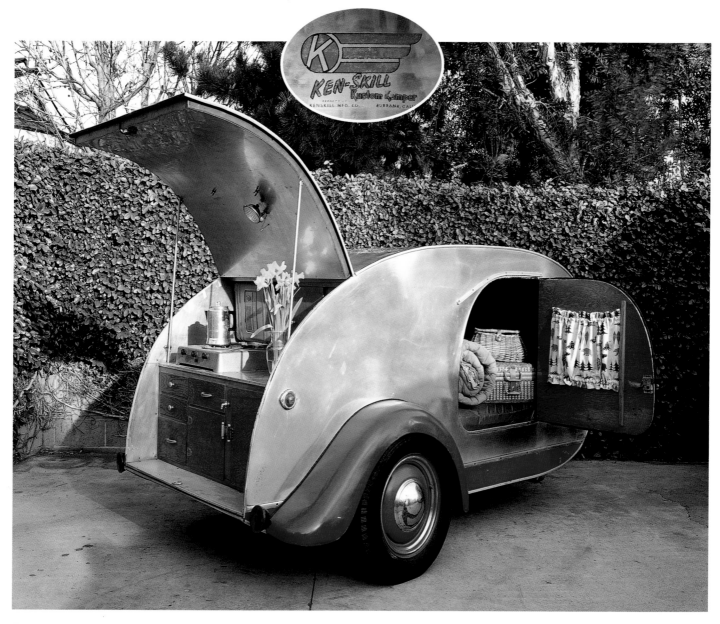

Yet another version of the teardrop, the Ken-Skill Kustom Kamper boasted a dashing two-toned paint scheme that enhanced its look of streamlined motion, as well as an especially tidy yachtlike galley. The wheels and fenders are again standard automotive items, possibly from surplus stock.

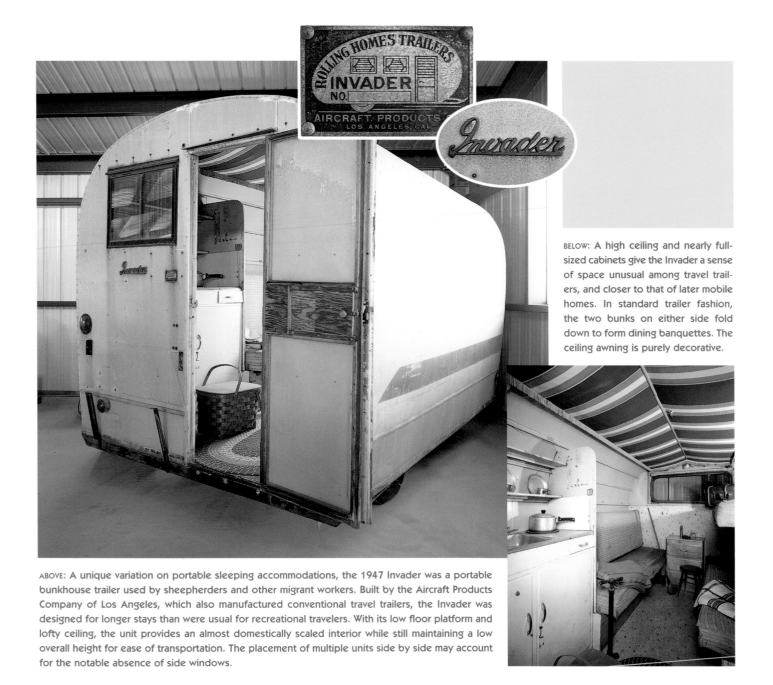

BELOW: A high ceiling and nearly full-sized cabinets give the Invader a sense of space unusual among travel trailers, and closer to that of later mobile homes. In standard trailer fashion, the two bunks on either side fold down to form dining banquettes. The ceiling awning is purely decorative.

ABOVE: A unique variation on portable sleeping accommodations, the 1947 Invader was a portable bunkhouse trailer used by sheepherders and other migrant workers. Built by the Aircraft Products Company of Los Angeles, which also manufactured conventional travel trailers, the Invader was designed for longer stays than were usual for recreational travelers. With its low floor platform and lofty ceiling, the unit provides an almost domestically scaled interior while still maintaining a low overall height for ease of transportation. The placement of multiple units side by side may account for the notable absence of side windows.

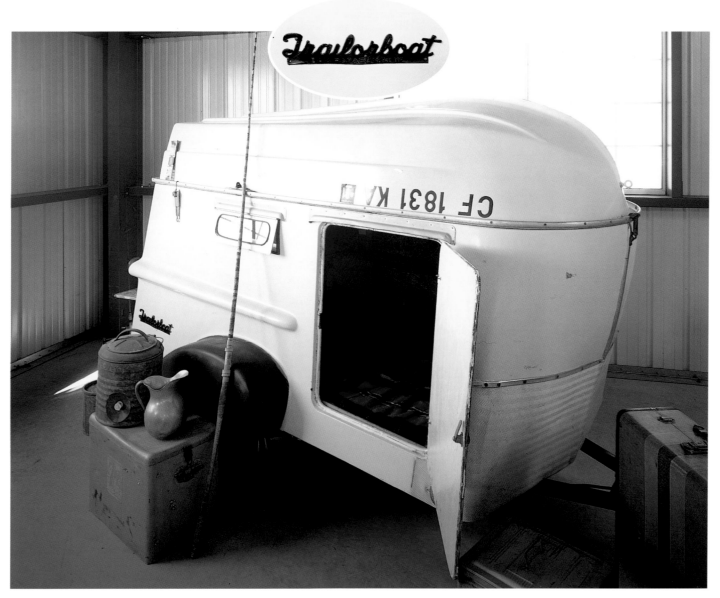

Another clever twist on overnight accommodations was the Trailorboat, whose streamlined "roof" was actually an inverted fiberglass boat hull. Built during the fifties and sixties by Trailorboat Engineering of San Rafael, California, the units were aimed at sport fishermen, whose expeditions often required them to tow both a camping trailer and a boat trailer. The Trailorboat simply combined these functions, though it was not the only product to do so.

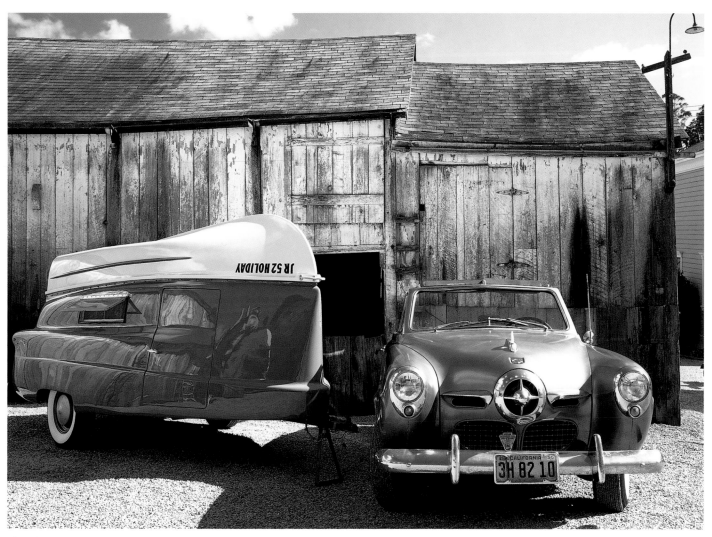

The 1956 Kom-Pak Sportsman echoed the Trailorboat's ingenious configuration, but also boasted a rakish fiberglass body better suited to the automotive styling of the period. The industrial use of fiberglass advanced steadily after World War II; in 1953, the Chevrolet Corvette became the first American car to use the tough, lightweight, and rustproof composite for all major body panels. Camping vehicles, with their demand for both strength and lightness, were another natural application for fiberglass technology. Fiberglass was also much cheaper than formed or stamped steel where limited numbers of complex shapes were required—an important advantage for the small production runs typical of the recreational vehicle industry.

The tow car pictured here is the infamous "bullet-nosed" 1950 Studebaker, built by the venerable Studebaker Corporation of South Bend, Indiana.

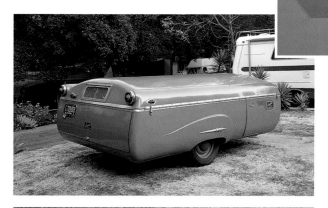

TOP LEFT: The fiberglass-bodied Ranger camp trailer built by the Hille Engineering Corp. of Anaheim was a direct descendant of the tent trailer and was also its equal in ingenuity. The low-slung design, with its easily recognized 1953–54 Ford passenger car taillights, proved an exceptional fit for the rakish automotive styling of the mid-1950s. This 1955 Ranger, shown here in the stowed position, has a fiberglass tonneau covering the trailer body down to the bright metal molding.

BOTTOM LEFT: After unlocking a set of catches, the tonneau is raised on its folding stanchions and then locked in the deployed position. Note the galley and bunks visible in the lower body and the door seamlessly faired into the front corner.

BELOW: Finally, the tailgate is slid back, expanding the interior. Canvas front, rear, and side curtains with screened windows are secured to the trailer body at top and bottom, and the Ranger is ready.

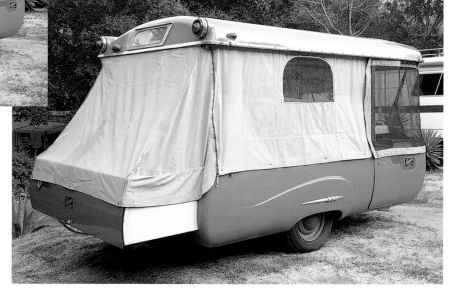

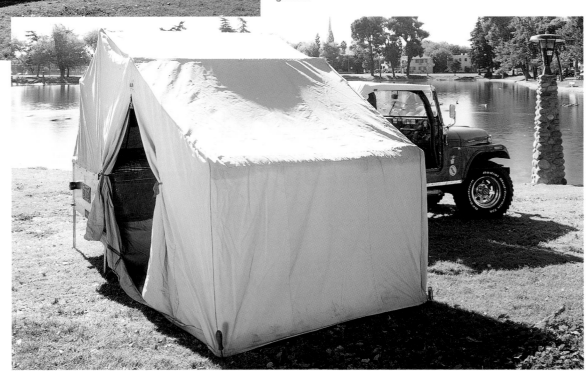

LEFT: The Heilite, another variation on the tent trailer of the 1920s, differs from all its predecessors in having but a single wheel. The Lodi, California-based Heilite Manufacturing Company was founded in 1953 and pioneered the curious concept of rigidly attaching the trailer to the bumper of the tow vehicle by means of a special hitch. The single rear wheel was caster mounted, enabling it to follow the trailer's lateral movements on turns. Heilite also built some two-wheeled models, though these are even less common than the one-wheeled variety.

BELOW: The Heilite's tent arrangement is somewhat more conventional. The trailer is first stabilized, using legs much like those of the Auto-Kamp tent trailer of the twenties.

Next, various struts are assembled in lean-to fashion and covered with a large canvas tent whose corners are then staked to the ground.

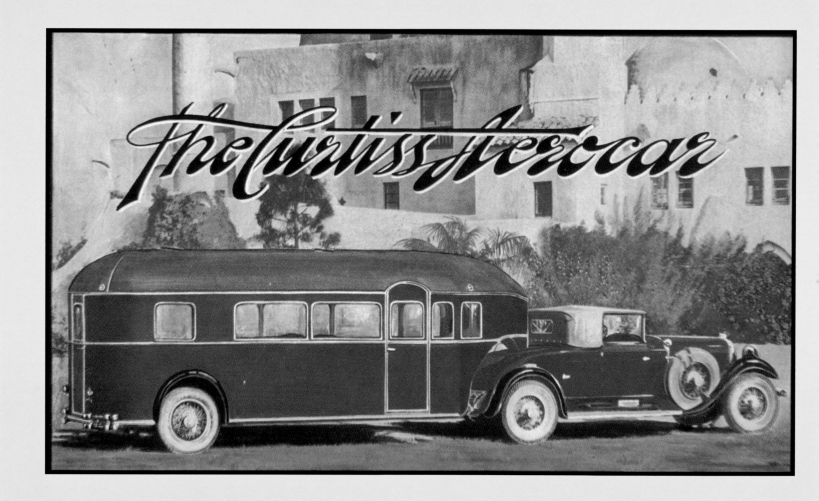

The Curtiss Aerocar

*T*he story of the fifth-wheel trailer begins with Glenn Curtiss, prodigal inventor and aircraft engineer, who began a brilliant career tinkering with bicycles and motorcycles in his Hammondsport, New York, shop. After inventing the motorcycle handlebar throttle in 1904 and setting a world speed record of 77.6 miles per hour in 1907, he expanded his interests to aviation, where his experiments won him the *Scientific American* trophy in 1908.

The following year, Curtiss built and sold

Curtiss's interest in camping and the outdoors soon set him to work designing the consummate camping trailer. He developed a prototype in 1917, and two years later began marketing an improved version as the Curtiss Motor Bungalow. It was a natural outgrowth of Curtiss's wide-ranging interests, and displayed his usual engineering flair: It was towed via a patented gooseneck hitch coupled to what was the first commercially produced fifth-wheel assembly in America. The ingenious arrangement consisted of a modified aircraft

had to be removed for this specific purpose.

Curtiss's fifth-wheel towing arrangement, novel as it was, ultimately proved less influential on trailering than the Motor Bungalow's body construction, which used a system of strong, slender ribs clad in a lightweight skin. The concept grew out of Curtiss's aircraft-building experience during the Great War, when his company turned out some six thousand of the famed "Jenny" training aircraft using much the same system.

Despite such innovations, however, the

3. Aerocars

the first private aircraft in the United States and also set a new international air speed record of 46.5 miles per hour. In 1911, he designed the first successful pontoon aircraft, pioneered both the retractable landing gear and dual-pilot control and, just for good measure, was awarded the first pilot's license in the United States.

rim-and-tire assembly mounted over the tow vehicle's rear axle, where the inflated tire served to isolate the trailer from road shocks and vibration. Although the Motor Bungalow's axle was set well behind its center of balance, throwing a considerable load onto the hitch, it was nevertheless meant to be towed by an ordinary passenger coupe, whose trunk lid

Motor Bungalow had only modest commercial success, and production was halted around 1922. Perhaps its design was simply too radical to make inroads against the more familiar house car, with its heavy, buildinglike superstructure mounted on a wallowing truck chassis. Just as likely, the custom-built and steeply priced Motor Bungalow was simply too expensive to ap-

OPPOSITE: **Engineering elegance was the hallmark of Glenn Curtiss's unique Aerocar, seen here in a promotional photo dating from around 1932. With its patented fifth-wheel hitch—the first commercially produced in America—it stood alone among recreational vehicles for the whole of its existence. Strictly speaking, the Aerocar was not a trailer, but rather a semitrailer, since the tow vehicle absorbed a large portion of the unit's weight. This fine distinction has never prevented it from being included among the titans of trailering, however. The Aerocar's lofty price, which ranged from around $3,000 to $15,000, brought with it the privilege of extensive customization. Matching livery on the tow car and trailer was practically de rigueur. This stunning example is proudly posed before a fantastical North African-style backdrop in Opa-Locka, Florida—a resort which, not coincidentally, was another of Curtiss's diverse ventures.** Courtesy Vince Martinico Collection.

peal to a large market. Yet Curtiss did not abandon the trailer business; rather, he occupied himself with other interests for a number of years, dabbling in real estate and developing the Florida resort towns of Hialeah, Miami Springs, and Opa-Locka.

In 1928, at the height of the auto-camping craze, Curtiss returned to the scene with a redesigned fifth-wheel trailer named, with delectable ostentation, the Curtiss Aerocar Land Yacht. Though it retained the Motor Bungalow's bread-loaf-with-a-beak shape and fifth-wheel hitch arrangement, its exterior was now entirely swathed in padded DuPont Fabrikoid, an early artificial leather. Its opulent interior, replete with plush upholstery, fold-down berths, and a separate galley, owed much to the stately private railroad cars of the late Victorian era.

Technologically, however, the Land Yacht was every bit as advanced as Curtiss's aircraft. Designed to be occupied while in motion, it featured a cockpit with a comprehensive set of instruments furnishing compass, ground speed, and altitude readings, as well as a telephone that allowed its captain to communicate with the driver of the tow car. Larger models—some were more than 30 feet in length—boasted a sort of flying bridge at the bow end, equipped with a pair of captain's chairs and a roof that

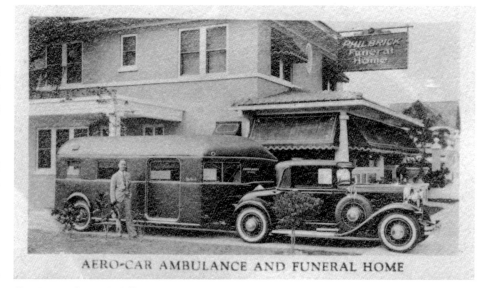

AERO-CAR AMBULANCE AND FUNERAL HOME

The Aerocar factory's ability to custom-build allowed Curtiss to offer a vast range of trailer configurations, including many for specialized commercial uses. The resplendent "ambulance" referred to here is more commonly known as a hearse; note the extrawide door designed to accommodate a casket. This promotional photo dates from the early thirties. Courtesy Vince Martinico Collection.

slid open. There was even a rudimentary form of air-conditioning that worked by taking in outside air and passing it across dry ice.

Such refined engineering did not come cheap, of course, and the Land Yacht's stratospheric price—ranging between $3,000 and $25,000—effectively excluded the thousands and eventually tens of thousands of middle-class Americans who sought a home on the highway. While the aristocratic Aerocar set the gold standard in trailer design (and continued to do so for years afterward), it ultimately had

little influence on the grassroots trailer revolution that was already at hand by the late 1920s.

Production of the Aerocar ended about a decade or so after Glenn Curtiss's death in 1930, and during that time it stood virtually alone among fifth-wheel travel trailers. Today, a number of recreational vehicle builders offer trailers using a fifth-wheel arrangment; alas, their boxy designs have little in common with Curtiss's elegant Pullman car for the road.

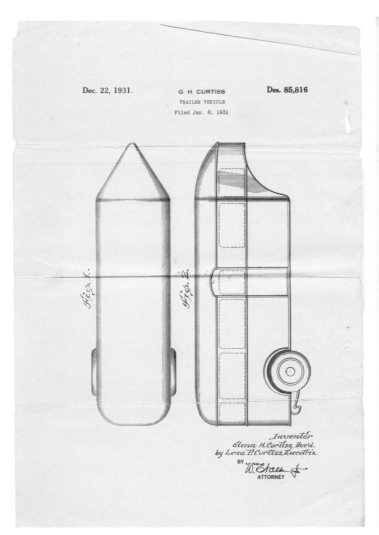

A fourteen-year patent for the "ornamental design" or basic body configuration of Curtiss's Aerocar was granted on December 22, 1931. Because Curtiss had died the previous year, the patent was executed by his wife Lena. The patent drawing shows the basic Aerocar concept in plan view and side elevation; the patent's curiously worded text, describes the Aerocar's "long, low-hung carlike body with bulging roof" as the basis for patenting Curtiss's "new, original, and ornamental Design for Trailer Vehicles." *Courtesy Vince Martinico Collection.*

ABOVE: The Aerocar factory in Coral Gables, Florida, circa the mid-1930s.

ABOVE RIGHT: An Aerocar awaiting completion on the factory floor . . .

RIGHT: . . . and the finished product. That the Aerocar's original profile still suited the more streamlined automotive shapes of the late 1930s points to the excellence of its basic design. The tow car pictured is a 1935 Oldsmobile LaSalle coupe. Aerocars were never coupled to four-door sedans, whose abbreviated trunks did not allow the fifth wheel to be placed directly above the rear axle as proper weight distribution demanded. Courtesy Vince Martinico Collection.

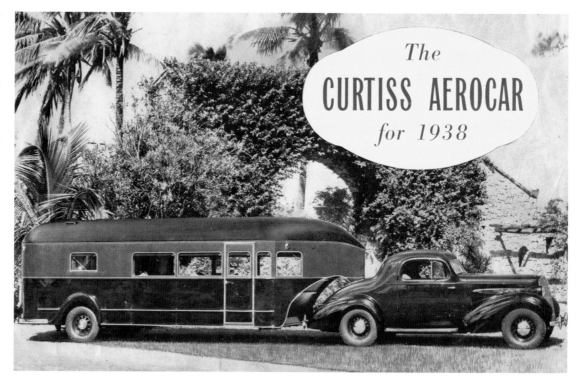

The
CURTISS AEROCAR
for 1938

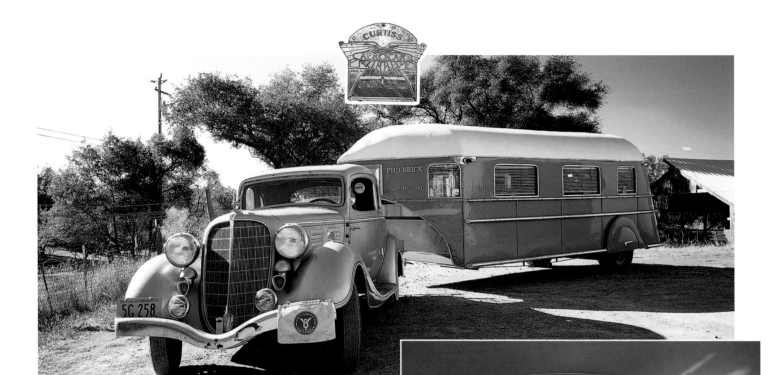

ABOVE: One of perhaps twelve Curtiss Aerocars known to survive, this 1936 model bows to the fashion for streamlining by sporting skirted rear wheels with "speed line" emblems. The equally rakish tow car is a 1934 Hudson coupe. Like all Aerocars, the trailer's sides form a load-bearing truss, making a deep frame unnecessary, and allowing an unusually low ground clearance for a vehicle of such length. Where the diagonal tension cables in the truss interfered with a customer's desired window location, they were simply exposed to view behind the glass.

RIGHT: The Aerocar's lavishly appointed interior was inspired by the private railroad cars of the late nineteenth century, and hardly suffered in comparison. While the arching roofline allowed plenty of hat room for a person standing upright, the low-set windows gave seated persons the optimum view. The trailer was intended to be occupied while in motion, hence the grab rail and numerous straps seen along the upper sill. State laws prohibiting trailers from being occupied while in motion began proliferating in the late twenties, spurred not by travel trailer mishaps, but by a number of horrific farm wagon accidents in which dozens of workers died. By 1960, thirty or so states had laws forbidding passengers from riding in moving trailers.

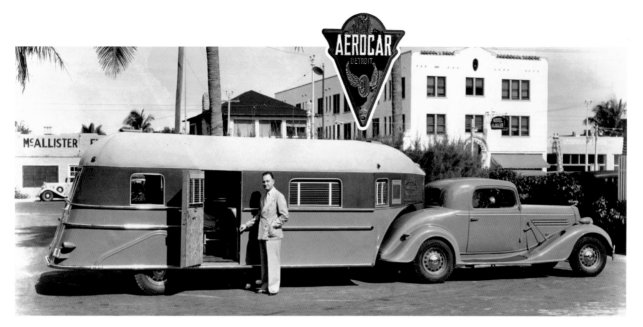

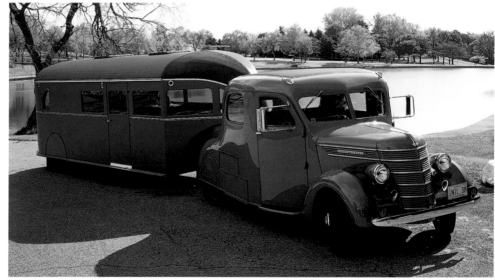

ABOVE: A proud owner poses before his unusually streamlined Aerocar; note the reverse slant at the aft end, a popular styling device on trailers of the late 1930s. Taillights faired into the body, along with horizontal speed lines consisting of a bright metal rocker panel molding, a heavy rub rail, and a narrower belt molding, help add to the look of forward motion. The tow car is a 1934 Buick coupe.

RIGHT: A rarity among rarities, this 1936 Aerocar was built for William Gray, the son of Chatham, Ontario, auto pioneer Robert Gray, builder of Gray-Dort automobiles. The 22-foot trailer was originally towed by a 1936 Plymouth coupe, which, alas, proved unequal to the task. Gray therefore commissioned a custom-built tow vehicle from the International truck plant at Chatham. Based on a shortened 1938 International D-line cab and chassis, the truck is powered by an in-line six-cylinder L-head engine; its curvaceous body was custom-built by Brantford Coach and consists of hand-hammered steel panels over hardwood framing members. Taken together, the tow car and trailer measure some 35 feet in length and weigh around 5 tons.

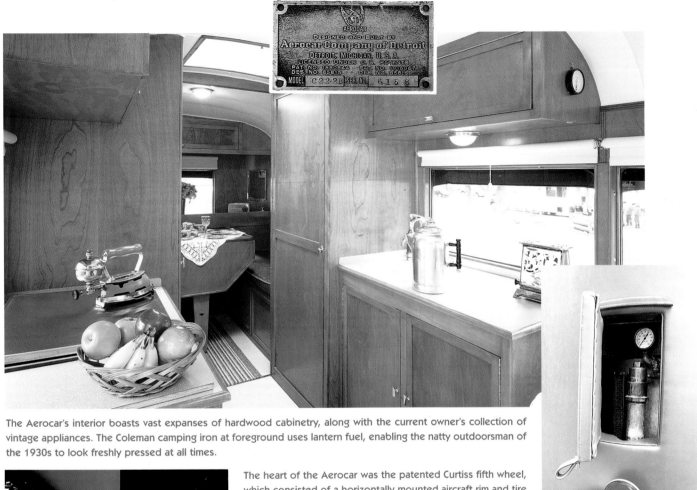

The Aerocar's interior boasts vast expanses of hardwood cabinetry, along with the current owner's collection of vintage appliances. The Coleman camping iron at foreground uses lantern fuel, enabling the natty outdoorsman of the 1930s to look freshly pressed at all times.

The heart of the Aerocar was the patented Curtiss fifth wheel, which consisted of a horizontally mounted aircraft rim and tire clamped inside a cast-metal bracket. The assembly was normally bolted to the trunk floor of a passenger coupe, or more rarely, to the bed of a specially designed tow vehicle as in this case. The inflated tire ingeniously absorbed lateral, longitudinal, and vertical road shocks from the tow vehicle. The kingpin at the end of the trailer's unique gooseneck prow slipped into the bearing journal where an axle would normally fit. Although the fifth wheel has since evolved into a less recognizable form on both commercial tractor-trailer rigs and recreational vehicles alike, its once literal name persists.

Curtiss's concern for engineering elegance extended down to the most mundane details. The Aerocar's water tank filler, sight glass, and pressure gauge are neatly concealed behind a small access door padded in matching Fabrikoid and fitted with an elegant pull strap.

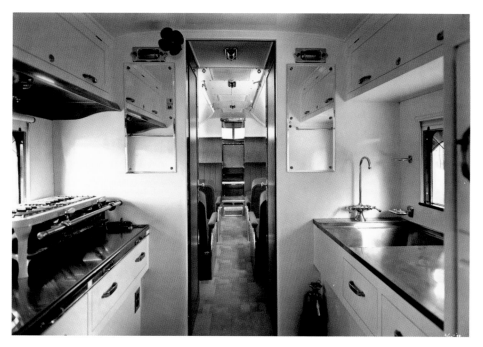

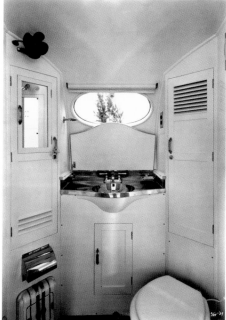

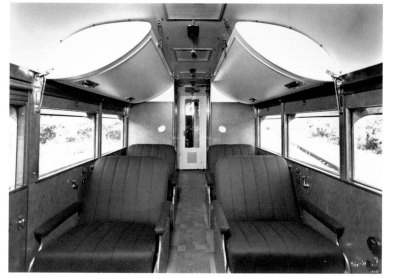

Three publicity photos dating from the late 1930s illustrate both the sophisticated engineering and elegant aesthetics of the Aerocar's interior. All photographs courtesy Vince Martinico Collection.

CLOCKWISE FROM ABOVE LEFT: the superb galley, separate from the main cabin, in which the owner's private chef could prepare gourmet meals on the road; the fastidiously designed lavatory tucked into the trailer's aft end, with its abundant storage and array of appointments, including an electric fan; and the airplanelike main cabin, with its lounge chairs and Pullman-style fold-down berths. The cranks beside each chair allowed the huge panoramic windows to be rolled down for ventilation.

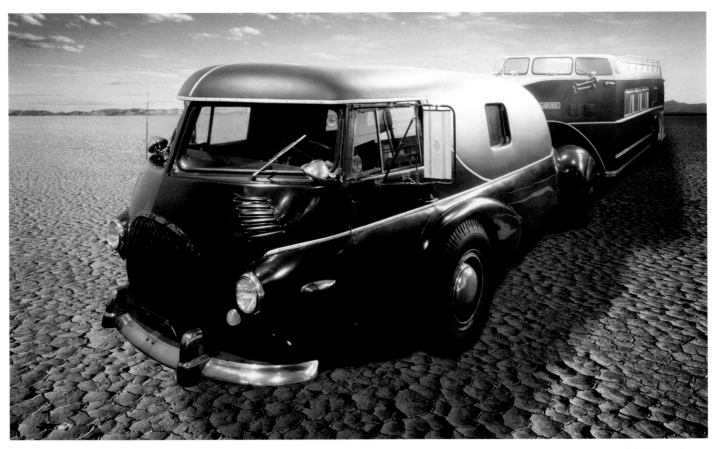

Among the most remarkable pairings in trailerdom is this spectacular rig built in 1938 for Dr. Hubert Eaton, owner of Forest Lawn Memorial Parks and Mortuaries. An avid outdoorsman, Eaton chose an Aerocar to serve as both company transportation and as a base for his hunting expeditions.

Nicknamed the "Vagabond," the Aerocar was built on a 29 1/2 foot chassis and weighed some 5 tons; hence it was wisely equipped with Westinghouse air brakes acting on dual rear wheels. Only a handful of trailers were fitted with the elevated cockpit seen here; it boasted twin lounge chairs and a panoramic sweep of six windows. Like the Reo tow vehicle, the Aerocar was scrupulously maintained by its owners, having been refurbished in 1948, 1957, and again in 1973, and it remains in exceptional condition.

To complement this investment, Eaton ordered an equally unique (and equally expensive) tow vehicle whose flamboyantly streamlined body, custom-built by the Standard Carriage Works of Los Angeles, rested on a 1938 Reo bus chassis with a White twelve-cylinder engine. In 1951, Standard Carriage Works was hired to rework the body which, among other changes, was shortened by 15 inches to reduce its turning radius. In the midfifties, the tow vehicle was repowered with a Cummins diesel engine at a reputed cost of $10,000.

After remaining in continual use by Forest Lawn officials, both the Reo and the Aerocar were retired in 1991; they were donated to the Petersen Automotive Museum of Los Angeles in 1999.

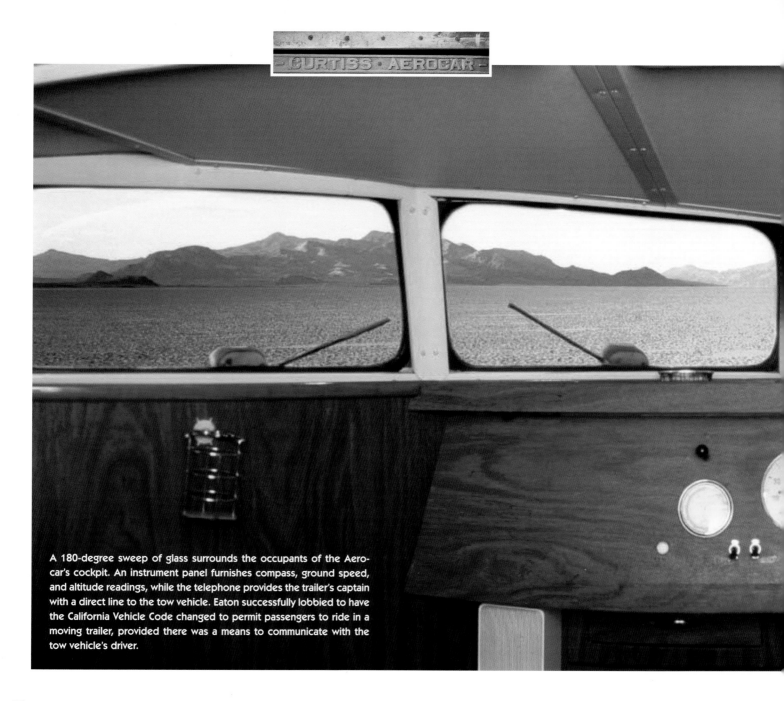

A 180-degree sweep of glass surrounds the occupants of the Aerocar's cockpit. An instrument panel furnishes compass, ground speed, and altitude readings, while the telephone provides the trailer's captain with a direct line to the tow vehicle. Eaton successfully lobbied to have the California Vehicle Code changed to permit passengers to ride in a moving trailer, provided there was a means to communicate with the tow vehicle's driver.

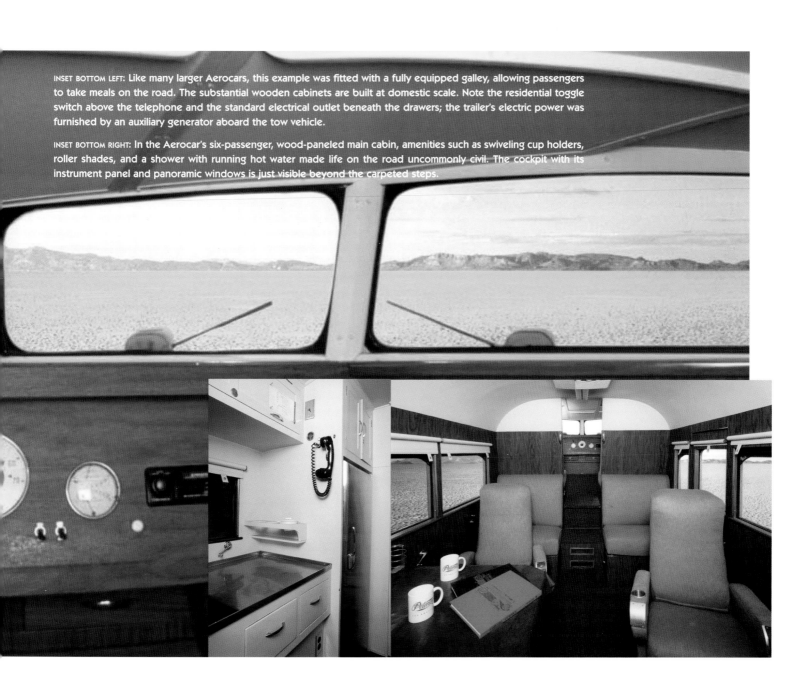

INSET BOTTOM LEFT: Like many larger Aerocars, this example was fitted with a fully equipped galley, allowing passengers to take meals on the road. The substantial wooden cabinets are built at domestic scale. Note the residential toggle switch above the telephone and the standard electrical outlet beneath the drawers; the trailer's electric power was furnished by an auxiliary generator aboard the tow vehicle.

INSET BOTTOM RIGHT: In the Aerocar's six-passenger, wood-paneled main cabin, amenities such as swiveling cup holders, roller shades, and a shower with running hot water made life on the road uncommonly civil. The cockpit with its instrument panel and panoramic windows is just visible beyond the carpeted steps.

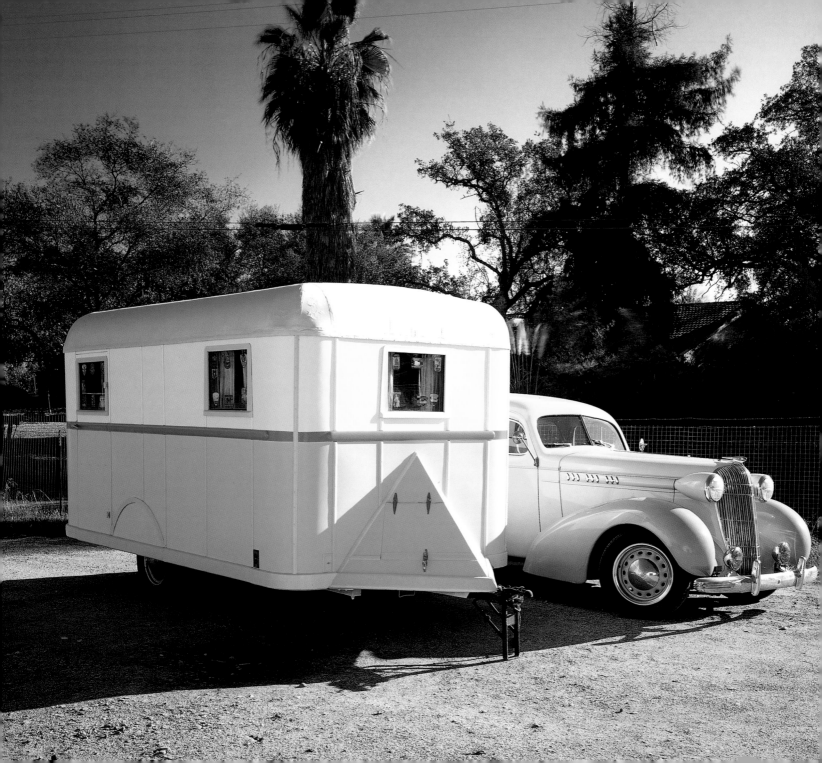

When Arthur Sherman completed his first trailer early in 1929, the result was little more than a white-painted Masonite box 6 feet wide, 9 feet long, and 5 feet high, with a slightly bowed top, square wheel cutouts, a door in the rear, and four tiny windows. Belying its homely appearance, however, the layout of Sherman's trailer was devilishly efficient. Immediately inside its rear-facing door was the "kitchen," consisting of a tall pantry cabinet with an icebox on the right and a gasoline cookstove on the left. Since the

folding bunks, the lower of which could accommodate an additional diner or two when folded down.

As Sherman and countless backyard builders well knew, a rectangular layout, like that of the sheepherder's ark and the Conestoga before it, made good use of space at minimal cost, and such trailers soon became standards of the growing trailer industry. By the mid-1930s, however, industrial designers were already favoring more curvaceous streamlined forms, giving rise to the canned-ham school of

lowing World War II, however, the bread loaf and canned-ham schools vied for dominance. Some manufacturers, such as Tulsa's Spartan Aircraft Company, fielded both types; during the early fifties, the firm's Spartan Manor and Spartan Mansion models took the form of elegantly styled bread loaves, while its concurrent Spartanette trailers had an elongated canned-ham profile. By the late 1950s, however, the ovoid shape of canned-ham models was no longer fashionable, and they, too, began tending toward blockier silhouettes.

4. Bread Loaves

interior was less than 5 feet high inside, Sherman designed the floor of the kitchen portion to drop to the ground when the trailer was parked, so that one could stand up while cooking.

Beyond the kitchen on either side were a pair of linoleum-topped benches with storage space beneath; a folding card table placed between them converted the area into a dining room. At the very front of the trailer were two

trailer design. Largely in response to this fashion, designers of conventional rectangular trailers softened their contours with the familiar rounded corners that gave this style its name.

After the sales bust of late 1937, booming wartime demand rescued the slumping trailer industry. Not surprisingly, the standardized committee trailer design of the war years, hobbled as it was by material restrictions, held to the more parsimonious bread loaf format. Fol-

The early 1960s saw the large bread loaf trailers of the previous decade expanded into full-fledged mobile homes, whose styling soon abandoned any suggestion of motion in favor of square, houselike forms. The tail end of the decade also brought wallowing, amenity-laden travel trailers with equally slab-sided styling. After forty years, Sherman's boxy beginnings had come full circle, though the Covered Wagon had long since been forgotten.

OPPOSITE: A number of trailers built from Hammer Blow plans still survive. This example dating from 1934 was built by a devoted groom for his bride-to-be's honeymoon. Many years later, it was purchased by a collector, complete with mementos from the couple's honeymoon trip as well as subsequent ones. The trailer's distinctive color scheme follows that of Hammer Blow's advertising illustrations. The tow car pictured is a 1936 Oldsmobile, built by a General Motors division once based in Lansing, Michigan.

This full-page advertisement for Covered Wagon trailers appeared in the March 27, 1937, issue of the *Saturday Evening Post*. It offered twenty-five first prizes consisting of a 1937 Ford sedan, a Covered Wagon trailer, and 1,000 gallons of Sinclair gasoline to the entries that best conveyed "Why I like Camay better than any other Beauty Soap." At the time, the Covered Wagon Company led the trailer industry, having pioneered the affordable solid-bodied bread loaf trailer. Yet just a half-year later, in the autumn of 1937, the erstwhile trailer phenomenon suddenly imploded, a victim of market saturation as well as its own improbable hype. Trailer manufacturers who had stockpiled materials in anticipation of a boom year suddenly saw their sales plummet. Among the hardest hit was Covered Wagon, which soon found itself saddled with a huge inventory of unsold trailers and components. Although wartime production eventually salvaged the trailer industry, Covered Wagon never recovered its earlier dominance. *Courtesy Wayne Fergusson Collection.*

"Start Right When You Build," declared the Hammer Blow Tool Company, a manufacturer of trailer components and accessories. To encourage people to buy its products, Hammer Blow offered inexpensive do-it-yourself plans during the midthirties. Thanks to their simple form, bread loaf trailers were a popular choice among do-it-yourselfers. *Courtesy Vince Martinico Collection.*

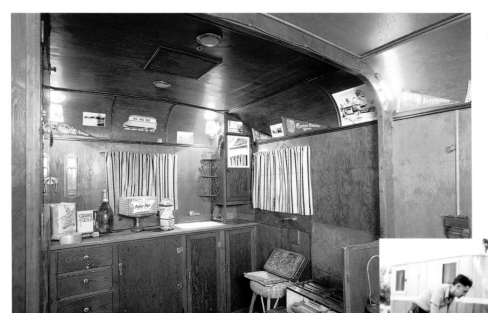

LEFT: The interior of the honeymoon trailer is almost entirely finished in varnished plywood, a favorite material for do-it-yourselfers. Most of the cabinetwork is blocky and straightforward—a distinct advantage of the bread loaf format.

BELOW: Trailering in the 1930s was not entirely carefree, as most popular automobiles were modestly powered and not well suited for towing. Moreover, the cotton-cord tires of the era were subject to frequent blowouts from the strain of overloading, making roadside repairs a frequent event. This photo of the honeymoon trailer was taken during one such unscheduled stop.

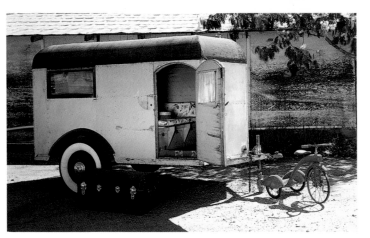

As many as three-quarters of the trailers on the road during the 1930s were homemade, some of them based on plans offered in magazines or by accessory manufacturers, others designed from scratch. The clean lines of this tidy 8-foot homemade trailer dating from 1932 suggest that it was probably built from plans. The interior included a bed, a heater, and a generous number of storage compartments, but no cooking stove or icebox.

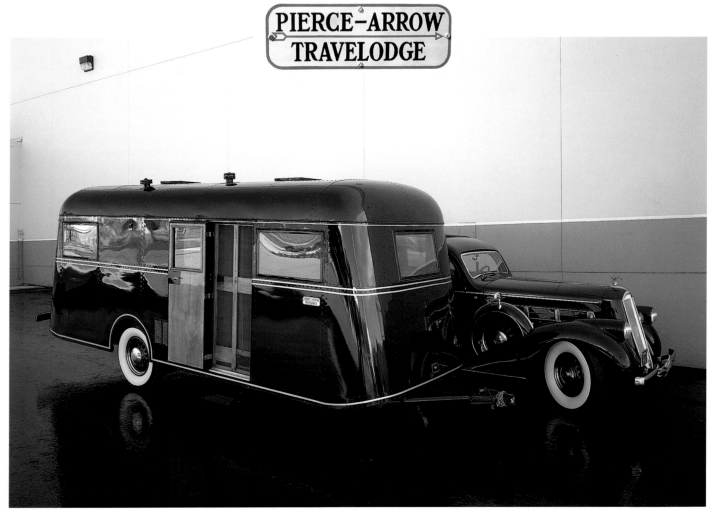

PIERCE-ARROW TRAVELODGE

The Great Depression spelled doom for many storied American firms, and among them was the Pierce-Arrow Motor Corporation, long one of the nation's premier builders of luxury cars. Pierce's automotive business was failing by the midthirties, just as trailer sales were booming. Accordingly, in late 1936, the firm made a last-ditch bid to shore up its income by introducing a luxurious camping trailer called the Travelodge. Pierce-Arrow's best engineering efforts went into these units. The trailer body was a rigid cage of welded channel steel sheathed in 18-gauge aluminum; independent suspension and Houdaille hydraulic shock absorbers were standard while Bendix vacuum-assisted hydraulic brakes could be had at a slight extra cost. Models A, B, and C, corresponding to lengths of 19 feet, 16 1/2 feet, and 13 feet 7 inches, were offered. Alas, only about 450 buyers materialized for these handsome units—far short of the number that might have saved the company. In 1938, Pierce-Arrow was declared insolvent, and its Buffalo factory was ordered liquidated.

Paired here are a 1936 Model A Travelodge and a 1937 Model 1702 V12-powered limousine, elegant legacies of Pierce-Arrow's eleventh hour.

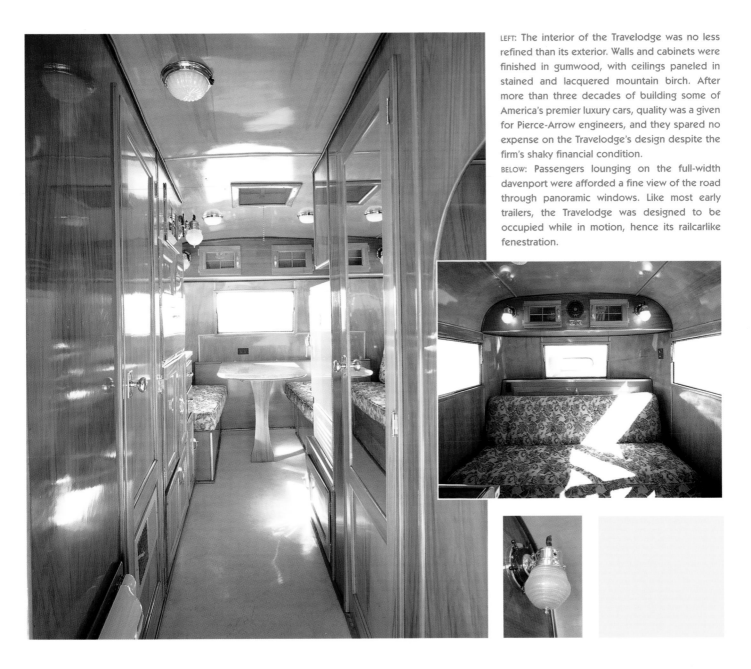

LEFT: The interior of the Travelodge was no less refined than its exterior. Walls and cabinets were finished in gumwood, with ceilings paneled in stained and lacquered mountain birch. After more than three decades of building some of America's premier luxury cars, quality was a given for Pierce-Arrow engineers, and they spared no expense on the Travelodge's design despite the firm's shaky financial condition.

BELOW: Passengers lounging on the full-width davenport were afforded a fine view of the road through panoramic windows. Like most early trailers, the Travelodge was designed to be occupied while in motion, hence its railcarlike fenestration.

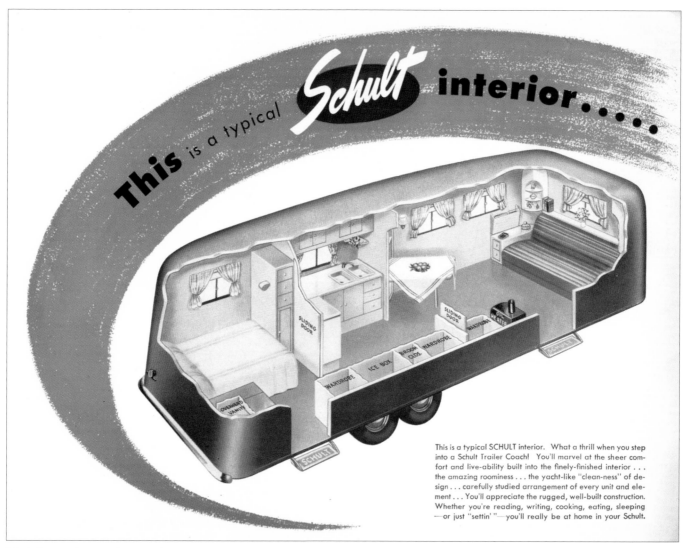

This is a typical *Schult* interior.....

This is a typical SCHULT interior. What a thrill when you step into a Schult Trailer Coach! You'll marvel at the sheer comfort and live-ability built into the finely-finished interior . . . the amazing roominess . . . the yacht-like "clean-ness" of design . . . carefully studied arrangement of every unit and element . . . You'll appreciate the rugged, well-built construction. Whether you're reading, writing, cooking, eating, sleeping —or just "settin' "—you'll really be at home in your Schult.

Schult Corporation, an Elkhart, Indiana, firm founded in 1934 by Walter O. Wells and former Covered Wagon dealer Wilbur J. Schult, became one of the leading trailer manufacturers of the postwar era. During World War II, Schult filled government orders for items such as mobile canteens, X-ray laboratories, and communications trailers, and provided prefabricated homes used for the Manhattan Project. As this advertisement dating from the late forties makes plain, Schult's designers subscribed to the boxy bread loaf school, a decision which stood the company in good stead when it eventually shifted its focus from travel trailers to mobile homes.

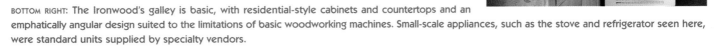

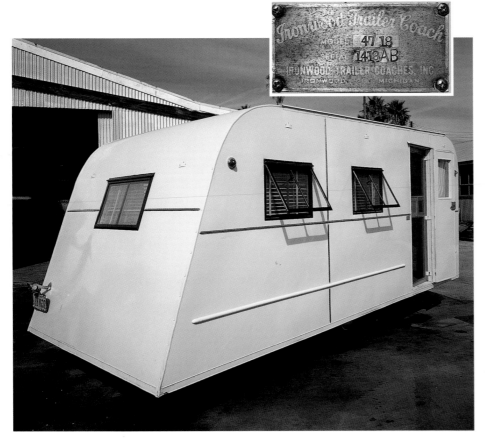

ABOVE: In contrast to the studied lines of the mass-produced Schult, the boxy design, Masonite finish, and arbitrarily applied moldings of this 1947 Ironwood bespeak the limited manufacturing sophistication of the smaller trailer builders. During the height of the trailer boom, hundreds of mom-and-pop firms existed in addition to about sixty major manufacturers. Though many vanished following the sales drought of the late 1930s, a new generation of trailer builders took their place during the prosperous postwar era.

TOP RIGHT: Like the galley, the Ironwood's sleeping area is pleasingly simple, containing little more than a reading lamp and a shelf. Before the days of sheet plastics, Masonite and plywood were the typical finishes used for trailer interiors; both could easily conform to simple curves like the ones seen here.

BOTTOM RIGHT: The Ironwood's galley is basic, with residential-style cabinets and countertops and an emphatically angular design suited to the limitations of basic woodworking machines. Small-scale appliances, such as the stove and refrigerator seen here, were standard units supplied by specialty vendors.

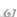

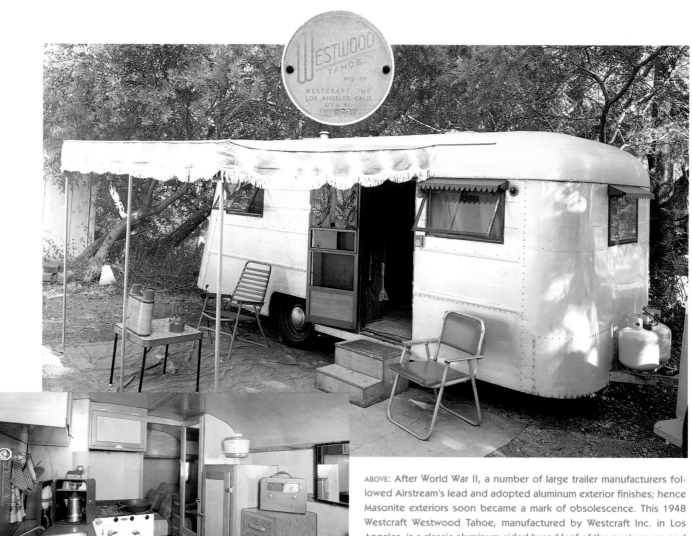

ABOVE: After World War II, a number of large trailer manufacturers followed Airstream's lead and adopted aluminum exterior finishes; hence Masonite exteriors soon became a mark of obsolescence. This 1948 Westcraft Westwood Tahoe, manufactured by Westcraft Inc. in Los Angeles, is a classic aluminum-sided bread loaf of the postwar era and remains in original condition.

LEFT: In contrast to its forward-looking aluminum skin, the Westcraft's glowing interior, with its old-fashioned panel doors and light-and-dark color scheme, remains a holdover from prewar design ideas. The arrival of laminated plastic finishes such as Formica in the 1940s soon added more color to trailer interiors; by the 1950s, brightly colored laminates were being applied to door panels as well as countertops.

ABOVE: While a number of postwar manufacturers adopted a more fashionable leaning-into-the-wind silhouette, New Hudson, Michigan-based Vagabond held to a conservative, bolt-upright design that has stood the test of time especially well. This 1950 Model 262 (signifying a 26-foot length and tandem axles) originally sold for between $3,500 and $5,000, depending on options. Vagabond was founded in 1931; today, the brand name survives as a division of American Recreational Vehicles.

INSET TOP RIGHT: The Vagabond's interior woodwork departs from the heavy recessed-panel doors seen in earlier trailers, taking a small step toward the more smoothly integrated cabinetry that would typify trailers of the 1950s.

BOTTOM RIGHT: A crosswise davenport occupying the forward end has long been a staple of trailer interiors. Following a few years of experimentation during the 1930s, interior arrangements soon settled into a fairly standard format. The "living room," whose status was signaled by the davenport, was placed at the forward end, with a main entrance door opening out to the right side; the galley came next, while the sleeping area occupied the aft end. Following World War II, there was little tampering with this well-tested scheme, and it continues down to the present, both in travel trailers and in the basic layout of manufactured homes.

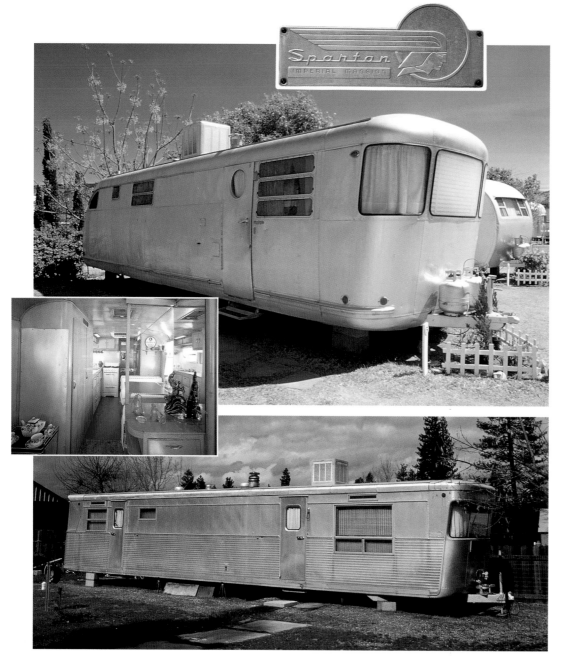

LEFT: A firm with vast experience in forming aluminum, Spartan Aircraft Company of Tulsa entered the trailer business after World War II, emphatically stressing its "All-Aluminum Trailer Coaches." Aluminum's ability to assume compound curves, so indispensible to aircraft design, also endeared it to stylists who longed for more streamlined shapes. This 1950 Spartan Mansion, photographed at Shady Dell RV Park in Bisbee, Arizona, exhibits Spartan's trademark leaning-into-the-wind profile and wraparound front windows.

INSET: However oxymoronic its model name, the Spartan Mansion's interior left little to be desired; its spaciousness, furniture-like cabinetry, and exceptional workmanship ranked it among the most luxurious trailers of the era.

BELOW: This Spartan Manor, big brother to the Spartan Mansion, illustrates the enormous size which so-called travel trailers had reached by the early fifties. Despite the fact that most large trailers were purchased, parked, and seldom moved again, the trailer industry remained loathe to admit that its products were used for full-time living. The charade of marketing 20-plus-foot trailers as recreational vehicles continued until the advent of the Tenwide, a trailer inarguably intended for year-round living, since it could not be transported without a special permit.

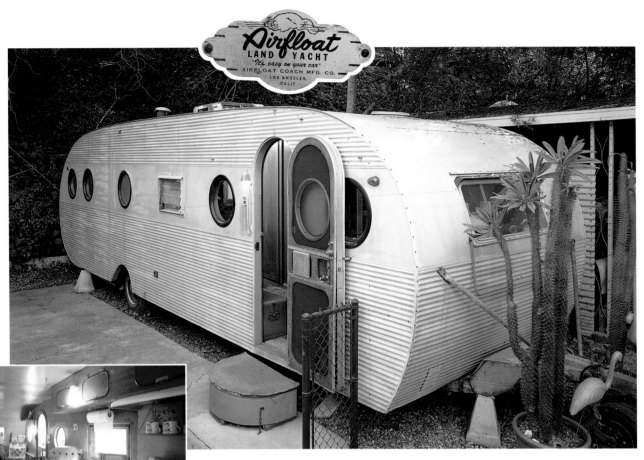

The distinction between bread loaves and canned hams is far from exacting, and the 1955 Airfloat Land Yacht (no relation to the Curtiss Aerocar) could arguably fit either category. While its rounded ends and streamlined shape qualify it for canned-ham status, its length is more typical of a bread loaf, hence its inclusion here. Porthole windows, a round-topped door, and a distinctive combination of corrugated and smooth siding further distinguish this unusual trailer built by the Los Angeles-based Airfloat Coach Manufacturing Company. Also of note is the Airfloat's towing hitch, which features an accessory known as a Slimpwheel Coupler after its maker, Slimp Axle Products of Colton, California. Slimpwheels were fitted to some large trailers during the midfifties to help reduce tongue load on the tow vehicle; however, frequent bearing problems soon discouraged their use. Also problematic on this particular Airfloat design were the struts bracing the tongue to the trailer body, which placed a considerable strain on the structure during transport.

INSET: A full-scale compact gas stove was only one of the amenites found in the Airfloat's spacious interior. The layout follows the postwar standard, with a crosswise davenport at the fore end, a galley, and sleeping quarters aft. Note the unique round-cornered storage hatches above the counter, a clever thematic link to the trailer's porthole windows.

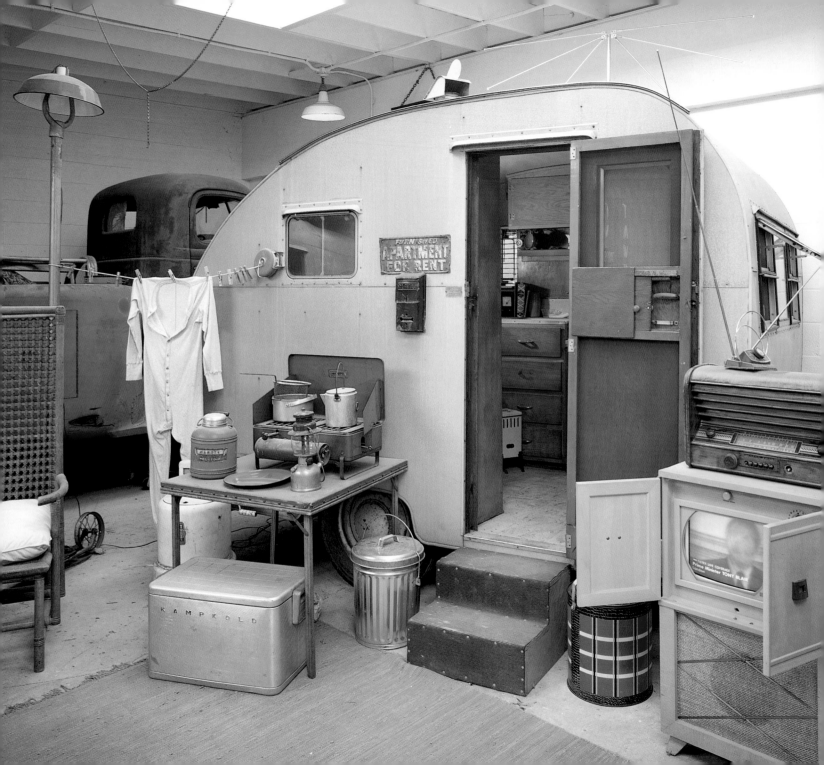

The most obvious form for early travel trailers was, of course, a box. Maintaining a rectangular floor plan and flat sides, with perhaps a slightly bowed roof to shed water, made for simple construction using ordinary materials and methods, and also maximized interior volume using the conventional cabinets and fittings then available. The earliest travel trailers, such as the English caravans built by Eccles in 1919 and by Bertram Hutchings in 1920, resembled a notched box, narrow between the wheels and wider above them, with

of the box format; his Aerocar Land Yacht was considerably sleeker than its contemporaries, partly as a natural consequence of the prowlike projection required by the fifth-wheel hitch, but just as probably because Curtiss's aircraft experience reflexively compelled him to design aerodynamic forms.

By the late twenties, the benefits of streamlining on aircraft performance were already well known. Hence, wood-and-canvas construction soon yielded to all-metal airframes of duralumin, a high-strength aluminum alloy that

profiles or other shapes having planar curves. By this time, the canned-ham form had already appeared in do-it-yourself plans in the United States, including those published by Wally Byam prior to his Airstream days. Commercially built units soon followed. However, despite their ovoid profiles, these trailers retained the flat sides of their predecessors—hence the ham can analogy. Flat sides were a nod to practicality for both do-it-yourselfers and commercial builders: While producing single-curved profiles in wood was a relatively simple

5. Canned Hams

the whole tottering contraption rather precariously balanced on a single axle. In the United States, Arthur Sherman's first Covered Wagon followed this prototype, except that the wheels were recessed into a full-width body.

As practical as a box shape was for construction, however, it was neither exciting to look at nor aerodynamically efficient when in motion. Aircraft pioneer Glenn Curtiss was one of the first trailer builders to begin breaking out

could be easily formed into the compound curves that true streamlined forms demanded. The Junkers J-4 fighter of 1917 was the first all-metal plane of duralumin, and thereafter the adoption of streamlined metal airframes continued at a slow but steady pace.

The streamlining bug bit the trailer industry in the early 1930s, when British caravan builders such as Bertram Hutchings and Angela abandoned rectangular forms in favor of ovoid

matter, creating true compound curves fairly demanded the use of metal, along with considerable fabricating skill.

Mounting cabinets and fittings in canned-ham interiors was almost as difficult as it was in true compound-curved streamliners such as the Bowlus-Teller, Airstream, Curtis Wright, and Silver Streak. Manufacturers devised a number of strategies to minimize wasted space: The front of the trailer might contain built-in seat-

OPPOSITE: **The 1947 Aljoa Sportsman, photographed in the Ventura, California, warehouse of trailer collector Steven Butcher, was a typical postwar canned ham, with an unpainted aluminum skin, aluminum-framed windows, and a modest size. The trailer was built by the Modernistic Manufacturing Company of Los Angeles, which also marketed both ready-made and do-it-yourself teardrop trailers.**

ing, mitigating the decreased headroom in that area, while the beds occupied the rear portion, where reduced headroom was again of little consequence.

Despite the pervasive clamor for streamlining, however, not all trailer manufacturers adopted the canned-ham shape. Covered Wagon, Palace, and Schult, among the larger firms, all retained variations on the bread loaf format, perhaps modified by a modest prow at the front or a slight taper at the rear. Others, such as Trotwood and Spartan, fielded both types. As the fifties wore on, however, the distinction became moot, as canned-ham profiles grew ever flatter and more oblong. The era of bulbous styling had passed, and trailers with rounded profiles suddenly looked dated compared to larger, more angular models sporting "action lines" and two-tone paint jobs. Moreover, the industry's increasing focus on mobile homes soon ensured that flat surfaces and sharp corners would dominate trailer styling for the remainder of the century.

Yellowstone Mobile Homes

Fine Construction Detail!

The dependability of the YELLOWSTONE TRAVELER is the result of many years of experience in building quality mobile homes. Where others fail, YELLOWSTONES can take it. You can always depend on "OLD FAITHFUL."

FRENCH'S TRAILER SALES
CONWAY, NEW HAMPSHIRE
TELEPHONE 169

TOPS FOR TRAVELING

The Wakarusa, Indiana-based Yellowstone Coach Company advertised its Yellowstone Traveler as a "mobile home," a term that was initially used to describe travel trailers of both the bread loaf and canned-ham schools. To satisfy the needs of year-round trailer dwellers, bread loaves continued to grow in length; canned hams, by contrast, usually remained compact enough to actually travel with. This 1950 advertisement for the 18-foot Yellowstone carried the slogan "Tops for Traveling"; unlike advertising for bread loaves, it stressed the trailer's roadworthiness rather than its size.

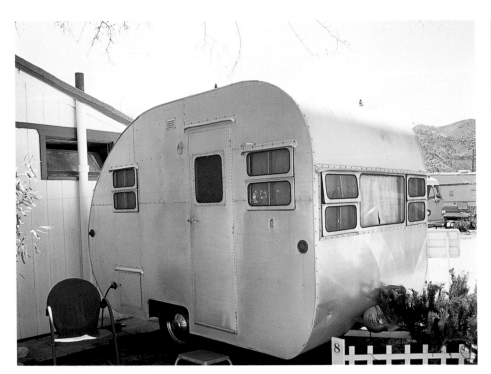

LEFT: The difference between a well-built home-made trailer and one built by a mom-and-pop outfit was often barely perceptible. This 12-foot trailer, whose finish compares favorably with that of the Aljoa Sportsman, is in fact a home-built model based on plans published in *Popular Mechanics* magazine; only a nameplate is lacking. Little wonder, then, that Arthur Sherman, Wally Byam, and other onetime amateurs could be successful in the trailer-building business.

BELOW: The interior of the *Popular Mechanics* home-built, seen here in a panoramic photograph, is carried out with equal aplomb. Handsome woodwork—note the sink cabinet with its radiused corner—easily matches the workmanship found in most factory-built trailers.

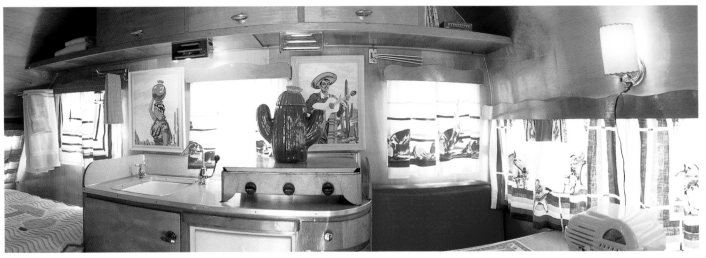

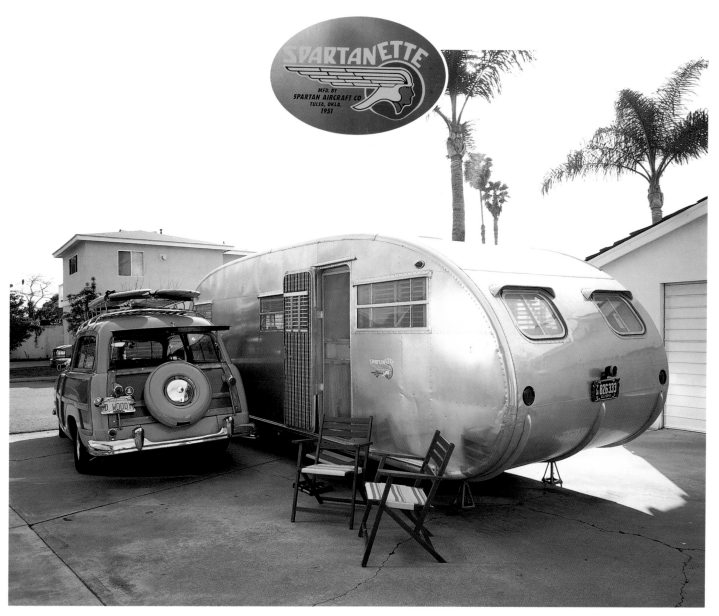

The Spartan Aircraft Company, known for its luxurious series of bread loaves, also marketed canned-ham models during the early fifties. Spartan's background in aircraft production gave the firm fabricating expertise well beyond most of its competitors, as amply evidenced by the sweeping curves of this 1951 Spartanette restored by Craig Dorsey of Vintage Vacations.

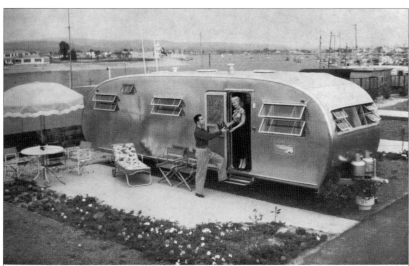

SPARTANETTE TANDEM

The Spartan Home *completely equipped* — Look for it at your Dealer's Display Today — finely furnished Interiors and well-designed Floor-Plans

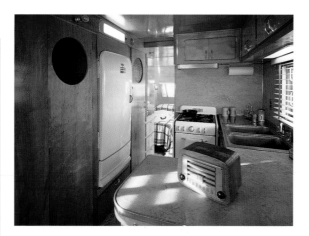

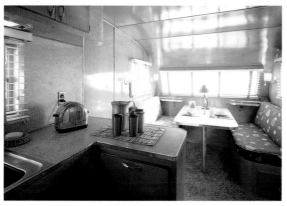

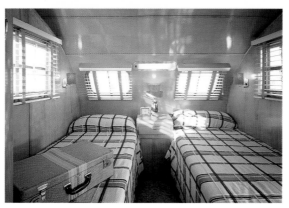

ABOVE: The 1953 Spartanette Tandem, seen here in a sales brochure entitled "Spartan Homes Today," is an aluminum-skinned canned ham whose shape has been considerably stretched to provide a larger interior. The design of very large trailers with elliptical profiles persisted through the midfifties, but by the end of the decade, the superior economy and space utilization of the bread loaf format won out. Thereafter, travel trailers and dwelling trailers alike took on more rectangular profiles.

TOP RIGHT: An unusually spacious galley distinguishes the Spartanette's interior. Note the metal-edged, laminated plastic countertop, a design that rapidly gained popularity both in homes and in trailers during the postwar era. The radiused corner of the countertop and the portholes in the wardrobe doors continue the trailer's curvaceous styling theme.

MIDDLE RIGHT: The projecting galley peninsula and the dining booth beyond were both popular architectural features of the early 1950s, and were widely adapted to trailer floor plans.

BOTTOM RIGHT: The converging ceiling resulting from the Spartanette's canned-ham shape gives the booth an unusually cozy atmosphere; no bread loaf could match the dramatically arched roof planes of the Spartanette's wood-paneled bedroom. Just above the head of each bed, windows set in the sloping ceiling afforded retiring occupants a fine view of the stars.

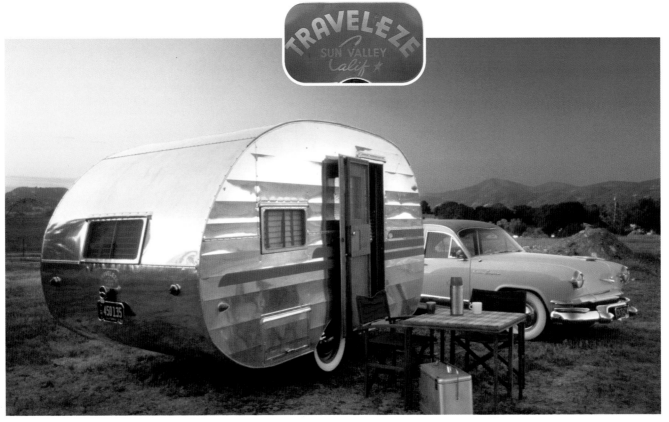

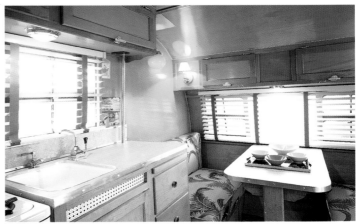

ABOVE: A canned ham of unmatched elegance, this 1954 Traveleze features boldly fluted side panels that provide a visual foil to the smoothly curved panels that wrap the trailer from front to rear. In addition to adding visual interest, fluting or corrugation increased the rigidity of flat panels, allowing builders to use a thinner gauge of metal and thus reduce the trailer's weight. Corrugation was less critical on curved panels, whose shape was inherently stiffer.

The low-slung tow car in the background is a 1953 Kaiser Dragon, manufactured at Willow Run, Michigan, by the Kaiser-Frazer Corporation. The trailer was restored by Craig Dorsey of Vintage Vacations.

RIGHT: The popular dining booth reappears in the interior of the Traveleze, its tabletop matching the cheerful yellow laminated plastic countertop. The design of the cabinetwork remains conservative; a few years hence, however, the influence of modern art would bring considerably more color to trailer interiors.

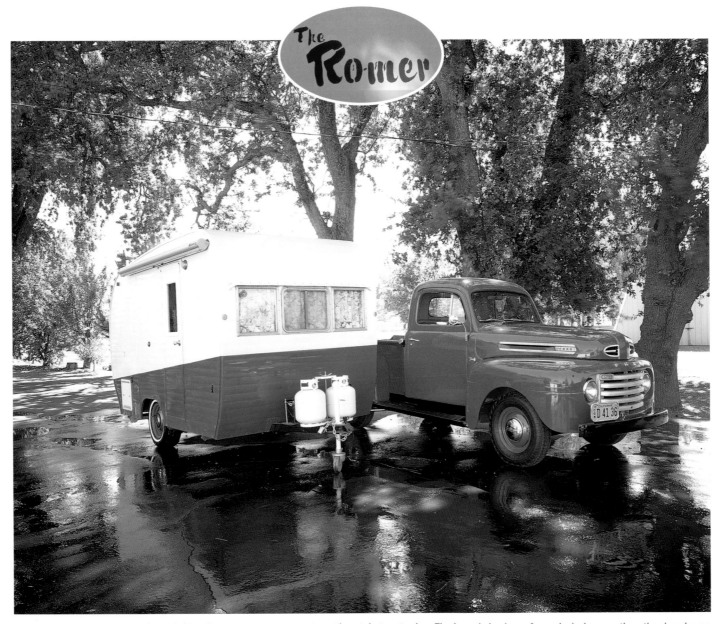

The 1956 Romer made a fashionable if rudimentary attempt at automotive-style two-toning. The broad aluminum-framed window, on the other hand, was borrowed from contemporary ranch house architecture. The tow vehicle pictured is a 1950 Ford pickup.

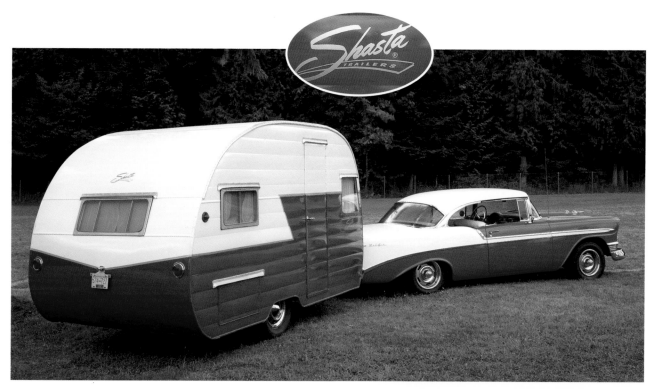

ABOVE: A more rakish two-toning scheme enlivens this 15-foot 1957 Shasta. The zigzag action line on the trailer's corrugated sides gamely emulates the tail fins that were all the rage in automotive designs of the mid- to late 1950s; the V motif at the rear was yet another favorite styling theme of the era. The tow car is a 1956 Chevrolet Bel Air, one of the best-selling cars of the decade.

RIGHT: Following a quarter century of subdued, wood-toned interiors, strident colors finally found their way into trailers during the mid-1950s, influenced by the mainstream arrival of modern art. Meanwhile, cabinetwork emulated the contemporary trends found in homes. The postwar era saw the rise of the ubiquitous California Rancher, a home style featuring simple lines and rustic materials such as brick, stained wood, wrought iron, and copper. However, entirely new materials also appeared in Ranchers; among them were laminated plastic countertops sold under brand names such as Micarta and Formica, which offered a virtually infinite range of pattern and color possibilities. The Shasta's interior features splashes of bright yellow in the laminated plastic center panels of the overhead storage cabinets, as well as in the upholstery of the dining booth. The wig-wag pattern surrounding the panels was another popular Rancher motif of the late fifties.

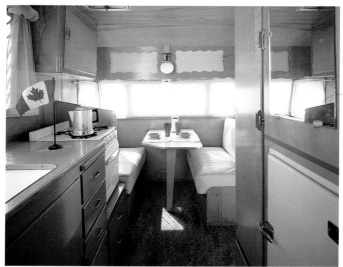

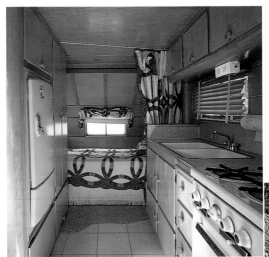

LEFT: The Jewel's interior features a stove and refrigerator in the popular sea foam color of the mid-fifties. The green theme is continued in the laminated plastic kitchen counter and backsplash.

BELOW: The oblong profile of this 1956 Jewel illustrates the gradual trend of canned hams toward more rectangular silhouettes. Ease of production and better use of space both argued strongly for straight lines over curved ones, making today's boxy shapes a foregone conclusion. The Jewel retained the handsomely embossed aluminum sides typical of early 1950s trailers at a time when some competitors were already adopting two-tone color schemes in keeping with automotive fashions.

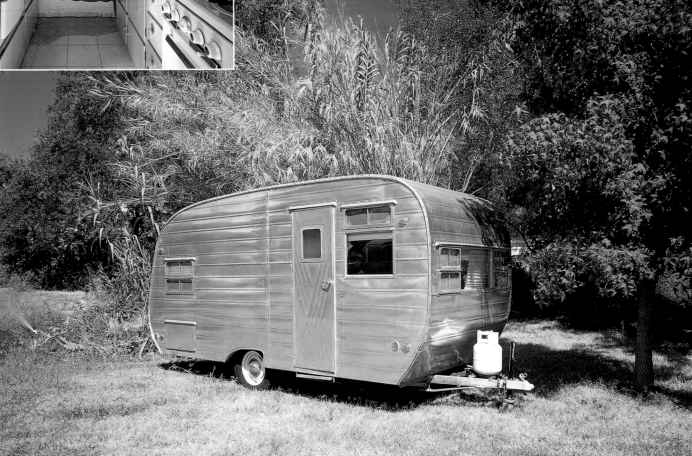

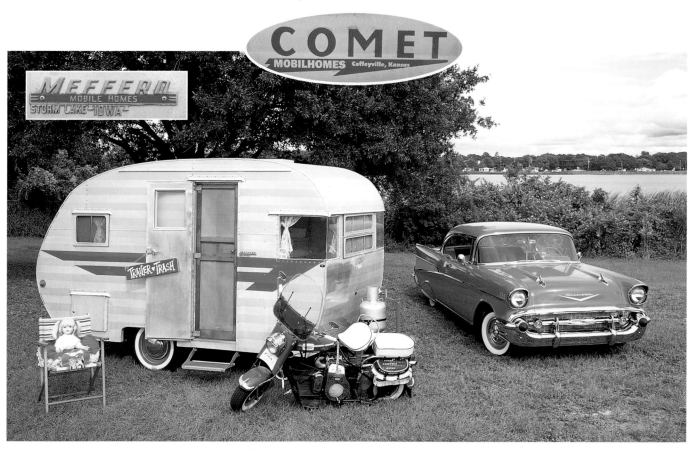

ABOVE: While trailer interiors of the late 1950s generally followed domestic trends, exterior styling was heavily influenced by the era's flamboyant automotive designs. Integrated two-tone paint schemes first appeared on cars during the early fifties; by 1955, virtually every make offered two-tone or even three-tone paint jobs, usually defined by some form of rakish side trim. Wraparound windshields and backlights had also been widely adopted by 1955, and quickly became an emblem of automotive modernity. Trailer manufacturers did their best to echo such features after their own fashion: This 1957 Comet trailer, with its glass-cornered wraparound windshield and two-toned action lines, echoes the classic styling of the 1957 Chevrolet Bel Air tow car beyond.

RIGHT: Even more vibrant interior colors arrived in the late 1950s, paralleling the fashion for vividly colored automobiles. The Comet features vinyl banquettes color keyed to the laminated plastic panels in the cabinet doors, while the drainboard uses a contrasting plastic laminate material edged in bright metal as was customary until the early 1960s. The checkered floor and stove cover are modern additions made by the owner.

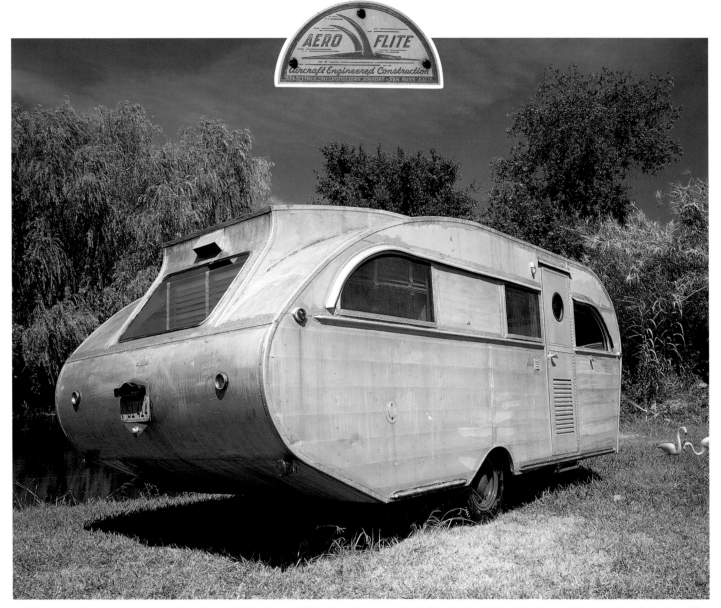

Built by Aero Lines at the Metropolitan Airport in Van Nuys, California, and appropriately flaunting its "Aircraft Engineered Construction," the Aero Flite endearingly bucked almost every trailer styling trend of the late 1950s. This model shunned the painted action lines and two-toning then in vogue; instead, its radically streamlined profile retained a bright aluminum finish set off by a highly original hood over the rear window.

The two-toned exterior paint scheme on the 1958 Arrowhead appropriated the popular V motif of the fifties and turned it on edge to flank each side of the forward window. Also evident is the squarer silhouette that would become increasingly apparent by the early 1960s. The trailer was photographed at Clear Lake, California.

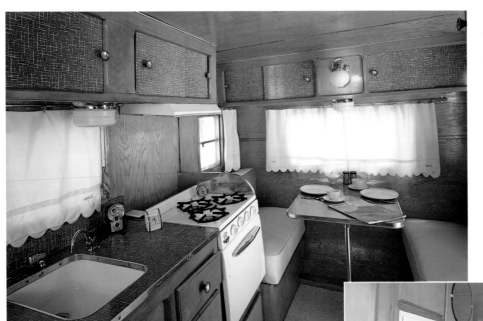

LEFT: Laminated plastic appears once again in the Arrowhead's interior; the popular residential pattern is featured in the metal-edged counter-top and is very effectively repeated in the center panels of the cabinet doors. The natural finish of the cabinets is also in keeping with contemporary ranch house ideals. A tidy three-burner range and a booth worthy of a drive-in diner—also finished in laminated plastic—complete the evocative period decor.

BELOW: In the Arrowhead's galley, cabinets of lauan mahogany, ubiquitous in California ranchers, are paired with the concave copper-finished pulls of the era. A comparison of this trailer's flooring to that of the 1957 Shasta suggests that sheet vinyl had finally supplanted the old-fashioned linoleum previously used.

LEFT: Based in Bellflower, California, Oasis Sales Incorporated was a popular trailer manufacturer of the early 1960s. This advertisement for the Oasis Seventeen and One Half shows a very square-lined canned ham indeed: By the early 1960s, rounded corners were considered embarrassingly behind the times.

BELOW: The interior layout of the Oasis bears an uncanny resemblance to that of the Arrowhead; natural cabinet finishes are once again evident, as are metal-edged laminated plastic tops. Here, however, the refrigerator is placed between the sink and the range, creating an ultracompact galley whose major work areas are all within arm's reach.

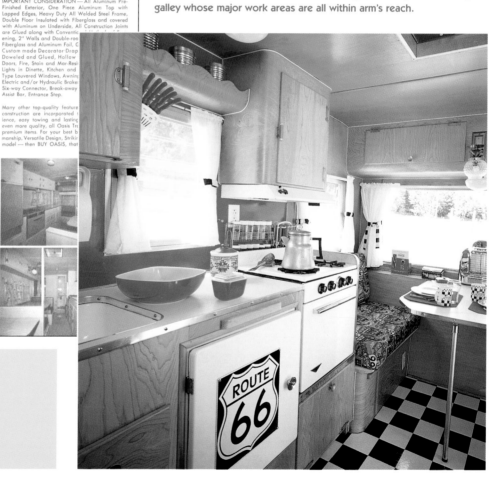

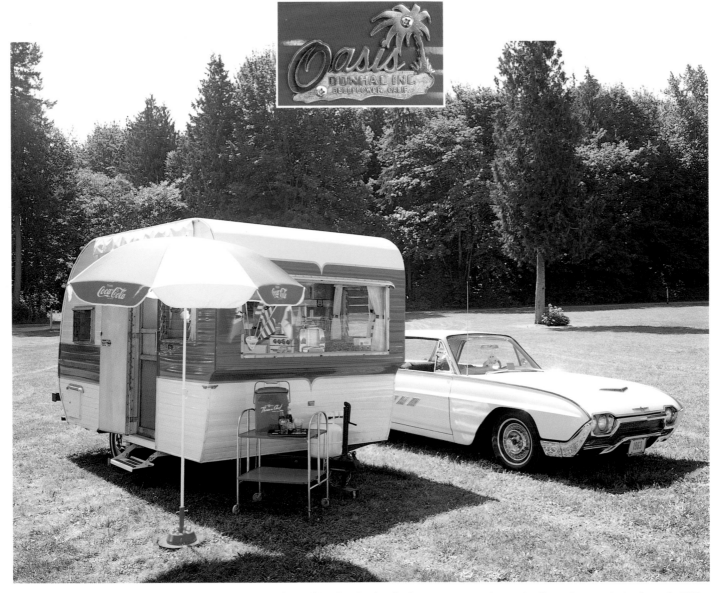

The 1961 Oasis still boasted vibrant red-and-white two-toning, evidencing the time lag between automotive- and trailer-styling trends; by the early 1960s, Detroit had already abandoned two-toning in favor of monochromatic color schemes. Contemporary architectural fashions are once again reflected in the unusually large front window, as well as in the jalousie-type windows on the sides of the unit. The formidable tow car beyond is a V8-powered 1961 Ford Thunderbird, which only six years earlier had been introduced as a two-seat sports car.

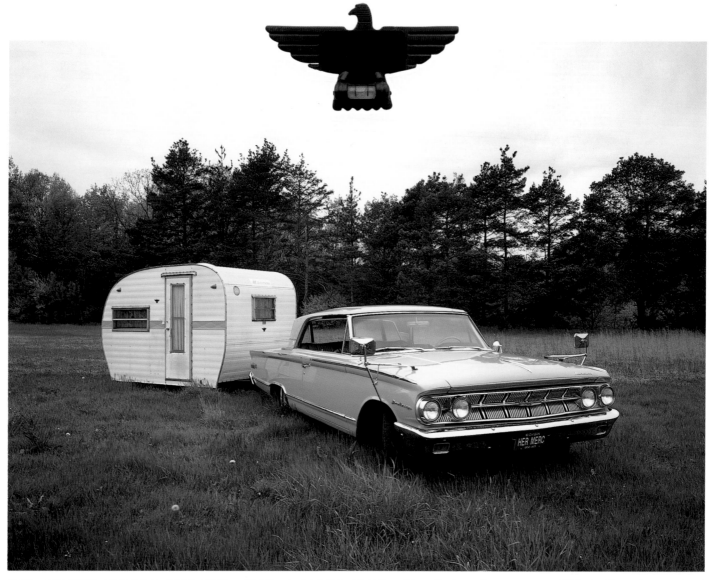

By the early 1960s, canned hams had inevitably evolved away from their original ovoid profile toward a more space-efficient oblong shape, a trend spurred by the more angular forms already evident in automobiles of the era. Ultimately, for reasons of economy rather than style, the bread loaf and canned-ham schools of design merged into the rather lackluster slab-sided forms that now dominate trailer design. This 1963 Fleetwing is a late holdover from canned-ham silhouettes of the past; its curved-fore-and-aft pattern contrasts notably with the crisp lines of the Mercury Monterey built the same year.

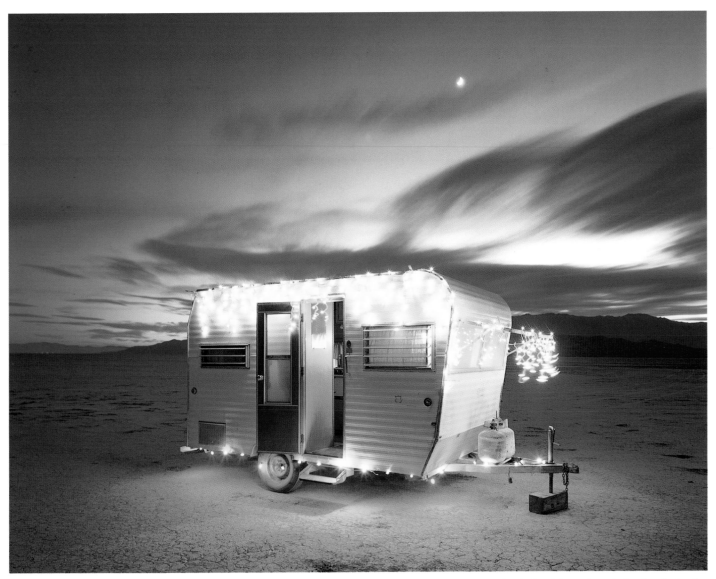

The angular Kit Companion, dating from 1966, represents the twilight of the canned-ham school. By the mid-1960s, right angles ruled trailer design for both aesthetic and economic reasons. Thereafter, only specialty trailers such as the Airstream and its imitators would retain the curving shapes they inherited from the streamline era. Their story follows.

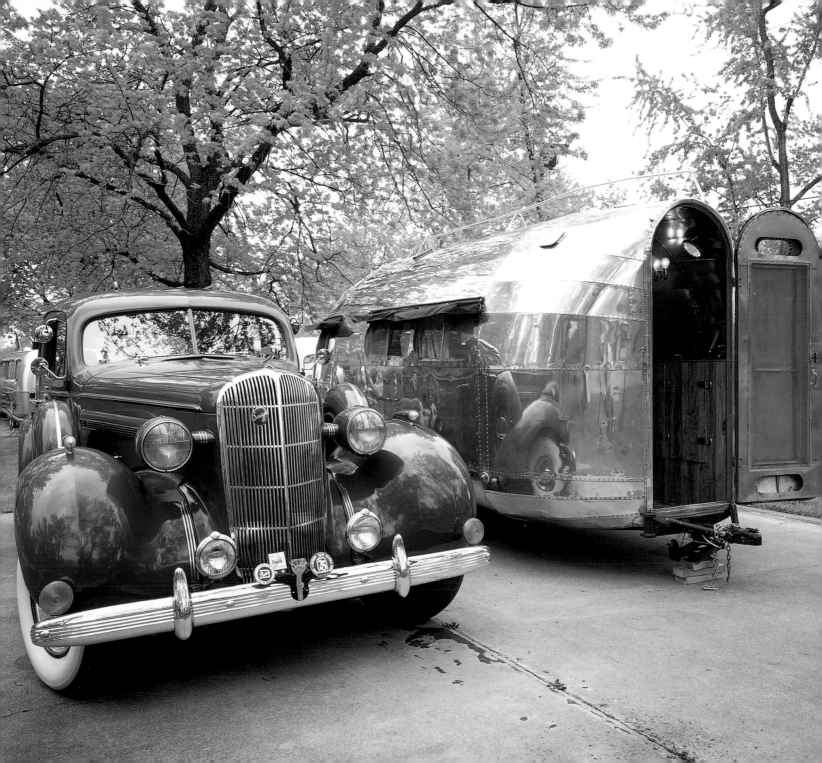

While canned hams paid superficial homage to streamlining, aircraft technology figured much more directly in the metal-skinned, fuselage-bodied trailers that first appeared in the mid-1930s. The man central to their early development was William Hawley Bowlus, an Illinois native who was building full-sized gliders by his midtwenties. Bowlus served as an aircraft mechanic in the U.S. Army Air Service during the Great War, received flight training in Venice, California, and thereafter worked as an aircraft mechanic in

design to a new world record for soaring. The following year, he designed and built the first of his renowned Albatross sailplanes, and over the next few years piloted these "paper wings" to new world records for distance and altitude.

During the course of his test flights in the California desert, Bowlus decided to construct a trailer as a temporary portable shelter from the searing heat. Shunning the clumsy cottage-on-wheels arrangement typical of the era, he instead devised a fuselage-like body with ra-

business, textile magnate William DuPont. Commercially built by the Bowlus-Teller Manufacturing Company in San Fernando, California, the trailer was sheathed in a riveted skin of duralumin, a high strength alloy one-third the weight of steel. The resulting monocoque structure weighed a scant 1,100 pounds in the 18-foot Road Chief configuration—far less than any contemporary trailer. The smaller Motor Chief and Papoose models were lighter yet.

Despite the breadth and ingenuity of this

6. Hawley and Wally

England and France for two years.

After a stint flying for the first regularly scheduled commercial airline in the United States, Bowlus was hired as shop foreman at Ryan Airlines, a San Diego aircraft manufacturer. There, in 1927, he supervised construction of the *Spirit of St. Louis*, a Ryan monoplane being custom-built for Charles A. Lindbergh's upcoming attempt to fly the Atlantic solo.

In 1929, Bowlus flew a glider of his own

dial wooden ribs springing from a longitudinal backbone integrated with the axle and hitch. A canvas skin was stretched over the whole skeletal structure, resulting in a strong yet remarkably light design.

Bowlus began commercial production based on this prototype in the mid-1930s, making good use of both his access to advanced aircraft design facilities and the formidable assets of his partner in the sailplane

lineup, however, only about 140 Bowlus-Tellers were built, of which perhaps 20 survive. In an era when a standard Ford or Chevrolet could be purchased for less than $600, the least expensive Bowlus-Teller trailer cost $1,050. Buyer resistance to such pricing, combined with the extravagant marketing done by Bowlus's partner, Jacob Teller, helped bankrupt the company by 1936.

Enter one of the trailer industry's legendary

OPPOSITE: A 1936 Bowlus Road Chief, paired with a 1936 Buick Roadmaster tow car, shows the unusual entrance door mounted above the trailer tongue; the galley is just visible within. The unconventional entrance location allowed Bowlus to provide a taller opening and also avoided the complication of placing a door in the trailer's rounded sides. The vehicles were photographed at Camp Dearborn, Michigan.

characters, Wallace "Wally" Byam. A 1923 Stanford Law School graduate, Byam switched careers to journalism, moved on to write advertising copy for the *Los Angeles Times*, and finally began publishing a do-it-yourself guide to woodworking. After a contributor's piece on building a homemade travel trailer drew a host of reader complaints, Byam designed and built his own version. Like Arthur Sherman before him, he quickly found willing buyers. After his plans appeared in *Popular Mechanics* during the late twenties, Byam found himself in the business of building custom trailers.

Byam's early trailer designs were of the English caravan-influenced canned-ham school, with flat sides, a curved front and rear, and a slight upward arc to the roofline. Byam also became a dealer for Bowlus-Teller trailers during the midthirties and advised Bowlus on marketing strategy, if none too successfully. Following Bowlus-Teller's bankruptcy, Byam purchased some of the firm's equipment, as well as lured a number of former Bowlus-Teller workers into his employ. When Byam finally inquired if Bowlus would mind his taking over the trailer's production, the beleaguered Bowlus replied, "I neither mind, nor is there anything I can do about it."

By year's end, virtually the same shiny duralumin trailers that had sold as Bowlus-Tellers in early 1936 were now fitted with nameplates reading AIRSTREAM. In addition to coining the Airstream name, which was meant to suggest effortless motion, Byam subtly modified Bowlus's design, relocating the door from its awkward position over the hitch to the side of

This Airstream emblem was the result of a publicity stunt demonstrating that Airstreams were were light enough to be pulled by a bicycle.

the trailer. It was the first instance of what would become Airstream's longstanding policy of evolutionary refinement.

While Airstream represented the leading edge in lightweight, aerodynamic trailer design, it was not immune to the catastrophic slump that hit the trailer industry in late 1937. Byam was bankrupt by 1938, and thereafter took a job with the San Diego-based aircraft manufacturer Curtiss-Wright. Characteristically,

though, by war's end he was busily selling Curtiss-Wright on the idea of devoting some of its peacetime-idled plant facilities to manufacturing lightweight trailers under his direction. He succeeded, and in 1946 the aircraft giant began marketing a line of Byam-designed, Airstream-like trailers under the curious variant brand name "Curtis Wright."

Yet the iconoclastic Byam was soon chafing under the corporation's bureaucratic strictures, and he left on less-than-friendly terms the following year. Curtiss-Wright continued to manufacture Byam's Airstream look-alikes until 1949, when it sold its trailer division to three investors who changed the trailer's brand name to Silver Streak, and for some years afterward ironically furnished Byam with competition of his own design.

As for Wally Byam, he had already reopened for business as Airstream Trailers, Incorporated in 1948, working from a modest building in Van Nuys, California. By 1952, he had expanded into the East Coast market, opening a plant in Jackson Center, Ohio. Today, more than four decades after his death in 1962, Byam's basic Airstream design continues to roll off the Jackson Center production lines, still widely regarded as the Rolls-Royce of trailers, and still inspiring imitations.

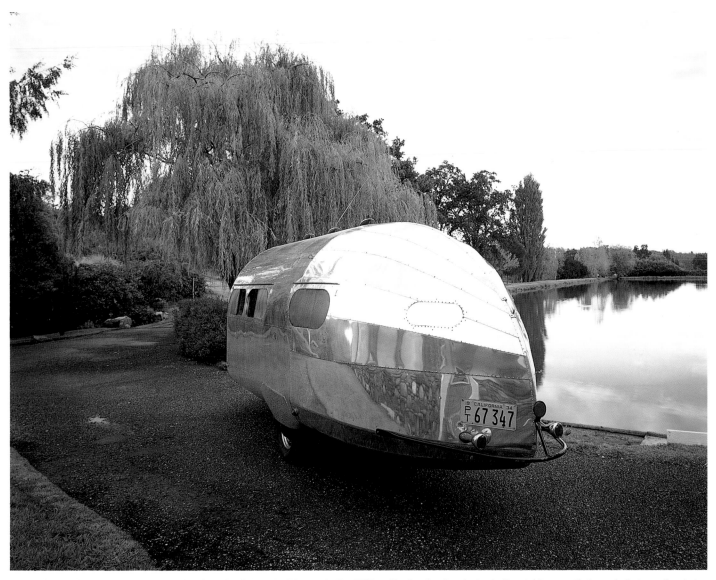

The 1934 Bowlus Road Chief, the brainchild of sailplane builder and pilot William Hawley Bowlus, is the indisputable grandfather of all streamlined aluminum trailers. Bowlus's pioneering design used a ribbed, aircraft-style fuselage sheathed in ultralight duralumin, an aluminum alloy one-third the weight of steel. Hence, belying its armored appearance, the 18-foot 3-inch Road Chief weighs a scant 1,100 pounds.

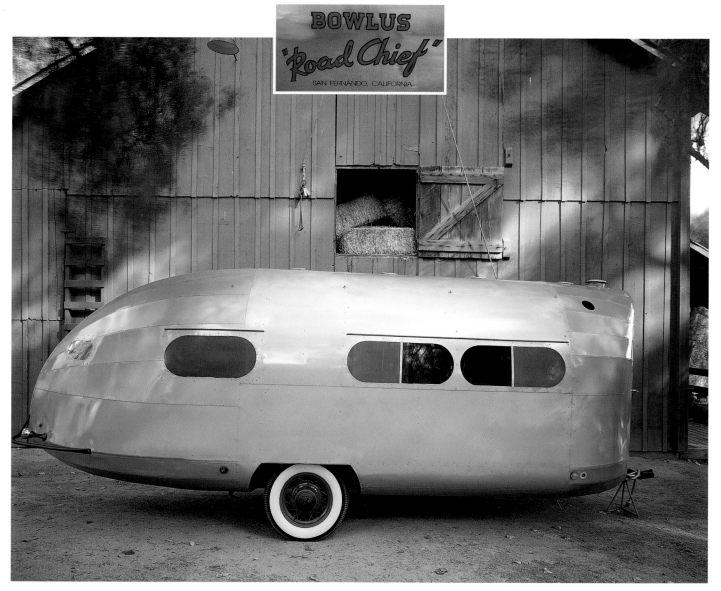

The dramatic zeppelin shape of the Road Chief's aft end, a reflection of its fuselage-style construction, ranks it among the most recognizable trailers ever built. The windows occur in the intervals between the structural ribs, much as they do in an airplane; the entrance door is placed in the blunt forward end, above the tongue. Only 140 or so Bowlus trailers were built by the Bowlus-Teller Company, of which about 20 are known to survive. This example has been completely restored, although it features a more easily maintained painted exterior finish in lieu of the original polished duralumin.

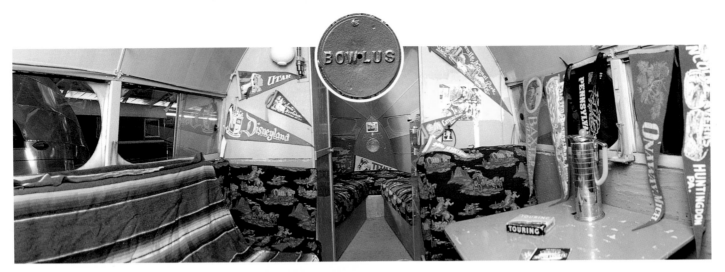

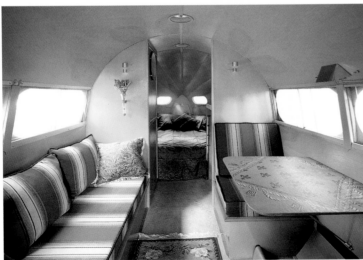

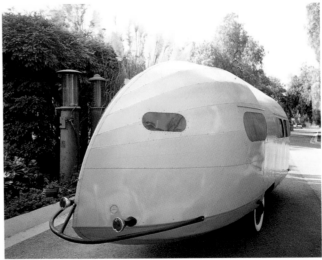

CLOCKWISE FROM TOP LEFT: Bowlus's prototype design grew out of his need for a portable shelter during sailplane test flights in the California desert; hence, the Road Chief's interior was functional, but not especially spacious. The slender, aircraft-style fuselage ribs can be glimpsed between the trailer's capsule-shaped windows; the Road Chief's lovingly restored interior, austerely paneled in a honey-toned birch, conveys the basic simplicity of Bowlus's conception. The lounge area in the foreground occupies the central portion of the trailer, with the sleeping area tucked into the pointed aft end. A tiny galley, not visible here, flanks the front-mounted entrance door. The diminutive Art Deco–flavored lighting fixtures reflect the architectural fashion of the era; another view of the Road Chief's otherworldly aft end reveals the two tiny capsule-shaped portholes that light the sleeping area; the taillight assemblies are standard automotive accessories of the mid-1930s. The bumper on this example is painted tubular steel. The trailer was photographed at Rancho Los Alamitos, California.

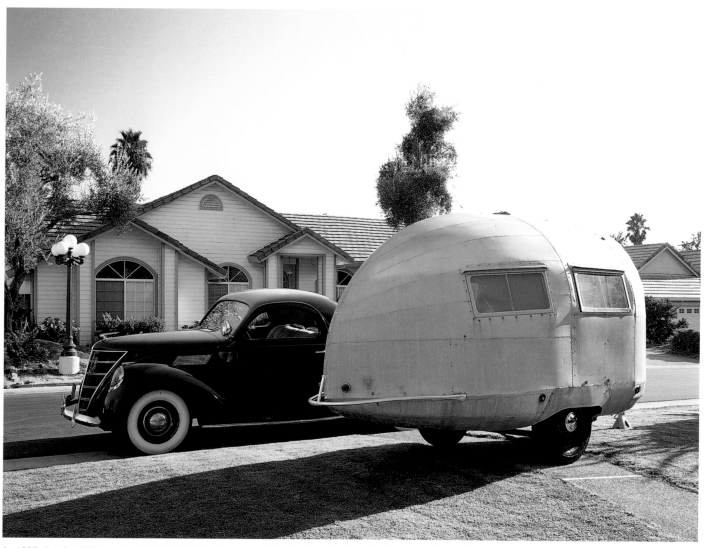

In 1935, Bowlus-Teller also fielded a shortened version of the Road Chief called the Papoose. Offered at $750, it included a two-burner gasoline stove, a 25-pound icebox (referring to its capacity for ice, not for food), a water tank and pump, an extension cord, double-strength glass, curtains, and an innerspring mattress. Also furnished was a tripod, probably the equivalent of a modern jack stand, to stabilize the trailer in camp. Bowlus-Teller also invited requests for custom design, though there were apparently few takers. The 1937 Lincoln Zephyr coupe in the background, among the sleekest automotive designs of the era, superbly complements the Bowlus's slippery shape.

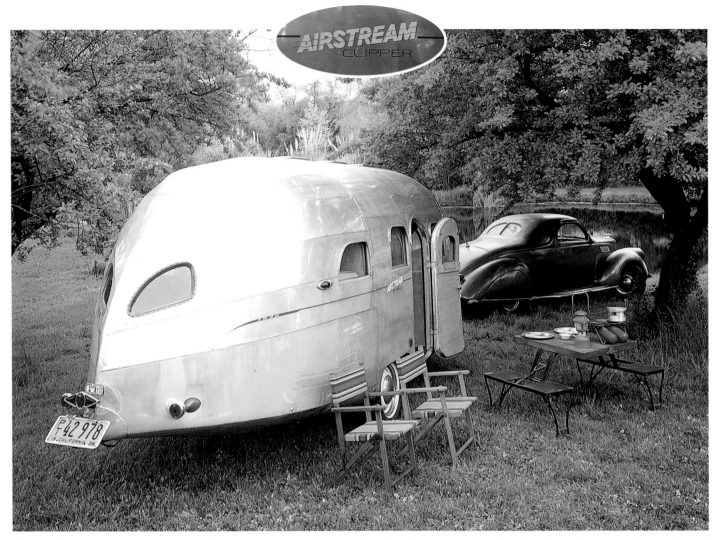

Patriarch in a long line of classics, this 1936 Airstream Clipper carries the earliest known Airstream serial number, and also reveals its close kinship to the pioneering William Hawley Bowlus design it was based upon. Following Bowlus-Teller's closing in 1936, trailer builder and former Bowlus dealer Wally Byam purchased some of the firm's equipment and also lured a number of former Bowlus workers into his employ. The resulting trailer, which Byam marketed under the name "Airstream" to suggest effortless motion, naturally bore a striking resemblance to its predecessor. Yet Byam also took the first steps in launching what became Airstream's creed of evolutionary refinement: In Bowlus's design, the door had been placed above the hitch; Byam moved it to a more convenient position on the right side of the trailer, where it has remained ever since. The tow car is a V12-powered Lincoln Zephyr. This photograph was taken in Penryn, California.

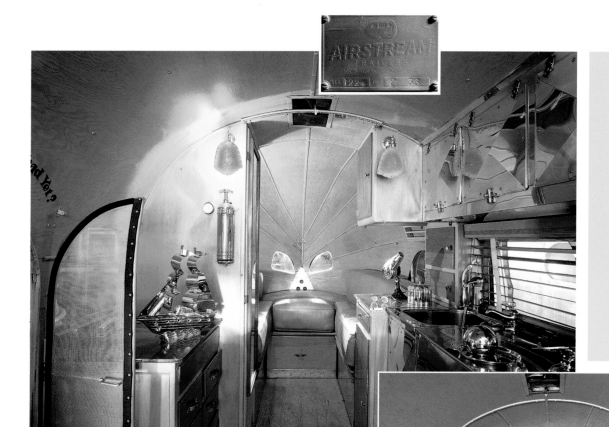

ABOVE: Polished metal and honey-toned upholstery set an Art Deco mood in the interior of the earliest known Airstream, owned by an Auburn, California, trailer collector. This view looking aft toward the sleeping quarters reveals the Airstream's close kinship with the Bowlus Road Chief: The zeppelin-like tail with its twin portholes remains basically unaltered. However, prior to starting production, Byam reengineered the fuselage to accommodate an entrance door on the side, here just out of view at left.

RIGHT: The individual sections used to form the Airstream's compound-curved ends are clearly visible in this view looking forward. Later models reduced the number of facets to simplify construction, a change which also led to a blunter end profile.

RIGHT: In 1938, Wally Byam abandoned the moribund trailer business and eventually joined the aircraft manufacturer Curtiss-Wright, where he remained for the duration of the war. By 1946, Byam had successfully lobbied Curtiss-Wright executives to allow him to produce a travel trailer. Predictably enough, the result closely resembled Byam's earlier Airstream design, and even carried the model name "Clipper." A portion of the trailers were marketed under the curious brand name "Curtis Wright," whose variant spelling and lack of hyphenation were apparently due to some fine point of trademark law. The Curtis Wright Clipper was produced from mid-1946 to mid-1949; however, the iconoclastic Byam had already left Curtiss-Wright around 1947 after he grew tired of wrangling with the firm's vast corporate bureaucracy. This advertisement harks back to the brief heyday of Byam's Curtis Wright trailers.

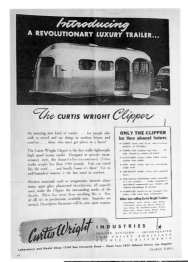

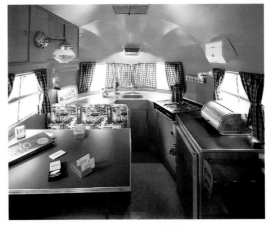

LEFT: The interior of the Curtis Wright featured an unusual galley located in the prowlike forward end, where it was generously lit by large, curved Plexiglas windows. The interior furniture was demountable, and the trailer could be ordered unfurnished for specialized commercial uses—an apparent attempt by the Curtiss-Wright Corporation to broaden its market appeal.

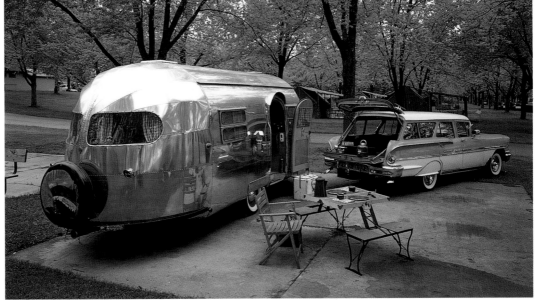

ABOVE: Looking suitably Airstreamesque, this 1947 Curtis Wright represents the middle phase of Wally Byam's peripatetic career. Byam's design grew more oblong during the Curtis Wright years, and would continue to do so after he resumed production of Airstream trailers. The trailer's larger front and rear windows were of Plexiglas, a material widely used for aircraft gun turrets during the war. At 34 inches wide, the "airplane type door" was also much larger than that of early Airstreams. In addition to the 22-foot Clipper, which weighed less than 1,500 pounds, Curtis Wright also offered 16-foot, 27-foot, and 31-foot models. The tow vehicle pictured is a 1958 Chevrolet Brookwood station wagon; the photograph was taken at Camp Dearborn, Michigan.

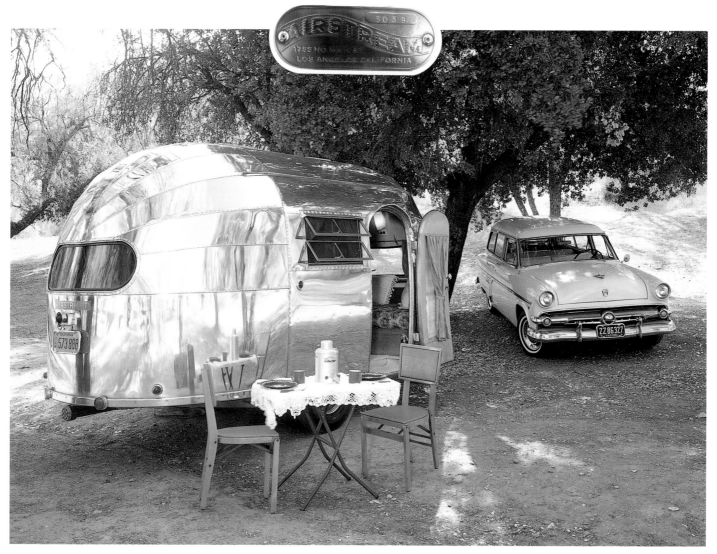

In 1948, a year or so after leaving Curtiss-Wright, Byam resumed business as Airstream Trailers, Incorporated in a small factory near the Metropolitan Airport in Van Nuys, a suburb of Los Angeles. Among his earliest products was this tiny Airstream Wee Wind, also dating from 1948. Early trailers of this era used a lengthwise spine of tubular steel (seen protruding from beneath the rub rail on the aft end) to support the floor members and ribs. After problems developed with torsional flexing, later units adopted a more conventional ladder-type frame. Airstream marketed a series of "Wind" models during the late forties and into the fifties; at 16 feet, the Wee Wind was the smallest. Thanks to its tubular frame, it was also the lightest Airstream ever made. The tow car pictured is a 1954 Ford Ranch Wagon, one of the most popular station wagon models of the fifties.

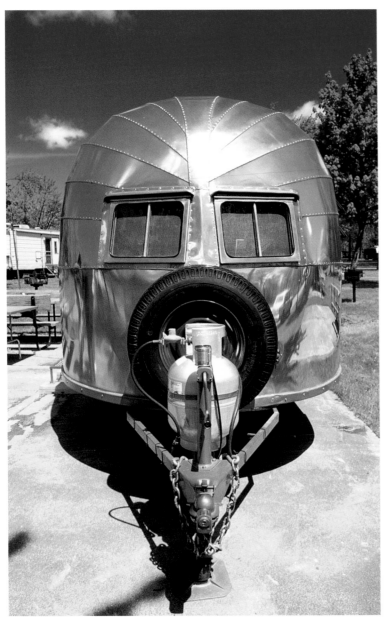

LEFT: To most laypersons, all Airstream trailers look pretty much alike, but to aficionados, various years and models can be easily distinguished by a host of details. One of these telltale features is the number of individual metal facets or "skins" used to form the compound curvature of the trailer's fore and aft ends. Models up to 1957 generally used thirteen separate facets riveted together, as seen here on a 1949 Airstream Southwind; thereafter, engineers reduced the number of facets to seven in order to simplify body construction. Today's squarer models use a mere five facets.

RIGHT: In 1949, two years after Wally Byam's departure, Curtiss-Wright sold its trailer business to three investors, Kenny Neptune, Frank Polido, and Pat Patterson, who offered essentially the same trailers under the brand name "Silver Streak." Eventually, Neptune and Polido bought out Patterson, who went on to found the Streamline Trailer Company. This Streamline advertisement dating from the early sixties, with its woodsy scene of duck hunters and a pair of eager pointers, stresses the idyllic ambience of trailer travel

rather than outlining technical features as was previously common. Billing its product as "The Aristocrat of the Highway," Streamline fielded a full line of trailers, including the 22-foot Duchess, the 24-foot Duke, the 26-foot Countess, the 28-foot Empress, and finally the leviathan 33 1/2-foot Emperor. The trailers had slightly squarer lines than the contemporary Airstream, but were otherwise quite similar. However, buyers seemingly found little reason to choose an Airstream look-alike over the genuine article, and Streamline remained an also-ran for most of its existence. The firm closed in 1974.

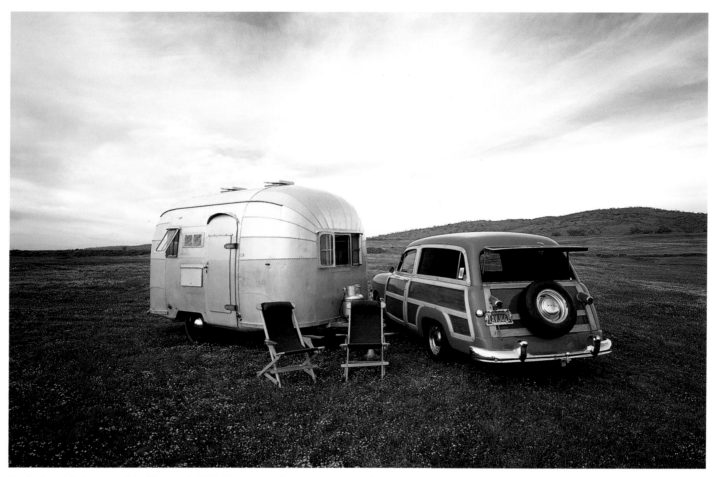

Beginning with the venerable Clipper of 1936, Airstream trailers have appeared in a plethora of lengths and configurations, and have carried a bewildering array of names. By the early sixties, the company was fielding eight basic series, running the gamut from the 16-foot Bambi to the palatial, 30-foot-long Sovereign. The larger models were offered in either double- or twin-bed versions, and all units included bathrooms regardless of size.

The 1952 Cruisette pictured here, measuring just 14 feet 8 inches in length, has the distinction of being the smallest Airstream model ever made. Although by this time Byam was busily constructing a new plant in a vacant paper goods factory in Jackson Center, Ohio, the Cruisette continued to be built in Los Angeles. Less than one hundred were manufactured, and only four are now known to exist.

The 1950 Ford Country Squire "woodie" station wagon, with its elegant wood-paneled sides and tailgate, exemplifies an automotive tradition held over from the days when station wagon bodies were actually constructed of hardwood. Each of the Big Three automakers offered station wagons in "woodie" dress, while Chrysler also offered a wood-paneled Town and Country coupe and sedan from 1946 through 1949. These vehicles were photographed at Los Molinos, California.

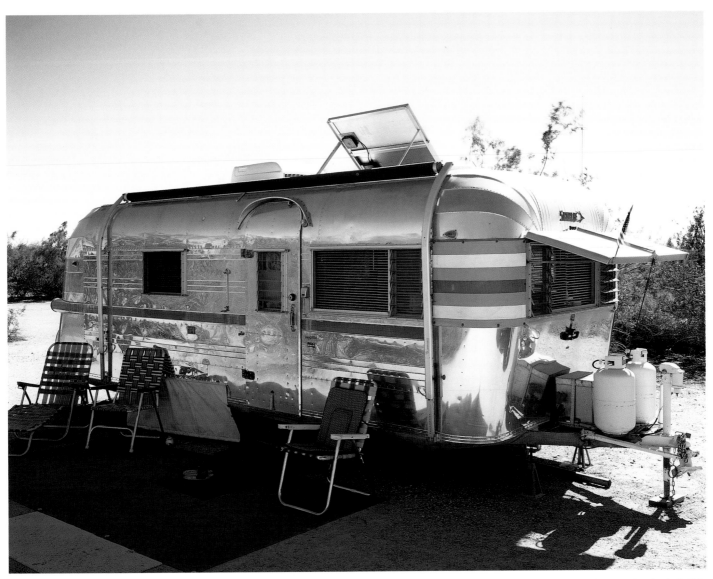

On the smaller end of the Streamline model range was the 24-foot Duke, a direct competitor of the contemporary 24-foot Airstream Tradewind. This 1962 model resembles Airstream products both in finish and in its prolific use of louvered jalousie windows, which were just then popular in homes of the era. Still, the Streamline can be easily distinguished from its arch competitor by the bands of color flanking its front window.

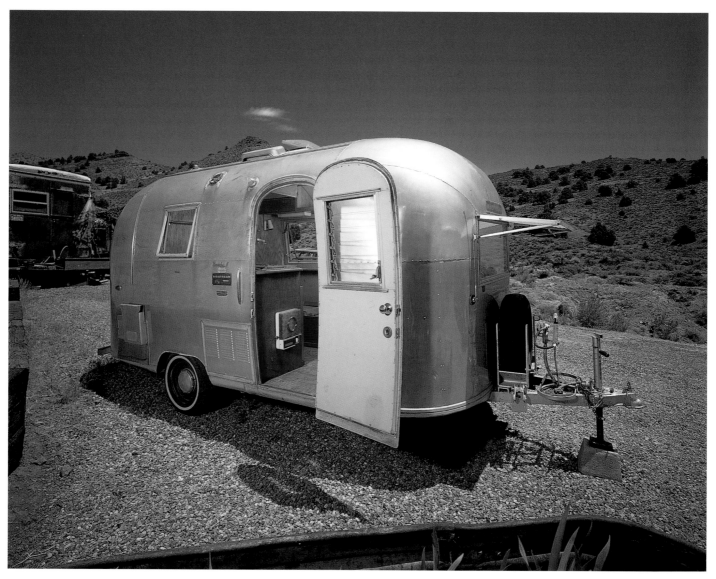

Despite its 16-foot length, the ultracompact Airstream Bambi included both a toilet and shower. This Bambi II dating from the mid-1960s typifies post-1957 Airstream styling, with its squarer lines and fewer facets forming its compound-curved body shell. This trailer was photographed in Silver City, Nevada.

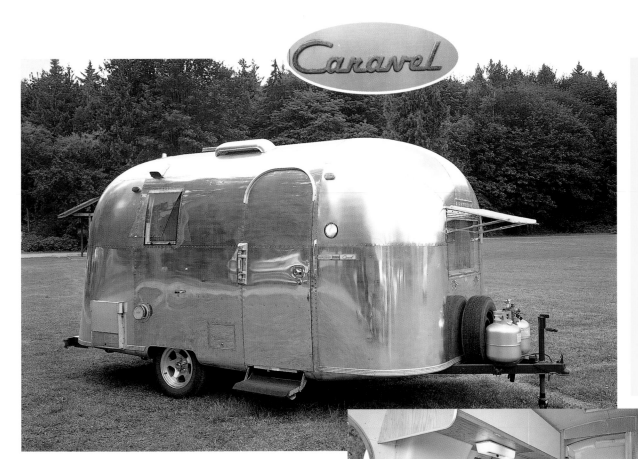

Caravel

ABOVE: Most of the length variations in Airstream models involved the galley and sleeping areas at the center of the trailer. The forward end on all but the largest units retained the familiar crosswise davenport that converted into a bed, while the aft end containing the lavatory, toilet, shower, and wardrobe varied little regardless of length. By the midsixties, Airstream had shuffled names again; for model year 1967, the 17-foot Caravel was among the smallest in the lineup.

RIGHT: Despite some minor updating with lighter-colored woods and a few plastic panels, the basic interior appointments of the Caravel vary little from earlier postwar trailers. With the increasing use of molded plastic, laminated plastic, and fiberglass panels during the seventies, however, trailer interiors began to look more like vehicles than homes.

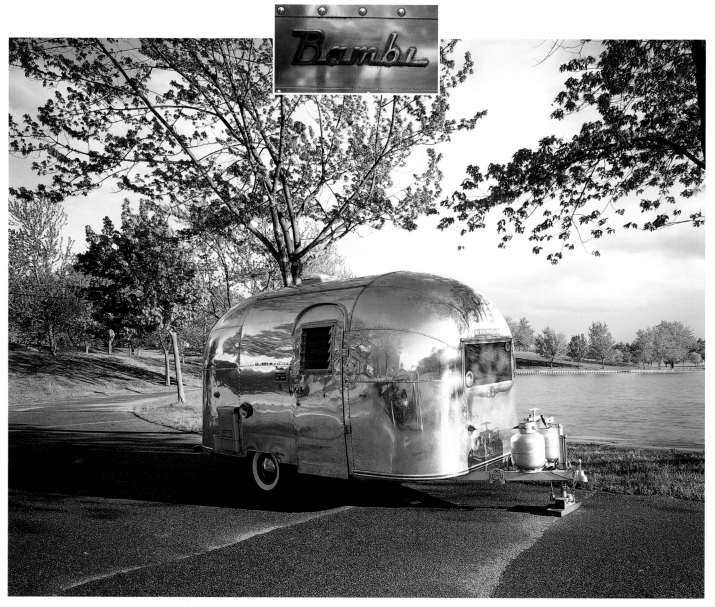

The tiny, easily maneuverable Bambi has long been a popular choice among Airstream buyers; this 1963 model is kept polished to mirrorlike perfection by its devoted owners. The Airstream's trademark aluminum skin is not entirely maintenance free—it can become permanently pitted if allowed to oxidize—and keeping a trailer in this condition demands a fair amount of elbow grease.

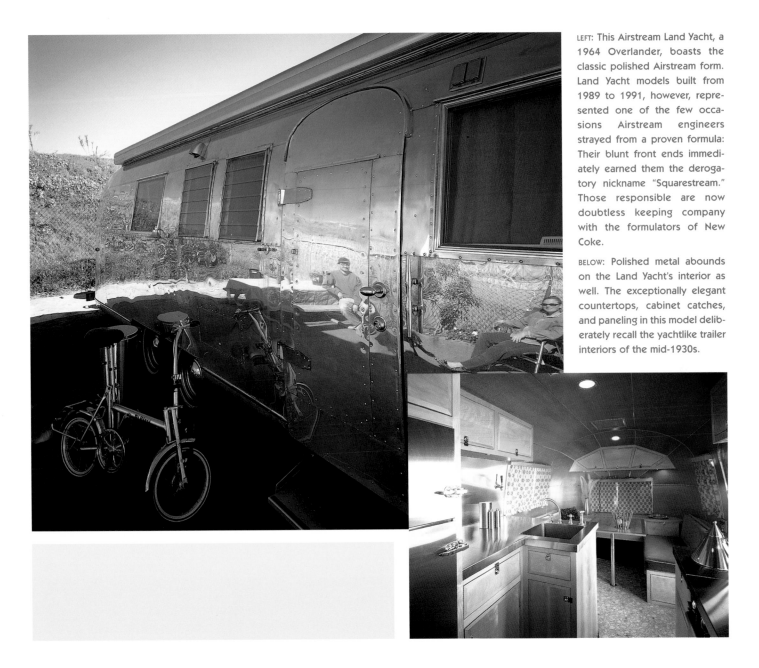

LEFT: This Airstream Land Yacht, a 1964 Overlander, boasts the classic polished Airstream form. Land Yacht models built from 1989 to 1991, however, represented one of the few occasions Airstream engineers strayed from a proven formula: Their blunt front ends immediately earned them the derogatory nickname "Squarestream." Those responsible are now doubtless keeping company with the formulators of New Coke.

BELOW: Polished metal abounds on the Land Yacht's interior as well. The exceptionally elegant countertops, cabinet catches, and paneling in this model deliberately recall the yachtlike trailer interiors of the mid-1930s.

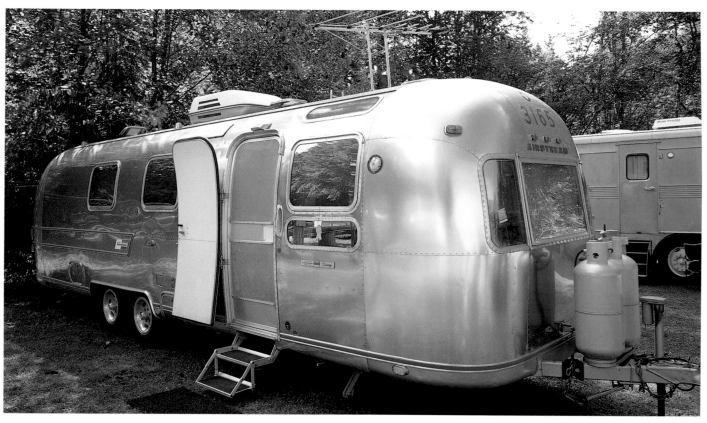

ABOVE: During the 1970s, motor homes made significant inroads into recreational vehicle sales by offering the advantage of self-propulsion. As weight was less of a factor in a powered vehicle than a towed one, motor home designers were free to include bulky amenities ranging from air-conditioning to television without the adverse effects on handling or tongue load that would plague a comparably sized trailer. The results were some of the clumsiest recreational vehicle designs in half a century. Trailer manufacturers were obliged to keep up with this unhappy trend: Note the rooftop air conditioner and television aerial on this 1976 Airstream Sovereign.

RIGHT: With its molded plastic panels, overhead storage bins, and integrated, ceiling-mounted lighting and ventilation housing, the Sovereign's interior was clearly inspired by the passenger cabin of contemporary jet aircraft. The Boeing 747, the very symbol of modernity at the time of its introduction in 1975, no doubt inspired Airstream engineers searching for a fresh aesthetic.

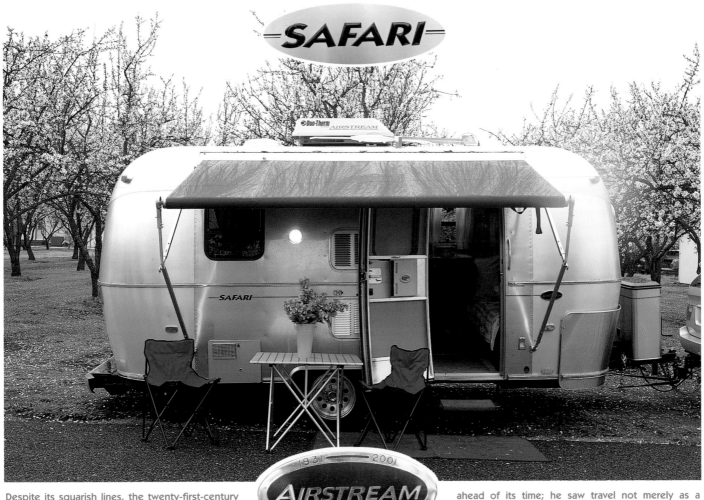

Despite its squarish lines, the twenty-first-century Airstream trailer still bears a clear family resemblance to its prewar ancestors; a 2001 Safari (rechristened the "Bambi" in 2002) is pictured here. Unlike many industrial creeds, Wally Byam's policy of evolutionary refinement has somehow survived both fluctuating economies and newfangled managerial theories. Today, after some seven decades of refinement, the Airstream aesthetic has transcended the vagaries of fashion to become a timeless industrial object along the lines of the Coca-Cola bottle or the Fender Stratocaster guitar.

Apart from his farsighted company policy, Byam's worldview was also ahead of its time; he saw travel not merely as a sybaritic pastime but as a means of furthering understanding among cultures. This was a very genuine motivation for his frenetic travel schedule with the Airstream Caravans that began in the late fifties, although the accompanying publicity for Airstream was of course a welcome side effect. In 1960, two years before his death, Byam declared: "Whether we like it or not, any fool can see that this earth is gradually becoming one world. Nobody knows what the form of the "one" will be, but it's going to be one or none." The events of the late twentieth century, not to speak of the twenty-first, have certainly proved him right.

In the American lexicon, the words "trailer park" generally do not conjure an especially positive image. For at least fifty years, persons living in trailers have been made the butt of endless jokes in which they are typified as lowlifes and yokels. Yet the reality is that the sort of trailer parks that exist in the popular imagination only represent a tiny minority. Most are in fact just the opposite of this stereotype—somewhat overly tidy and dull, and filled with bland and boxy double-wide manufactured homes.

Yet there are also fascinating trailer parks which stand out due to their age, their location, or their residents. We refer to them as "nomadic neighborhoods" because some are truly temporary, such as gatherings of the Tin Can Tourists and the Vintage Airstream Club, or the Escapees' "Escapade" in Chico, California.

Other parks, such as Bradenton, Florida's Braden Castle Park and Reno, Nevada's Chism's Trailer Park, are of historical interest, having been around since trailering's beginnings in the 1920s. Some are simply nice places to visit, such as Bisbee, Arizona's Shady Del RV Park, a unique bed and breakfast where guests spend the night in one of eight restored trailers of the forties and fifties.

Still others are included here simply because they have unusual character—or should we say characters—though this is a quality seldom lacking where trailerites are involved. Quartzsite, Arizona, and Slab City near Niland, California, fall into this category. So does Funky Junk Farms in Los Angeles, which furnishes local movie studios with a selection of vintage trailers and other transportation-related props. A bit further south, in Jamul, California, is Simpson's Garden Town Nursery, a unique hybrid of business and museum whose grounds are dotted with the owner's vintage trailer collection.

Perhaps the most publicized of these ten selections is Blue Skies Trailer Village, located in Palm Springs, California. Founded by singer and actor Bing Crosby, Blue Skies boasted a list of investors ranging from Humphrey Bogart to Claudette Colbert. With spectacular views of the surrounding mountains and streets named after its illustrious investors, Blue Skies Village remains quite possibly the most exclusive trailer park in America.

7. Great Nomadic Neighborhoods

OPPOSITE: **The sun sets over a sea of recreational vehicles at Quartzsite.**

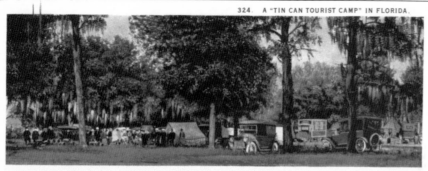

324. A "TIN CAN TOURIST CAMP" IN FLORIDA.

"A TIN CAN TOURIST" CAMP IN FLORIDA.

'Neath spreading oak and pine tree tall Then other tourists come along, And ere the blooming May comes round
"A tin can tourist" in the Fall The camp force now is growing strong They'll buy a piece of fertile ground
Puts up his tent and plans to stay Cars from the North, the East, the West, And mark it off in streets and squares
In Florida till blooming May, Bring weary tourists seeking rest, And every tourist take some shares,
And soon another tourist comes. All happy in this flowery glade For they will build a city here
They meet and greet like old time chums, Beneath the broad oaks welcome shade When they come back another year
They tell new jokes and make new plans, They're singing songs and making plans Just as the "tin can tourist" plans
And mess from out the same tin cans. And piling up the empty cans. When he piles up the empty cans.
 —Ruth Raymond

VERSE COPYRIGHTED BY ASHEVILLE POST CARD CO. 105348

LEFT: This idyllic image of the mid-1920s depicts a Tin Can Tourist camp in Florida, accompanied by the sort of maudlin poetry characteristic of the era. During the early twenties, most auto campers simply carried tents aboard their cars; tent trailers were just beginning to grow popular by the middle of the decade. *Courtesy Milton Newman Collection.*

RIGHT: Some eighty years later, the Tin Canners are still hanging out the welcome sign for their brethren. Pictured here is a TCT gathering at Camp Dearborn, Michigan, a recreation area tucked away in the countryside west of Detroit. In the background is the first trailer to arrive, a 1949 Airstream Southwind belonging to the meet's organizer.

BELOW: Tin Canners pose for a group photo at Camp Dearborn; recreational vehicles both old and new populate the background.

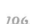

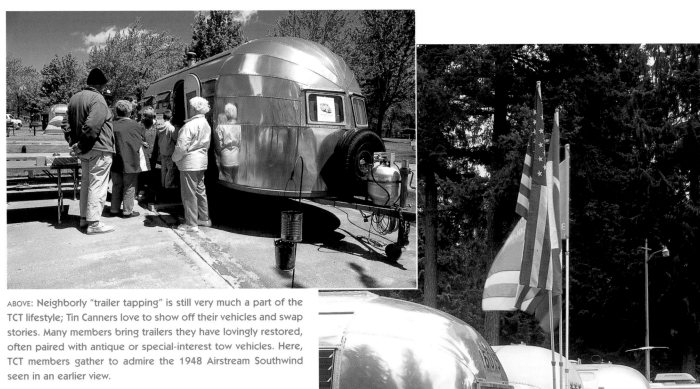

ABOVE: Neighborly "trailer tapping" is still very much a part of the TCT lifestyle; Tin Canners love to show off their vehicles and swap stories. Many members bring trailers they have lovingly restored, often paired with antique or special-interest tow vehicles. Here, TCT members gather to admire the 1948 Airstream Southwind seen in an earlier view.

RIGHT: A row of "silver palaces"—the trailerite's fond nickname for Airstreams and their imitations—lines up beside the pines at a combination Vintage Airstream and Tin Can Tourist rally at the Deming Log Show Grounds near Bellingham, Washington.

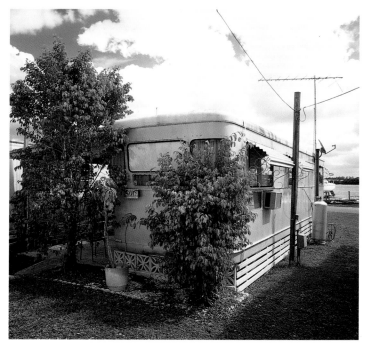

TOP: Braden Castle's integral role in the history of both the Tin Can Tourists and the rise of recreational trailering has earned it status as a State of Florida landmark. The park's simple white-painted wood-frame buildings serve as communal facilities; the steel ring hanging beneath the tree at foreground is a fire bell made from the discarded steel tire of a locomotive driving wheel.

RIGHT: A postwar Spartan trailer has practically grown into its site at Braden Castle. Wood-and-concrete-block skirting, a large liquid propane tank, a television aerial and satellite dish, and a poured-in-place concrete patio all suggest that the owner has occupied this spot for some time.

ABOVE: A 300-foot-deep artesian well, now capped by a wellhead in the form of a lighthouse, was one of the features that attracted the Camping Tourists of America to the Braden Castle site. Generations of campers have since come here to fill their water jugs, or simply to hobnob with the neighbors.

LEFT: Dating from 1925, the diminutive, tin-roofed office at Braden Castle remains carefully maintained along with the park's other communal facilities. In 1985, the park was placed on the National Register of Historic Places, protecting it from potential threats of development or eminent domain proceedings.

BELOW: A colorful row of trailers faces one of the narrow lanes at Braden Castle. Although trailers of many vintages coexist side by side, the majority are 12-foot single-wides dating from the early sixties or later. Unlike the park's early days, most trailers are now permanently moored here, though their owners still come and go with the seasons.

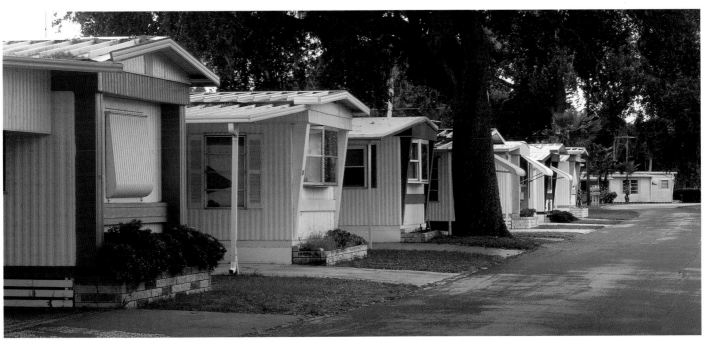

LEFT: Reno, Nevada's Chism's Trailer Park has occupied its idyllic site on the banks of the Truckee River since the summer of 1927. Originally called Chism's Auto Camp, it was founded by Harry Chism to serve a joint Nevada/California industrial fair held nearby. After Harry's death in 1929, his son John expanded the park to accommodate trailers and also added eight motel rooms and sixteen cabins. Following World War II, some of the trailer spaces held modular dwelling units that housed returning veterans; these were eventually replaced by trailer spaces.

BELOW: A picturesque riverside location gives Chism's the feeling of a campground rather than that of a mobile home park. Additional trailer spaces have been added over the years, and today the park accommodates 124 permanent units along with twenty-eight recreational vehicles.

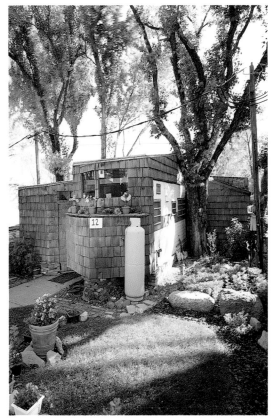

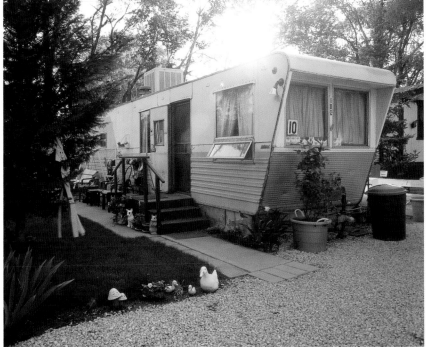

ABOVE: Mobile homes parked at Chism's are essentially permanent, and are lovingly tended by their owners. Unlike so many mobile homes which seem disconnected from their sites, this Pan American National, probably dating from the early sixties, has become very much a part of its surroundings.

TOP RIGHT: Some residents at Chism's have customized their mobile homes; this example, whose owner is in the U.S. Merchant Marine, has a distinct nautical flair. Perhaps as an afterthought, the owner has left one section of the original trailer exposed to reveal its mobile past.

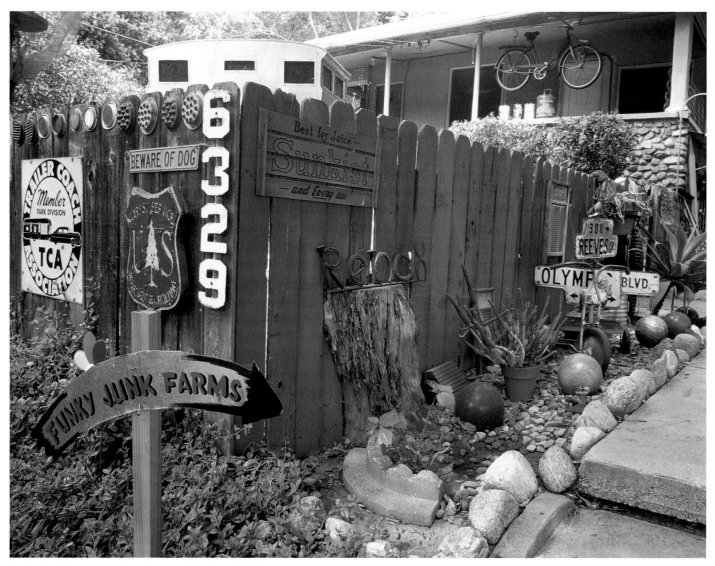

Funky Junk Farms occupied a Los Angeles site originally purchased by the Drummond family in 1898. It was opened as Monterey Auto Camp in the early 1920s and, like many other such businesses, was converted to serve trailers during the trailering boom that began in the early thirties. It remained in substantially the same form for the next seventy years. After these photographs were taken, Funky Junk Farms moved to Altadena, California, where it continues its business of renting vintage trailers, motor vehicles, and other travel-related memorabilia to local film and television studios for use as props.

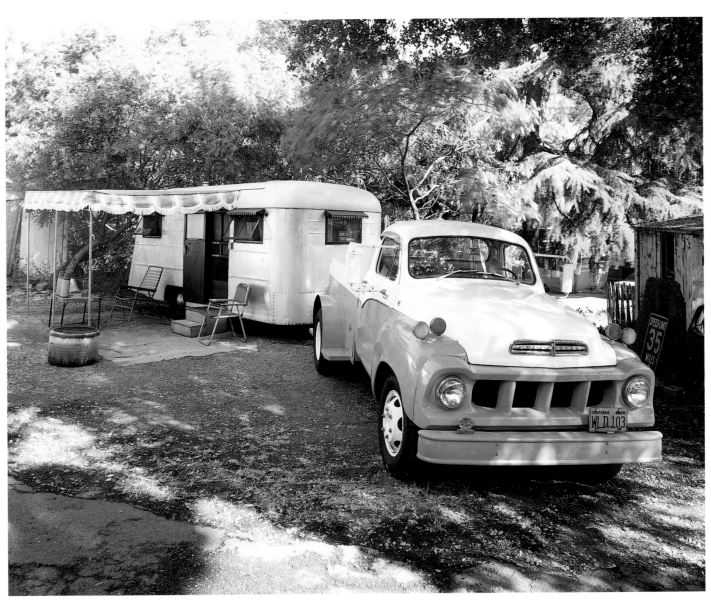

A 1948 Westcraft Westwood Tahoe poses behind a 1957 Studebaker Transtar pickup at Funky Junk Farms. The vehicles are for the most part original and unrestored, since they are often subject to damage during filming and are also frequently modified to suit the wishes of studio property managers.

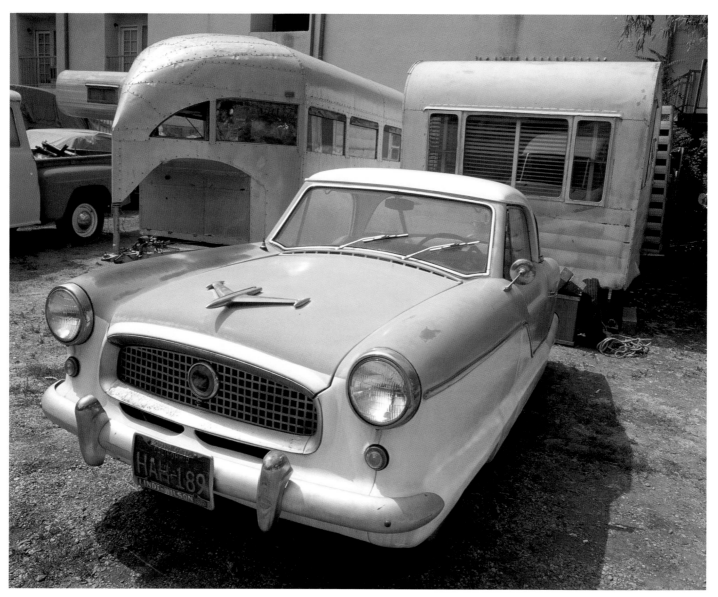

Among the unusual vehicles on the Funky Junk Farms lot is this ultracompact Nash Metropolitan, dating from the late fifties, a product of the now defunct Nash Motors Corporation of Kenosha, Wisconsin. In the far background, a Curtiss Aerocar awaits renovation.

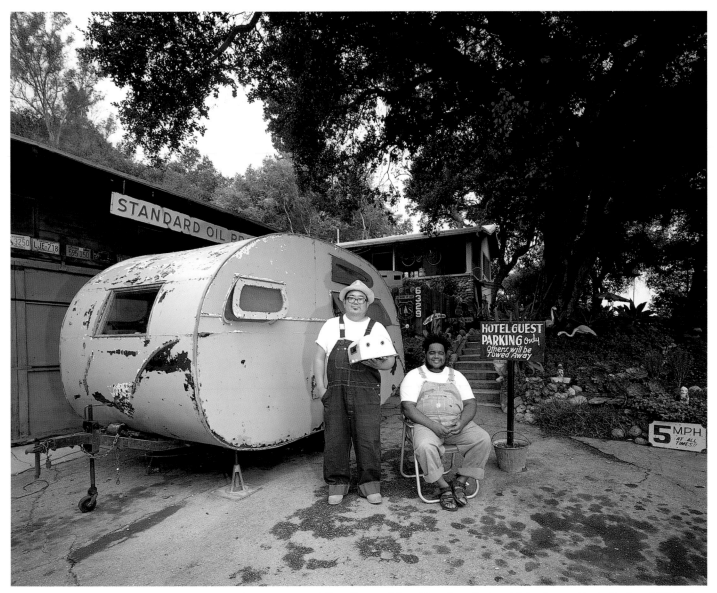

Presiding over Funky Junk Farms are inveterate trailer and memorabilia collectors Edward Lum (standing) and John Agnew. The trailer is a 1937 Master-bilt.

Blue Skies Trailer Village

Billed as "America's Most Luxurious Trailer Park," Blue Skies Trailer Village has always traded heavily on its movie star connections. This stylized rendition of the park's entrance sign touted cofounder Bing Crosby as president, and also managed to drop the names of Humphrey Bogart, Lauren Bacall, and Greer Garson. The park opened in 1953; its streets were named after the most celebrated of its forty-eight investors. Courtesy Grant Dixon Collection.

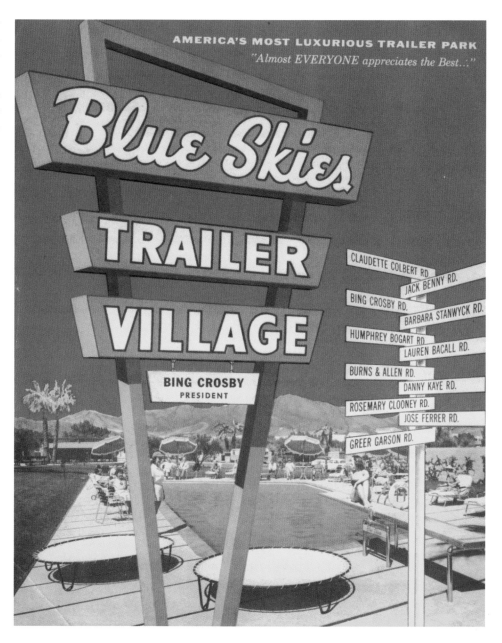

AMERICA'S MOST LUXURIOUS TRAILER PARK
"Almost EVERYONE appreciates the Best..."

Blue Skies
TRAILER
VILLAGE

BING CROSBY
PRESIDENT

CLAUDETTE COLBERT RD.
JACK BENNY RD.
BING CROSBY RD.
BARBARA STANWYCK RD.
HUMPHREY BOGART RD.
LAUREN BACALL RD.
BURNS & ALLEN RD.
DANNY KAYE RD.
ROSEMARY CLOONEY RD.
JOSE FERRER RD.
GREER GARSON RD.

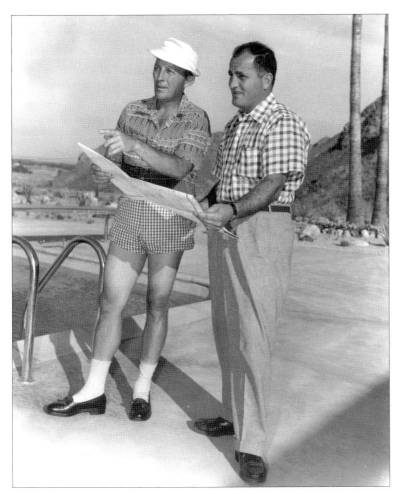

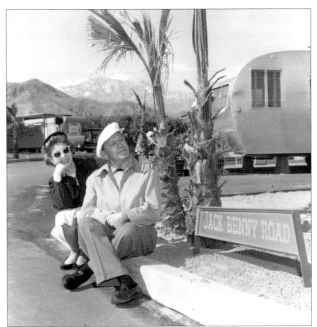

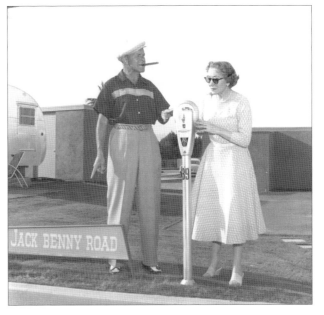

CLOCKWISE FROM ABOVE: Famed crooner and film actor Bing Crosby poses in a publicity photo with Blue Skies Village cofounder Pete Pettito. Crosby reputedly named the park after the title of one of his favorite songs. Courtesy Grant Dixon Collection; Blue Skies Village's illustrious tenants provided a fount of publicity for the park. In this gag sequence, comedian Jack Benny (with wife Mary Livingston), assuming his pinchpenny role, ponders how to capitalize on having a road named after him . . . whereafter the husband-and-wife comedy team of George Burns and Gracie Allen discover a parking meter installed on Jack Benny Road. Courtesy Grant Dixon Collection.

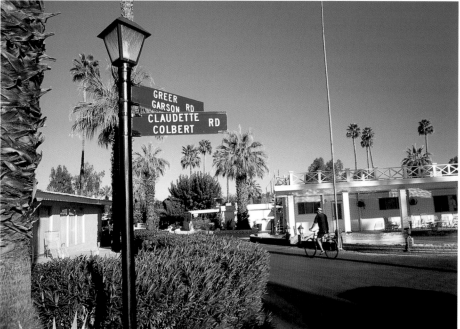

ABOVE: The focal point of Blue Skies Village is the pitch-and-putt golf course located a short distance from the park's entrance, down Bing Crosby Road.

LEFT: Film actresses Greer Garson and Claudette Colbert were among a handful of the forty-eight park investors who had streets named in their honor.

RIGHT: Blue Skies Village is known for the unusual architecture of its mobile homes, many of which feature site-built additions. This unit boasts a facade dressed up with a pitched roof, as well as a large awning and a lean-to at the rear.

BOTTOM LEFT: A larger California Rancher–style addition surrounds this single-wide mobile home.

BOTTOM RIGHT: Some well-chosen stucco amendments manage to turn this unassuming single-wide into a miniature palace of Karnak.

ABOVE: Beginning in early November of each year, recreational vehicle enthusiasts from all over the nation begin a winter sojourn to tiny Quartzsite, Arizona, turning the town of two-thousand-odd residents into Arizona's third largest city. The gathering culminates in the nine-day Quartzsite Sports, Vacation, and RV Show that begins the third week of January. The Quartzsite Chamber of Commerce claims that more than one million RVers spend time there in January.

RIGHT: Many of Quartzsite's snowbirds set up camp on federally owned land outside of town, where they pay the Bureau of Land Management $125 for the privilege of spending the winter. This campground host welcomes new arrivals to BLM property.

ABOVE: Known as the big tent, the carnivallike Quartzsite Sports, Vacation, and RV Show is estimated to draw about one hundred thousand people each year. It is now beginning its third decade.

INSET: For most of the year, Quartzsite is little more than a rest stop for truckers on Interstate 10; during the winter, however, it becomes a metropolis of recreational vehicles, with all the attendant requirements of a good-sized town. For the reckless, overindulgent, or just plain unlucky, medical attention is naturally also available.

RIGHT: During the 1850s, Secretary of War Jefferson Davis, later president of the Confederacy, approved a trial plan for the military's use of camels in the arid Southwest. Accordingly, thirty-three camels were landed at Indianola, Texas, in February 1856, with a second voyage adding another forty-one. With the first shipment came a caretaker, Haiji Ali, whose name the soldiers promptly corrupted to "Hi Jolly." In 1857, under Hi Jolly's charge, the camels proved their worth on the Beale expedition, which sought to open a wagon road across Arizona from Fort Defiance to California. Nevertheless, the War Department abandoned the experiment, and the camels were set free to fend for themselves in the desert. The herd remained a curiosity for many years in the area around what is now Quartzsite. Today, this miniature pyramid is the sole reminder of Hi Jolly and his camels.

ABOVE: Perhaps the most unlikely nomadic neighborhood of all is Slab City, an abandoned World War II–era navy base outside Niland, California. The structures on the 640-acre base were demolished long ago, leaving only concrete slabs on the ground—hence the name Slab City. This unlikely venue attracts snowbirds of an especially independent stripe, as there are no water or electrical connections, and life here is truly basic. This guard shack, a remnant of the area's military past, now serves as one of Slab City's unofficial entrance gates.

RIGHT: Slab City's resident artist is Leonard Knight, a Vermont native who came here by way of Nebraska in 1985 to launch a hot-air balloon. Failing that, he stayed to build a small monument to God, and has been at it ever since. What has come to be known as Salvation Mountain is a 30-foot-high artificial hill built of old refrigerators, car parts, and various other scraps obtained from the local dump, which Knight has plastered over with lean concrete and adobe and coated with an estimated 100,000 gallons of surplus paint. Slogans of religious salvation share the mountain's surface with depictions of flowers and children, all sculpted in concrete or adobe and brilliantly colored.

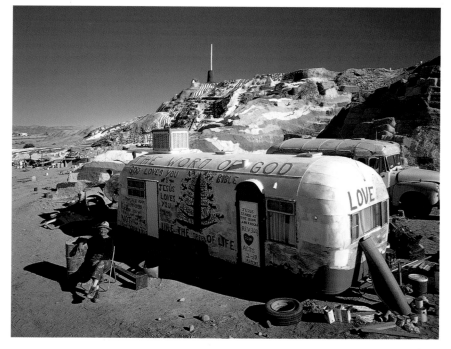

TOP LEFT: Among the winter residents who gather here are the Slab City Singles who, along with other retired singles groups such as the Loners of America, the Loners on Wheels, and Women on Wheels, have found camaraderie in this parched and unwanted parcel of land.

TOP RIGHT: Sociologists have long been intrigued by the lively social interaction found in trailer parks as compared to apartment houses or suburban dwellings. Slab City's transient population is no exception; this bulletin board topped by a whimsical sculpture bespeaks the sense of community found in this most unlikely setting.

BOTTOM RIGHT: "Slabbers" come from all walks of life, but all seem to share a disdain for whiling away their retirements in suburbia. In a wry commentary on "normal" retired lifestyles, this Slab City resident maintains a representative piece of the suburbs near his Slab City trailer.

BOTTOM LEFT: This Slab City abode consists of a Corvette trailer and a water tank planted amid a patch of desert scrub; with typical Slabber humor, its owner has christened it "Rancho Not-So-Grande."

LEFT: Simpson's Garden Town Nursery, located in Jamul, California, boasts a miragelike nomadic neighborhood unique to trailerdom. The owner's collection of vintage trailers can be found throughout the nursery grounds, while other restored examples are displayed in a warehouse along with a number of classic cars.

MIDDLE LEFT: A 1930 Model A Ford poses ahead of a 1950s-era Trailorboat in Simpson's warehouse.

MIDDLE RIGHT AND BOTTOM: A phalanx of vintage trailers share the roadside with potted palms at Simpson's.

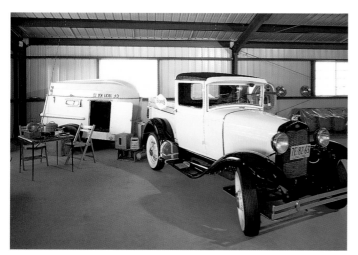

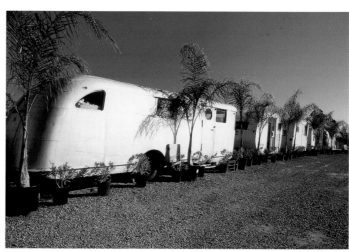

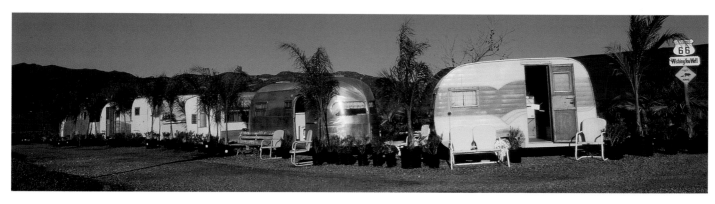

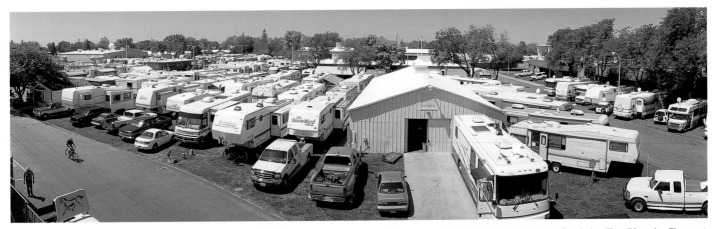

ABOVE: The recreational vehicle enthusiasts known as the Escapees are so named because of their desire to escape a fixed-dwelling lifestyle. The vast majority are retired, and roughly half live in their trailers or motor homes all year long. The overwhelming majority of Escapees travel without children, although many bring along at least one pet. The sea of motor homes and trailers seen here is from a recent group gathering—or in Escapees parlance, an "Escapade"—in Chico, California.

FAR LEFT: A book signing at the Chico Escapade features, left to right, Escapees founders Kay and Joe Peterson, who wrote *Survival of the Snowbirds*; Stephanie Bernhagen, author of *Take Back Your Life! Travel Full-Time in an RV;* and anthropologists Dorothy and David Counts, who wrote *Over the Next Hill: An Ethnography of RVing Seniors in North America.*

LEFT: An Escapee shows off badges from previous Escapades.

BELOW LEFT: A carnivallike air surrounds the Chico gathering, where booths offer members all manner of items useful to nomadic living.

RIGHT: The innate fellowship found among travelers is integral to the Escapees' lifestyle. Here, two members enjoy an impromptu jam session with guitar and harmonica.

ABOVE: Arizona offers yet another unique nomadic neighborhood, this one in Bisbee. Here, the Shady Dell RV Park offers overnight guests lodging in a choice of eight fully restored vintage trailers, ranging from a 1949 Airstream to a 1957 El Rey.

INSET: A modest trailer, homebuilt from plans found in *Popular Mechanics* magazine, sits opposite Shady Dell's top-of-the-line Spartan Royal Mansion, with its picket-fenced yard and evaporative "swamp cooler" on the roof.

RIGHT: Shady Dell's equivalent of the presidential suite is the 1951 Spartan Royal Mansion; like all the trailers here, it is furnished with items corresponding to its vintage, including magazines and movies.

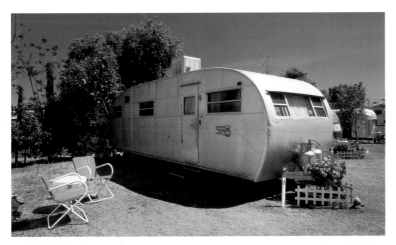

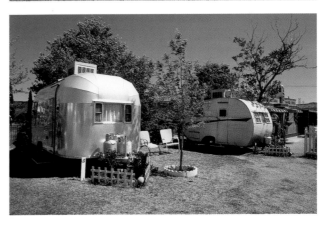

BELOW: The gleaming 1949 Airstream is known as the Honeymoon Suite for the reflective metallic interior of its sleeping area. Its guest book is filled with sentimental notes from couples who have spent honeymoons or anniversaries there.

BOTTOM: A 1957 El Rey (foreground) and a 1954 Crown await guests at Shady Dell. The El Rey's suspicious resemblance to concurrent Streamline trailers may be due to the proximity of their manufacture: Both were produced in El Monte, California. In the background is tiny Dot's Diner, which serves American breakfast staples such as pigs-in-a-blanket and biscuits and gravy.

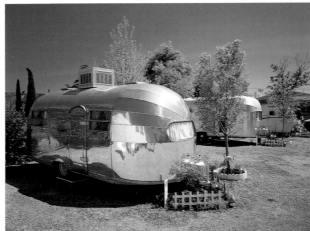

TOP: An inviting pair of lounge chairs complements Shady Dell's 1950 Spartanette, Spartan Aircraft Company's entry into the canned-ham school of trailer design.

BOTTOM: Like all the trailers at Shady Dell, the Spartanette's honey-toned interior is furnished with period accessories such as the ubiquitous glass-and-pitcher set and the early RCA Victor portable television atop the counter. The sleeping area can be glimpsed far in the background.

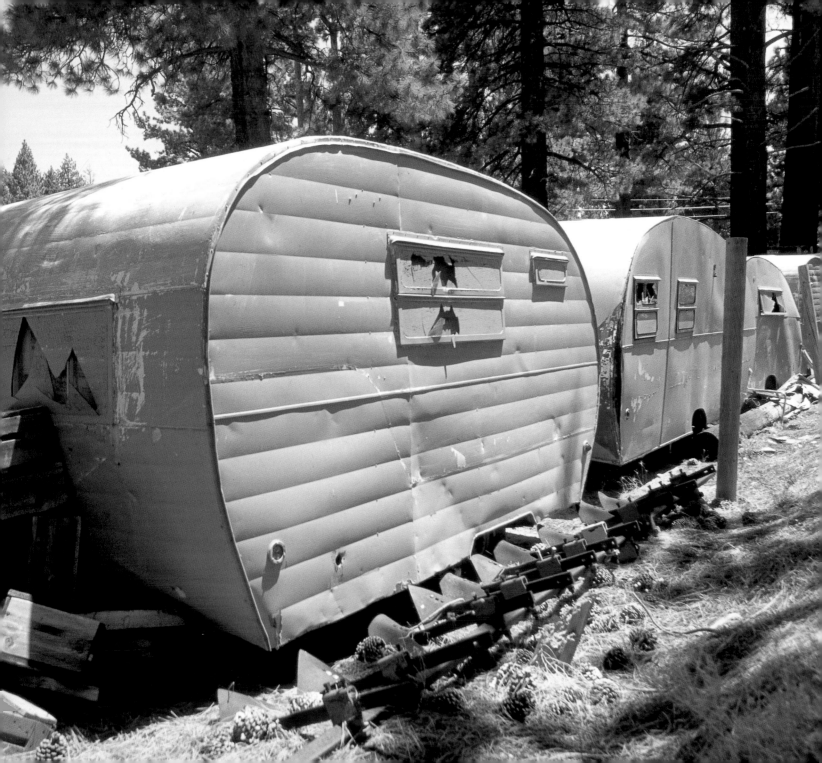

It would be difficult to venture a guess as to how many travel trailers survive in America today, but there is little doubt that many tens of thousands of examples from the postwar years remain scattered throughout the country. Nor are these necessarily queued up in trailer parks or sequestered in backyards. Throughout the United States, vintage travel trailers can be found moldering away in barns, slumping across cinder blocks at the end of overgrown lanes, or slowly turning to powder in the desert heat. They can even be found

cratic Aerocars were painstakingly built to order, and carried commensurately vast price tags that ensured their exclusivity. Hence, the Aerocar's reputation has always outweighed both its production numbers and its negligible impact on mainstream trailer design.

During 1934 and 1935, William Hawley Bowlus built about 140 of his sleek, duralumin-sheathed trailers, of which only about 20 are thought to remain. The various early descendants of Bowlus's design—the Curtis Wright and Silver Streak trailers, and of course the

ous agencies of the U.S. government, but their notoriously flimsy construction—a consequence of wartime materials shortages—has left us only trace reminders of their existence.

Hence, the bulk of survivors are the mainstream travel trailers of the postwar era—aimed at the middle class, and built by an incredibly large number of manufacturers in a whole galaxy of forms. There were the Spartans, the New Moons, the Westcrafts and Airfloats, the Comets and Aljoas, Trotwoods and Shastas, Roadhomes and Silver Streaks, Almas and Indi-

8. Endings and Encores

grafted onto houses or, just as often, with houses grafted onto them.

A fair number of these units are probably home-builts, their owners and histories now obscured by neglect and the passage of time. Still, commercially built models likely make up the bulk of extant travel trailers, simply because the technical refinements that accompany mass production tended to favor their survival. Some commercial trailers were, of course, quite rare to begin with. Glenn Curtiss's aristo-

early Airstreams—are nearly as rare. The Pierce-Arrow Travelodge, a distinguished automaker's last-ditch bid for survival, was aimed at an exclusive market which, alas, had evaporated by the time the trailer was introduced in late 1936. Only about 450 Travelodges were built before Pierce-Arrow was liquidated in 1938.

In other cases, trailers were built in vast numbers, but their poor quality guaranteed an early demise. Some thirty-five thousand "war trailers" are known to have been built for vari-

ans, Nomads and Masterbilts, Streamlines and Daltons, Schults, Pacers, Fleetwings, and Yellowstones.

And now, Twisters. In the late 1990s, brothers Gerry and Rod Hagelund of Coquitlam, British Columbia, began repairing and rebuilding vintage trailers. Like Arthur Sherman and the many hobbyists who followed him, the Hagelunds soon found themselves building brand-new trailers. Their Twister is built on a modern chassis, but designed in the spirit of

OPPOSITE: Along Nevada's Mt. Rose Highway, a group of 1950s-era canned hams slowly decays beneath the pines. Collectors have been known to cross several state lines to retrieve trailers in far worse condition; hence, these units may yet be rescued to live out a second lifetime.

postwar canned hams. Its windows are reproductions of midcentury examples, while its fluted aluminum siding is produced by vintage embossing rolls. A two-tone action line sweeps along the sides and terminates in a classic V motif fore and aft; 1950s-era vinyl and plastic laminate patterns and hand-rubbed birch cabinets complete the period interior.

The Twister is aimed at a specialized market—one which is drawn to the midcentury aesthetic, but prefers not to deal with the problems and shortcomings of the era's genuine articles. Given that so many contemporary products are inspired by the aesthetics of the forties and fifties, yet also benefit from modern technology, the Twister may be the right trailer at the right time. Whether vintage reproductions represent trailering's future, or just a brief revisitation of its past, remains to be seen.

An early sixties-era single-wide is melded with a site-built office in Ione, Nevada.

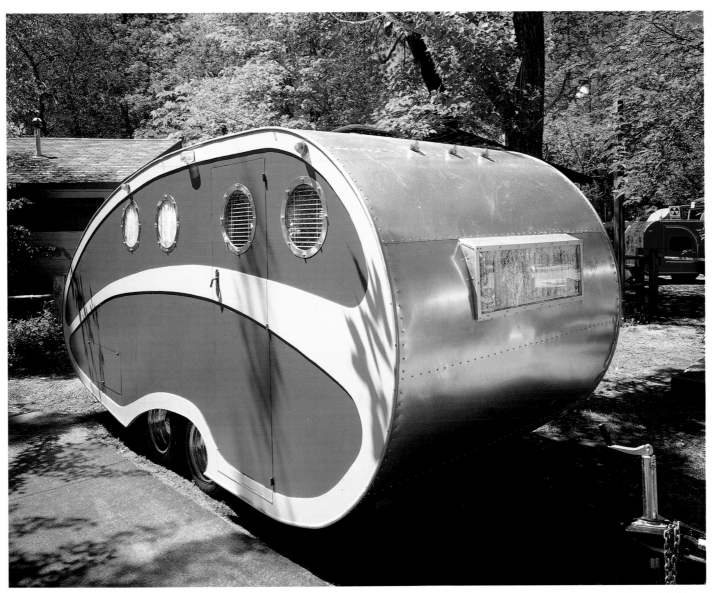

Christened the "Maxi Tear," this homebuilt trailer was completed by Jerry and Carolyn Piper of Bakersfield, California, in 2002. The couple modeled it on Airfloat designs of the 1950s. Note the careful integration of the entrance door and its porthole window into the overall design of the side panel.

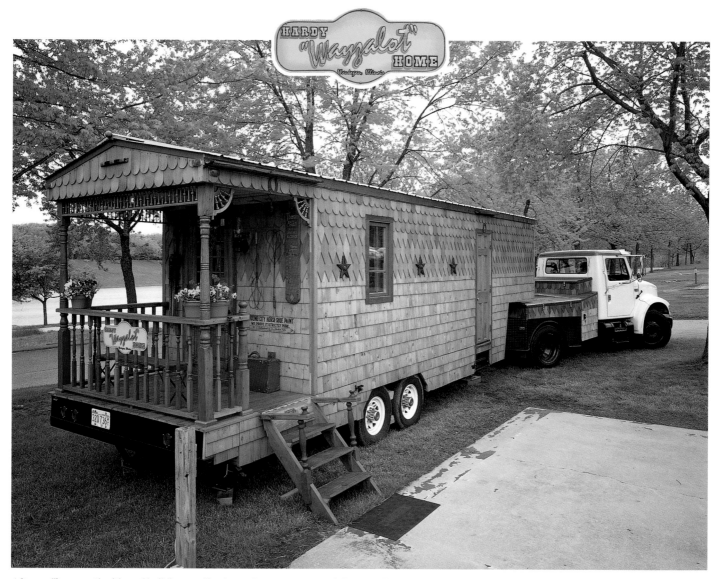

After mulling over the idea of building a rolling home for some twenty-eight years, Hardy and Terry Evans of Waukegan, Illinois, finally found time to begin tinkering in 1998. Just fifteen months later, they completed the Wayzalot, a 24-foot wood-framed trailer with an additional 5 feet of back porch. The Evanses describe the Wayzalot as "a piece of our very own folk art;" its name, incidentally, grew out of Hardy and Terry's oft-repeated answer to queries about the trailer's weight: "It weighs a lot." The Wayzalot does in fact weigh a lot, but not as much as many other mobile homes: Its 9,800 pounds are easily carried by a steel frame rated at 15,000 pounds.

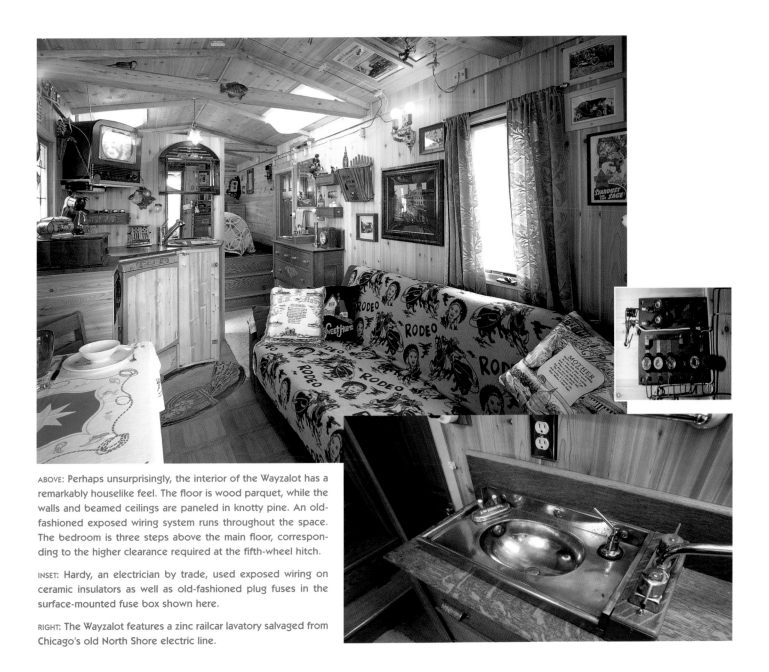

ABOVE: Perhaps unsurprisingly, the interior of the Wayzalot has a remarkably houselike feel. The floor is wood parquet, while the walls and beamed ceilings are paneled in knotty pine. An old-fashioned exposed wiring system runs throughout the space. The bedroom is three steps above the main floor, corresponding to the higher clearance required at the fifth-wheel hitch.

INSET: Hardy, an electrician by trade, used exposed wiring on ceramic insulators as well as old-fashioned plug fuses in the surface-mounted fuse box shown here.

RIGHT: The Wayzalot features a zinc railcar lavatory salvaged from Chicago's old North Shore electric line.

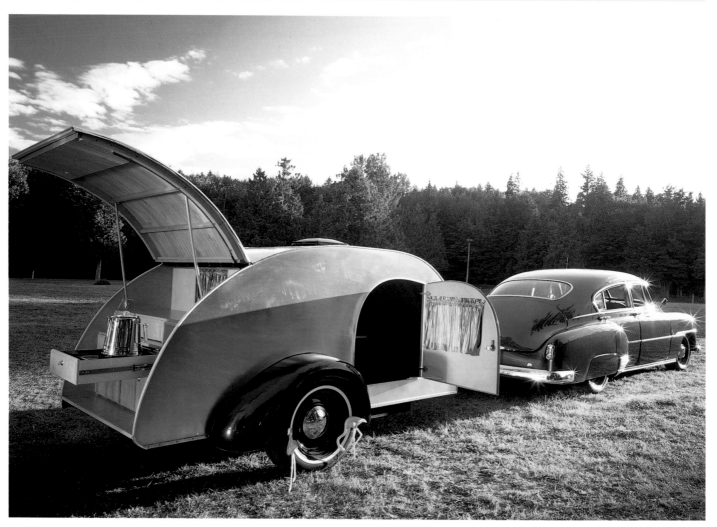

In 1999, Jack and Sue Jacobson of Tacoma, Washington, built this 9-foot teardrop trailer from a purchased set of plans. The Jacobsons completed it in three and a half months at a total cost of $2,300—excluding, of course, a considerable amount of sweat equity. The tow car is a 1951 Chevrolet sedan.

The teardrop's tiny interior nevertheless features a dinette that folds into a double bed and locking cabinets with a built-in television niche.

Backyarders are not the only enthusiasts building retro-looking trailers. Since the late 1990s, brothers Gerry and Rod Hagelund of Coquitlam, British Columbia, have been commercially building the Twister, a trailer emulating the classic canned hams of the 1950s. The Twister's two-tone action lines and V motif fore and aft—classic hallmarks of 1950s-era design—are just two of the devices the Hagelunds use to capture an authentic canned-ham feel. The trailer's exterior also features exact reproductions of authentic period windows, as well as corrugated aluminum siding made from original 1950s-era embossing rollers.

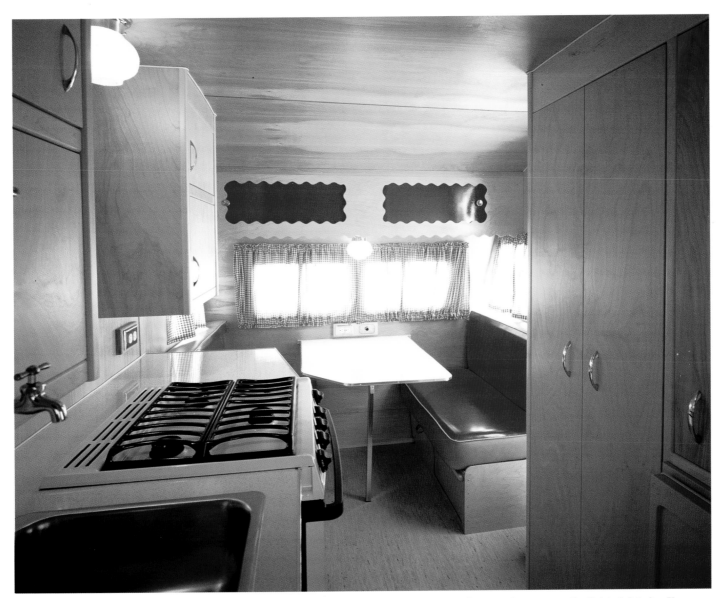

Colorful vinyl upholstery, plastic laminates, and hand-rubbed birch cabinets provide another set of retro styling cues on the Twister's interior. The overhead storage cabinets with their wig-wag door design are taken directly from examples of the late 1950s.

Resources

Interested in finding out more? Here's a list of Web sites that will help you on your quest. If you don't find exactly what you are looking for, you'll find that most of these Web sites have links to other trailer-related Web sites.

Information on Specific Trailer Brands and Types

www.singlewheel.com
www.airstream.net
www.teardrops.net
www.fiftiestrailers.com
www.spartantrailer.com
www.vintageairstream.com
www.maxitear.com
www.VintageOasis.homestead.com
www.sheepwagon.com
www.pierce-arrow.org
home.earthlink.net/~raulb/roadchief.html
 (Bowlus)
www.geocities.com/bolerama (Boler)
www.tompatterson.com/Streamline/Stream-
 line.html (Streamline)
www.geocities.com/MotorCity/Garage/7002/
 (Curtiss)
www.mrsharkey.com/index.html (House
 Trucks and Busses)
www.vintagebus.com

Publications

www.losthighways.org
www.trailerlife.com

Clubs and Organizations

www.escapees.com
www.airstream.net
www.teardrops.net
www.tincantourists.com
www.goodsamclub.com
www.TeardropTours.com

Trailer Supplies, Accessories, Memorabilia

www.hav-a-look.com
www.airstreamdreams.com
www.teardropparts.com

Trailer Sales, Rentals, and Restoration

www.vintage-vacations.com
www.funkyjunkfarms.com
www.vintagecampers.com
www.iowaboys.com

General Trailer Information, United Kingdom

www.jenkinsons-caravan-world.com

Museums

www.rv-mh-hall-of-fame.org
www.shelburnemuseum.org
www.nethercuttcollection.org
216.177.87.187/ (Petersen Museum)

Links

Most sites have links, but Craig Dorsey has links to links to links . . .
www.vintage-vacations.com/trailerlinks.htm

Trailer King

Vince Martinico is in a class by himself. He buys, sells, restores, and collects all manner of trailers, trailer memorabilia, and house cars. Ultimately he wants to build a trailer museum. He hasn't got a Web site yet, but you can contact him at bigyellowt@yahoo.com

Acknowledgments

Leonard Knight

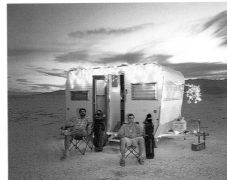

Steve and Scott Robison

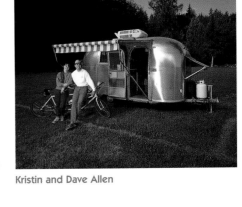

Kristin and Dave Allen

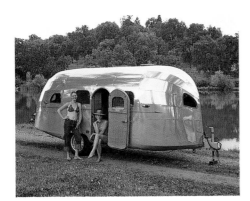

Jeanie Gartin and Abbey Levine

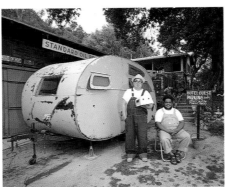

Edward Lum and John Agnew

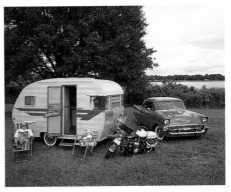

Duke Waldrop

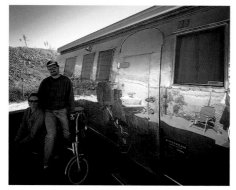
Sam and Bob Krumwiede

Sam and Bob's dog

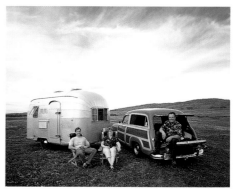
Mike Conner, Linda and Paul Lyons

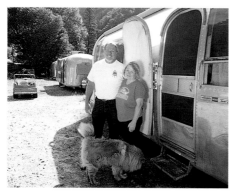
Loren and Rhonda Perkins and Goldie

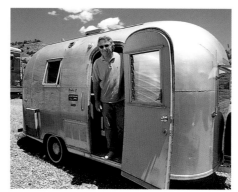
Beau Guthrie

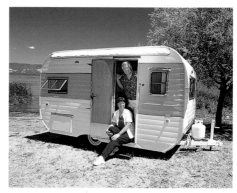
Kathy and Wayne Ferguson

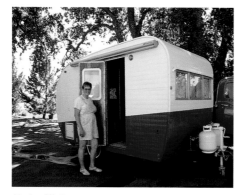
Marian Welton

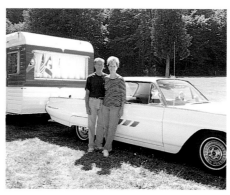
Don and Mary James

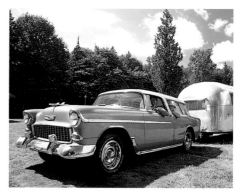
Richard Phillips and the kid

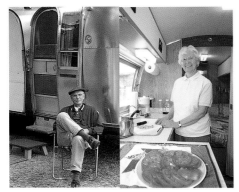

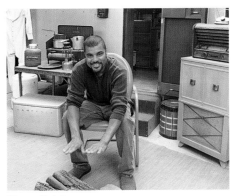

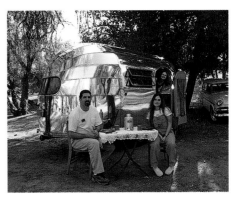

Fred and Ruth Maloney

Steven Butcher

Paul Farley, Vanessa Chadwick, and
Debra Richards

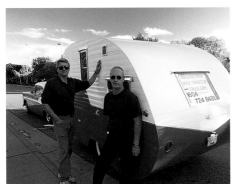

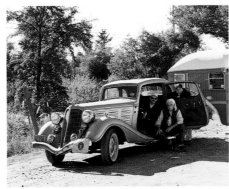

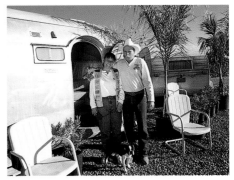

Gerry Hagelund and Mike Lauzon

Vince Martinico, Milton Newman, and
Mike Ceklovsky

Cathy and Lee Simth

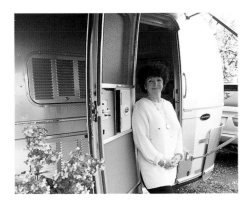

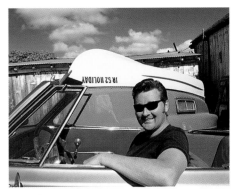

Judy Katz

Sarah Burkdoll and Dean Pederson

Jerry Rice

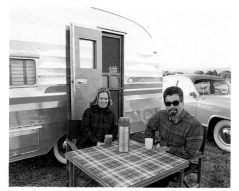

Dan and Susan Cutright

Hardy and Terry Evans

Don and Carol Mayton

Patti and Chris Huotari

Dave Mikol

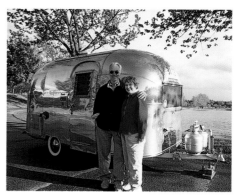

Ken and Petey Faber

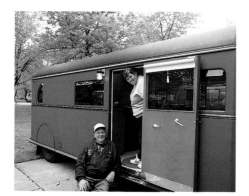

Ken and Lana Hindley

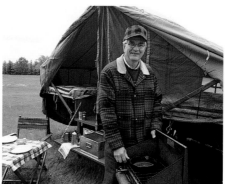

Les Sumner

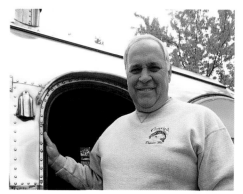

Forrest Bone

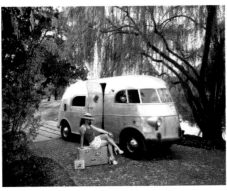

Elizabeth Mabry

Not pictured:
Tom and Gwen Akam
"Anonymous Bob" in Slab City
Dean and Debbie Bessom
Bill W. and Dr. Bob
Connie Bond
Jeri Bond
Julie Castiglia
Mick and Robin Carolan
Bruce Coons
Dorothy and David Counts
Clyde Davis
Joseph Dea
Ed and Rita
Grant Dixon
Craig Dorsey
"Earl" in Quartzite
Pete Eastwood
Stuart Echols
Michael and Sheila Evans

Patrick and Joanne Ewing
Rick Forter
Debbie Girts
Bob Goodman
Karl Grossner
CJ Hadley
James J. and Sylvia Horvath
Kris and Donna Hylton
Jack and Sue Jacobson
Andrew Jenkinson
Leslie Kendall
Dan and Karen Leonetti
Steve and Candy Marino
Skip Marketti
Ann and Norm Markus
Dick Messer
Rick and Janice Myer
Mike Mooney
Toni Moscini
Sherry Mullins
Cyril Nelson
Aidong Ni
Cori Olshavsky
Los Payasos
Chelsea Phillips
Dan Piper
Jerry amd Carolyn Piper
Chuck and Dianne Schneider
Sandy Schweitzer
Debbie and Mike Smith
Jess Smith
Travis Travinikar
Verna at Chism's
Bob and Marilyn West
Grant Whipp
Armand Wobo

Also:
The Magazine Archives, San Francisco
The Sunrise Motel, Cedarville, California
Skyline Park, Napa, California
Glasgow Museum of Transportation, Glasgow,
 Scotland
Braidhaugh Caravan Park, Crieff, Scotland
Rancho Los Alamitos
Walt Disney Enterprises
DaimlerChrysler
The Nethercutt Museum, Sylmar, California
The Petersen Automotive Museum, Los Angeles,
 California
Chism Trailer Park, Reno, Nevada
Blue Skies Village, Palm Springs, California
Brandon Castle, Bradenton, Florida
The Tin Can Tourists
The Vintage Airstream Club
Film processing by The Photo Lab, Chicho, Cali-
 fornia